THE
TATTOORIALIST

TATTOO
STREET
STYLE

— *for Mylène* —

THE TATTOORIALIST

TATTOO STREET STYLE

NICOLAS BRULEZ

MITCHELL
BEAZLEY

CON-
TENTS

INTRO-
DUCTION

NICOLAS BRULEZ

When I was little, my uncle sported a few tattoos which had been done on his wild travels. One of those tattoos, a much-flaunted flower with the iconic inscription "FOR MY MOTHER", was dedicated to my grandmother.

It was the first time I had seen anyone with a tattoo. During my teens, I longed to be different, experiencing a visceral urge to shout my existence out loud (like so many others, I think you would agree). As the whole issue of body modification continued to fascinate me, I had a growing urge to one day get a tattoo and become the secret rebel within me. So I went on to shake off the taboo, mine at least, which had either been instilled in me or which I had imposed on myself, and eventually decided to subject myself to the needle.

When I came to Paris, photography became the main form of expression for me. Though soothed by the work of Martin Parr, Henri Cartier-Bresson, Gérard Uféras, Richard Avedon, Diane Arbus, Raymond Depardon, and James Bort, I was more importantly stimulated, driven, and energized, my head filled with ideas: the quest for the photographic subject proved an ongoing and almost obsessive process.

It all effectively began during a sleepless night. Just as the first outlines started to take shape in my head, two images began to overlap: my tattoos merging into a street portrait I had done a few hours earlier. This image became so blindingly obvious to me, almost like a revelation. In actual fact, I think this idea had been

slowly maturing inside me for years. It gradually took root in my subconscious, bringing together my sources of inspiration, and my values in particular. The plan finally took shape, namely to photograph people with tattoos in the street. The pictures would be simple, authentic, and unenhanced, the sole trace of a fleeting encounter. I wanted to capture the image of these tattooed individuals at a specific moment: we would be alone in the midst of the bustling city. Under the curious stares of passers-by, all that would exist for us would be the tattoos. For apart from the photography, what excited me – swaying between enthusiasm and apprehension – were the encounter and the highly charged emotional interaction.

Thus The Tattoorialist was born in June 2012, the product of two passions – photography and tattoos – as well as being influenced by my professional job as a psychiatric nurse: several lives converged in this incredible adventure I am now living today. The sole aim of my approach is to promote the individuals involved and what makes them different, and give them a place where they can express themselves. The Tattoorialist is also set in my three favourite cities: Paris, my adopted city; Montreal, where my heart is; and Berlin, the city that never ceases to amaze me. I always thought that tattooing and sociology were closely linked, so I was interested in finding out attitudes to and experiences of tattoos in these cities, and what unique features I would find there.

A book project was a natural extension of the website. This book gives you 100 portraits accompanied by comments gathered during my encounters and contributions from Marie-Anne Paveau and Eirini Rari. These 100 portraits are as much testimonies as personal – and visual – interpretations of tattoos. You will find out that some people are inspired by love of the art form, while others have the need to "ink" the stages of their lives on their skin. Gathered together in front of my lens, these men and women are the reflection of my own vision of tattooing and my passion, just as I hope to reflect their own perspectives in these words and photos.

FORE-
WORD

JEAN-PAUL CLUZEL

*President of the Réunion des Musées
Nationaux and the Grand Palais
Former President of Radio France*

I am writing these lines on a high-speed train. A few rows down from me, a pretty young girl is speaking too loudly in what sounds like a Slavonic language. A few minutes ago, a very attractive young man was standing on the platform, wearing an outfit suggesting an impeccable taste for "shabby chic", the style that transcends a limited budget and is so typical of his generation. What they have in common is that they both have tattoos. On her back, the girl has a fake henna tattoo: the tattoo is in fact real, but the pearls are fake because they are actually tattooed on her neck. The young man has two very muscular forearms tattooed with a heavily-inked motif that my own tattooist Loïc would doubtless be able to categorize. What communities do these young people belong to? Does this question even mean anything any more? The answer would have been easy just 30 years ago, when I had my first tattoo done – not that long ago really. The young girl would probably have been classed as an alien, drugged-up no doubt. The muscular young man would of course have been gay, as he could not be categorized as a dock worker or repeat offender. Today it is no longer possible to "classify" these young people by their tattoos.

The best thing about this book, apart from revealing Nicolas Brulez's outstanding talent as a photographer, is to show that tattoos now belong to everyone and every social group. The decision to take the photos in the street locates the project within our society. The comments and text accompanying the images highlight the diverse reasons for getting a tattoo and the different ways of experiencing it. The backdrop of three completely different cities, Berlin, Paris, and Montreal, completes the picture.

There is no single explanation for this gradual change in attitude towards tattoos. The excellent contributions by Marie-Anne Paveau and Eirini Rari present the reader with some research conclusions, reached in the field of sociology in particular, to explain the explosion of this contemporary phenomenon. We can see that it has transferred from one world to another. In ancient times, tattoos traditionally denoted membership of an ethnic or social community, a "branding" that was often compulsory and linked to a ritual, or to passing from one stage of life to another. In our contemporary society people intentionally free themselves from the norm and tradition, taking charge of their own lives to the extent of imposing modifications on their bodies which seem to them to match their true nature.

To quote Nietzsche: "Become who you are".

This is something that the entourage of a recent French president, a determined and intelligent man, failed to understand in believing they could use my tattoos as a pretext for not renewing my position as head of a major group of public radio stations. They told him I thought "I could do whatever I liked" in publicly "exhibiting" tattoos on my naked chest (this was for a calendar produced by an AIDS charity illustrated with photos by Vincent Malléa). These photos were specifically designed to show the diversity of people with tattoos. It was a bad decision: no-one, from the media to our listeners and journalists to technicians, agreed that my management should be judged by my tattoos. I was invited to work on *Le Grand Journal,* a nightly news and talk show, a supreme honour that was unworthy of my 20 years' experience of managing leading cultural enterprises. The president's entourage further mishandled the situation by making a causal connection of guilt between my tattoos and my homosexuality, both being inextricably linked in their eyes. These people really did get everything totally wrong. But this turn of events was probably what led Nicolas Brulez and Mylène Ebrard to ask me to write this foreword.

Whatever individual paths are involved, I would venture to propose that tattooing meets three simple aspirations of modern life: pleasure, seduction, and youth.

Pleasure, firstly. It is not about the physical pain involved in tattooing your skin being transformed into potentially masochistic pleasure. Such masochism may apply to some people, but it is alien to the intrinsic nature of tattooing. On the contrary, many people with tattoos have extremely pleasant memories of each individual session. The rewarding power of such memories arises primarily from being able to control one's own body, something we often aspire to but rarely achieve. Now, for a tattoo to be successful, the "patient" must switch off all of his or her usual reflexes. A kind of pleasure also develops out of the inevitably intimate relationship forged between the tattooist and the person being tattooed. What springs to mind is the quartet in the wonderful film by Yoichi Takabayashi, *Spirit of Tattoo*. A male lover thinks their love could only be perfect if his mistress has her body tattooed. An old tattooist master agrees to carve his final masterpiece on the woman's back on the express condition that his young apprentice penetrates her while he is working and brings her to orgasm. At one point the apprentice himself tattoos the symbol of a snow flower in the armpit of the woman who is his lover for the duration of the tattoo sessions. Without reaching these extremes of eroticism, all extensive tattoo work creates a relationship between tattooist and tattooed which inevitably has a sensual rather than an intellectual basis. For this reason, choice of tattooist by the person being tattooed is neither innocent nor independent of their respective sexuality.

Seduction. Tattoos are often designed to be hidden under clothing. Yet there comes a time when the body is exposed to someone else, and this state of nudity is nearly always taken into account when deciding on a tattoo. Some tattoos are deliberately aggressive and "unpleasant". But underlying the visual violence is the desire to shock the other person, and hence attract him or her where appropriate. Tattoos are inextricably linked with seduction. Most tattooed people have them done simply to be more desirable, and as a rule, they feel they have achieved this aim. Others quickly find that it changes their relationship with other people, even though this was not their original intent; feeling stronger, they become more attractive. Tattoos are not, however, a substitute for beauty, and in this sense they do not serve the same purpose as bodybuilding. But they do give tattooed individuals a look which is more in

tune with what they want to be, more in line with their own personality. This reconstruction of personal identity is a profoundly modern phenomenon. Its aim is to allow us to become more attuned to ourselves, which in turn means we can be more open to others. This is why the choice of motif and the tattoo's location and size are such important points in this process of seduction, whether your aim is to seduce or to repel.

Youth and the tattoo's durability and indelibility go hand in hand. In 1984 the German band Alphaville sang "For ever young, I want to be forever young". It is no coincidence that this song still features in the charts even today, for ageing is one of the many inevitabilities that the 21st century has set out to overcome. It is often claimed that old age and tattoos are incompatible, but precisely the opposite is in fact the case. If it is beautiful, or simply impressive in size, a tattoo retains its power of attraction and seduction in the same way that the beauty of Renaissance frescoes manages to survive on the cracked walls of some Italian churches. Unlike the appalling and ridiculous process of facelifts, tattoos do not attempt to erase: they strengthen. We only need look at the tattoos of old sailors to see that an interesting tattoo never looks foolish; on the contrary, it comforts its wearer on a journey that is both problematic and characteristic of our time: the desire to be authentic at any age. Tattoos often have an indirect effect since people who have them feel obliged to maintain both their own shape and that of their artwork to the best of their ability – *mens sana in corpore sano* (a sound mind in a sound body). The weights room or a sports class come hot on the heels of the tattooist's studio. It is hardly surprising that the first people to get tattoos were generally employed in particularly manual jobs, or lived in societies where physical strength was inextricably linked with survival.

The following pages of this book, then, produce a sense of continuity and peace of mind, apparently indifferent to the dreariness of some urban design and giving visual reinforcement to the people photographed by Nicolas Brulez in their life choices.

I invite you all to browse through this book, taking from the images and words what you want. I myself experienced a kind of sensual pleasure looking at the vast range of what to my eyes were many different types of beauty. I hope you will experience the simple pleasure of an amorous, furtive, and voyeuristic flâneur as you meander through these pages.

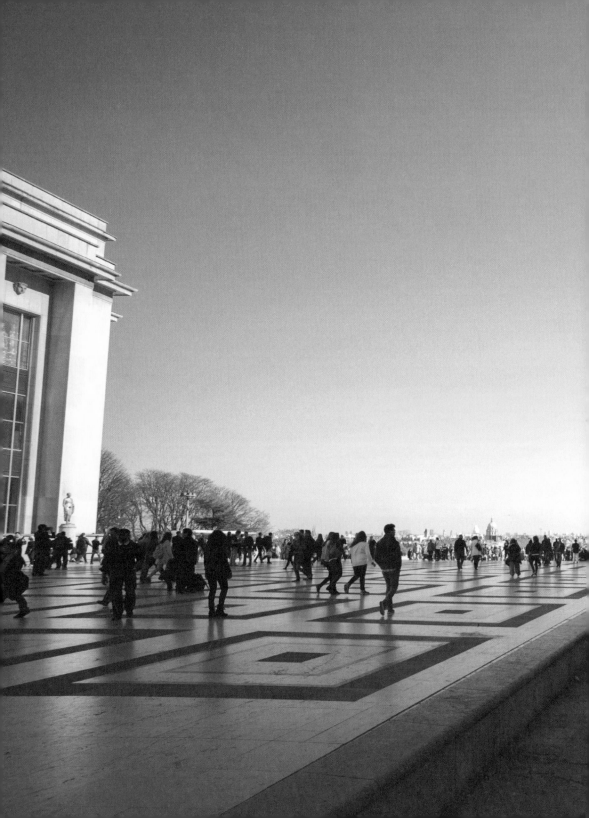

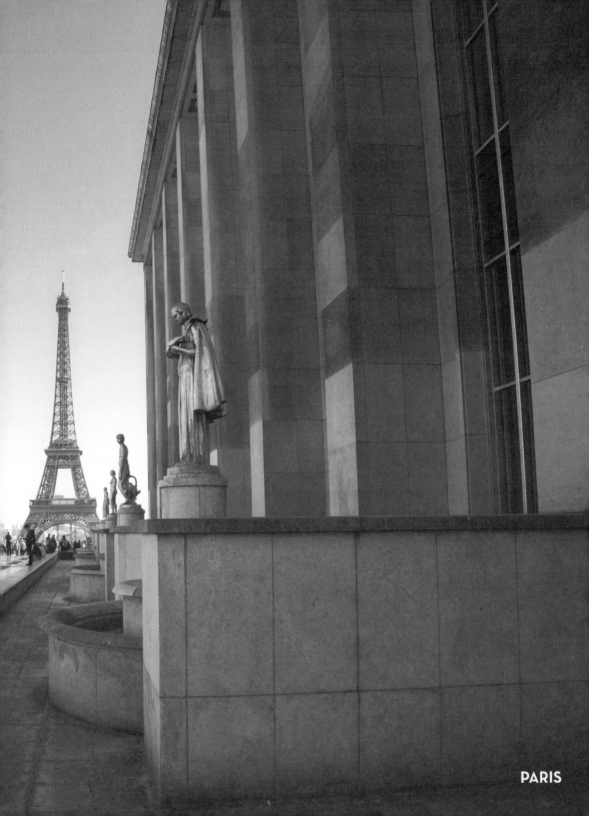

PARIS

01

LOCATION
rue Pernelle (Paris)

FLO

TATTOO ARTISTS

JOHNNY BOY
in Bordeaux

MANA MAURI TATAU
in Moissy-Cramayel

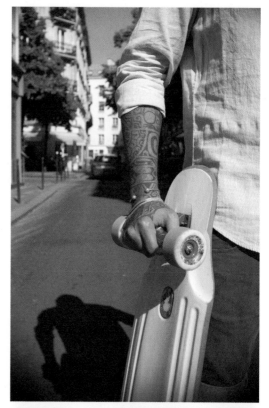

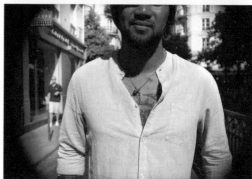

Tattoos are part of Flo's culture, born as he was in Polynesia. He is passionate about gliding and sliding – surfing, longboarding, and skateboarding. His tattoos represent his roots, his history, and his family – a whole encrypted world of Polynesian symbols indecipherable to everyone else!

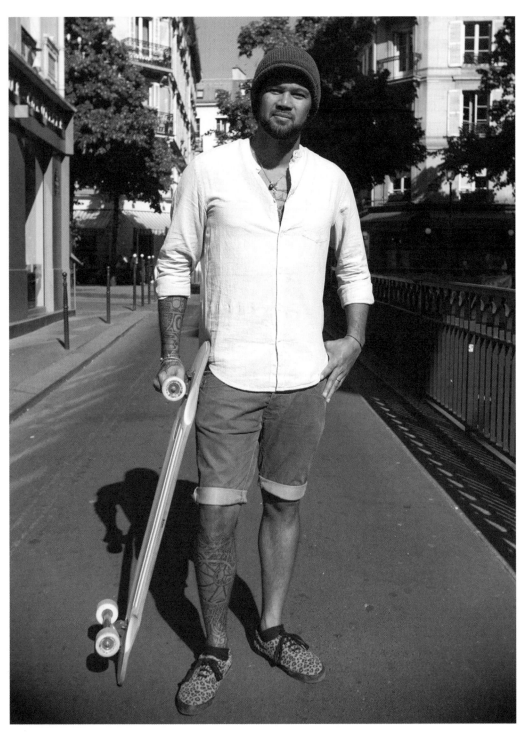

02

TATTOO ARTISTS

DIMITRI HK
in Saint-Germain-en-Laye
(p.173)

ROMAIN TATOUAGE
in Paris

LOCATION
passage Brady (Paris)

ROMAIN

Keen on travelling, meeting new people, and foreign cultures, Romain (aka "Trib") sees his tattoos as a worthy finishing touch to his personality. He is passionate about tribal and traditional motifs (especially Maori ones), often using them for designs because they remind him of the original aspect of tattooing: belonging to a group or tribe.

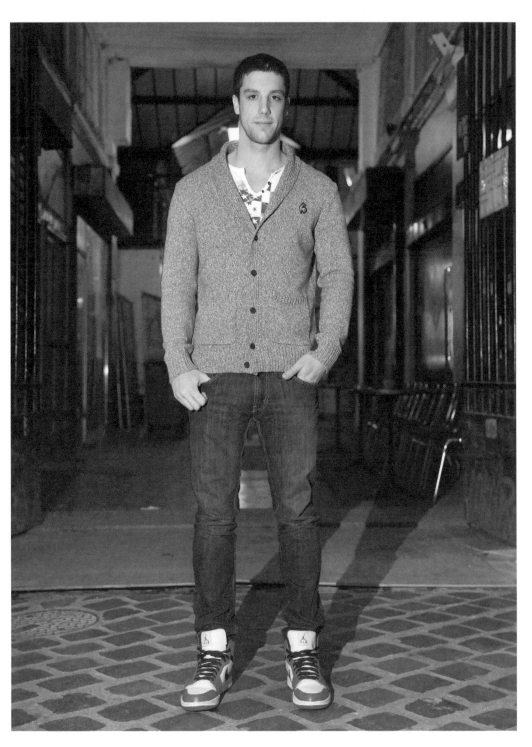

LADYCHIPS

TATTOO ARTISTS

SACHA *at*
EASY SACHA *in Paris*

SAILOR XA *at*
STEVE ART TATTOO
in Nancy

YANN *at*
BUZZ TATTOO
in Vannes

LUDO *at*
ART CORPUS *in Paris*

NICK *at*
TIN-TIN TATOUAGES
in Paris

PHIL VAN ROY
in Versailles

BENJI *at*
LA BOUCHERIE
MODERNE
in Brussels

ALEJO TATTOOIST
on the road

MISTER P *in Brussels*

YOM *at*
MYSTERY TATTOO
CLUB *in Paris*

TWIX *at* **FATLINE**
TATTOO CLUB
in Bordeaux

HUGO *at*
HAND IN GLOVE
TATTOO *in Paris*

RUDY *at*
23 KELLER *in Paris*

TEIDE TATTOO
now at
JOLIE ROUGE
in London

SACHA
MADEWITHLOVE
at **TRIBAL ACT**
in Paris

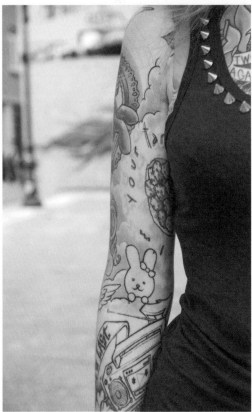

A performer in the Black Circus in Paris, Ladychips is a woman of many passions – not just tattoos, but also love, friendships, and work. From a very early age she dreamed of getting a tattoo, and since turning 21 she has had tattoos done which complete and define her as a person, like keeping an illustrated logbook of her life.

Even though Ladychips is fond of minimalist art, her tattoos are often quite the opposite, as we can see from the little ponies on her arm. They remind her of her childhood, when she collected these toys. She gets her tattoos first and foremost for herself: she doesn't care how others see her, as the people around her love her for what she is.

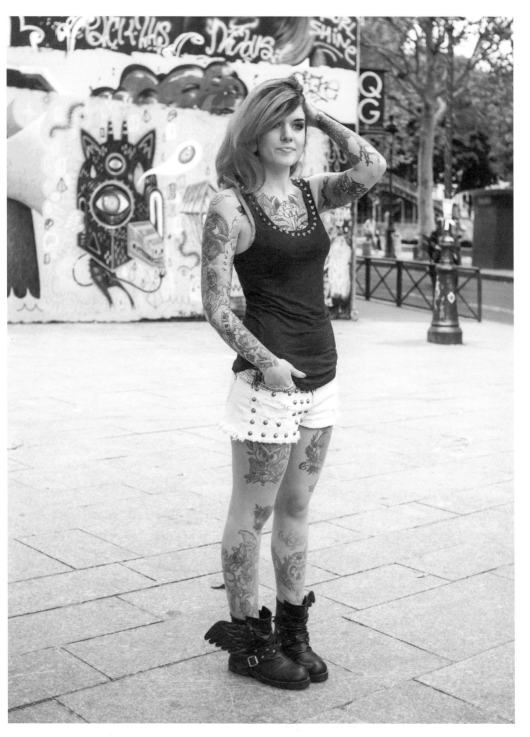

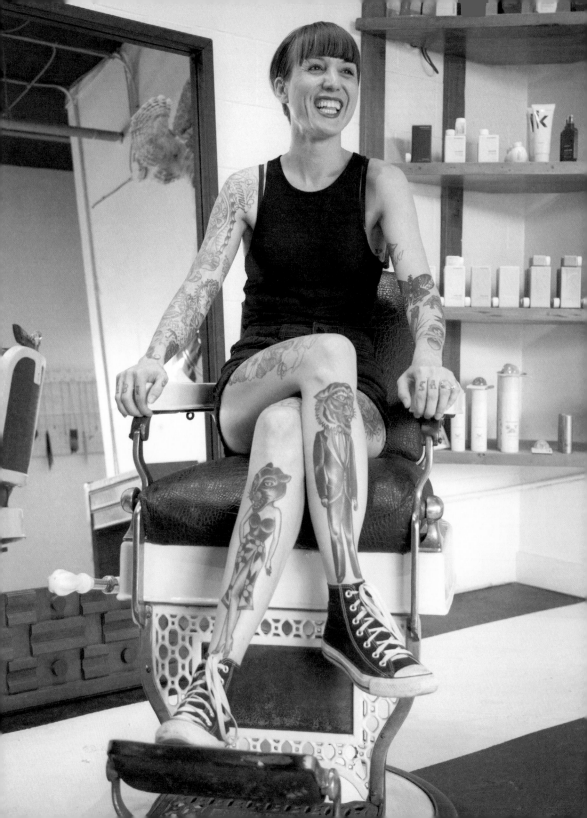

PORTRAIT

04

LOCATION
in the Two Horses studio, rue Jean Talon West (Montreal)

TATTOO ARTIST

JESSI PRESTON

TATTOOED BY

SAL PRECIADO, *her mentor*
in Los Angeles

TIM FORBUS *at*
ACME TATTOO *in Staunton, USA*

ADAM PADILLA
in Los Angeles

JACOB RAMIREZ *at*
BODY ELECTRIC TATTOO
in Los Angeles

MIKE ADAMS
in Richmond, USA

JOSH STEPHENS *at*
HOLD IT ON TATTOO
in Richmond, USA

MARK CROSS *at* **GREENPOINT
TATTOO COMPANY**
in Brooklyn

STEVE BOLTZ *and* **ELI QUINTERS**
at **SMITH STREET TATTOO**
in Brooklyn

CRAIG JACKMAN *at*
AMERICAN ELECTRIC TATTOO
in Los Angeles

At the Two Horses studio in the centre of Montreal, you get a warm North American welcome, whether you are there to have your hair styled, get a tattoo, or just to discover this highly original studio which is not yet well established. Jessi, a lovely woman who commutes between Brooklyn and Montreal, recently set up shop there with her business partner, and already they are operating the studio at full capacity.

Jessi came to tattooing out of curiosity, finding it "both original in terms of body modification and enriching through all the people you meet". Having a great respect for the history and traditions of tattoo culture,

she was thrilled at the idea of entering the inner circle and learning its codes, from the techniques to the vocabulary.

Jessi likes to draw inspiration from just about everything: classic works, nature, the circus, Victorian precious stones, old labels, mid-19th century furniture, Japanese clothing designs, and music. And she is definitely hooked on traditional tattoos which, as far as she is concerned, wear better through time periods and fashions.

Jessi's reasons for getting tattoos are for their aesthetic appeal and the desire to own the work of the artist to whom she has entrusted her skin.

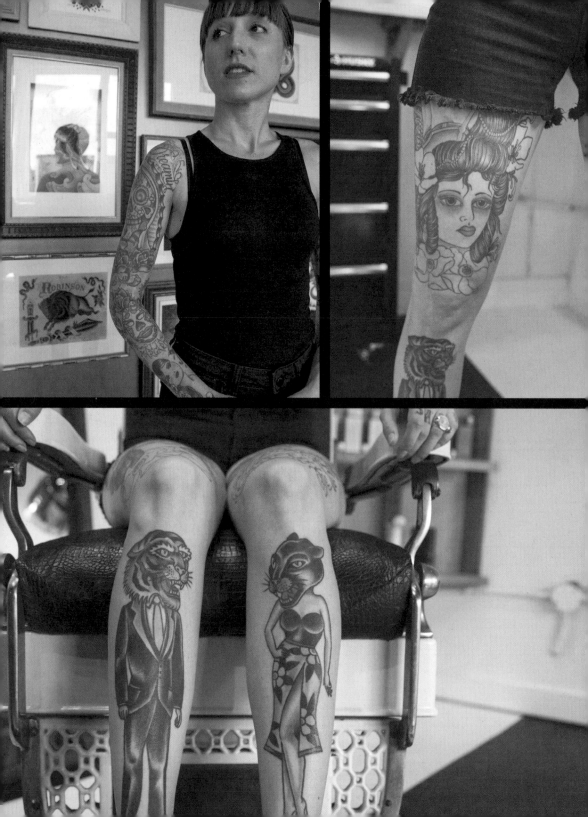

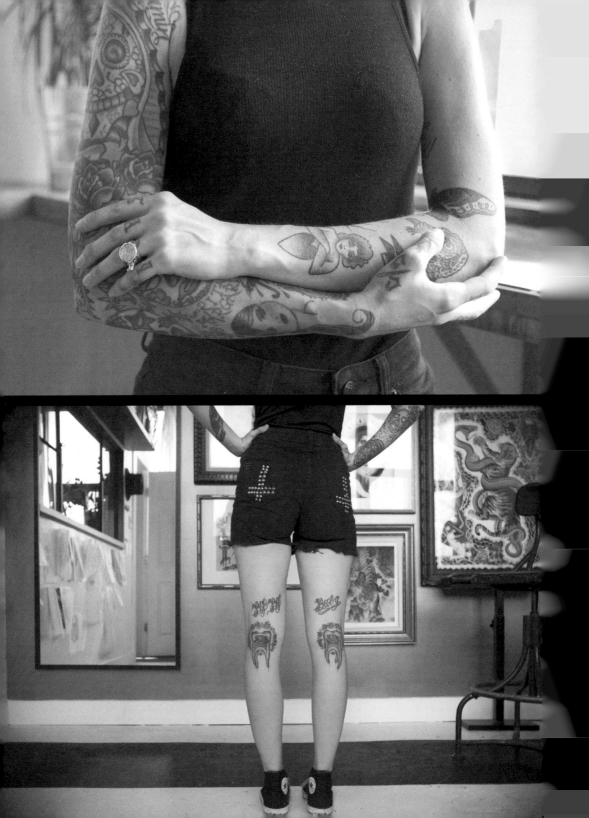

05

LOCATION
on the Debilly Footbridge (Paris)

SÉBASTIEN

TATTOO ARTISTS

YOANN *at*
ARTCANNES
TATTOO *in Cannes*

JESSA MOULIN
in Paris

Sébastien sees his tattoos as a scrapbook he could never throw away. He had his first tattoo done when he was 18. Each one reminds him of a place where he has lived and which has been a defining moment for him. What Sébastien loves about tattoos is the idea of permanently "inking" the stages of his life and wearing a design immortalized by his favourite tattoo artists.

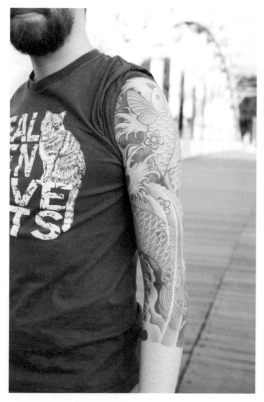
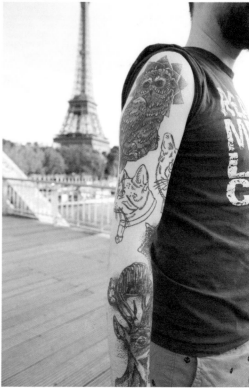

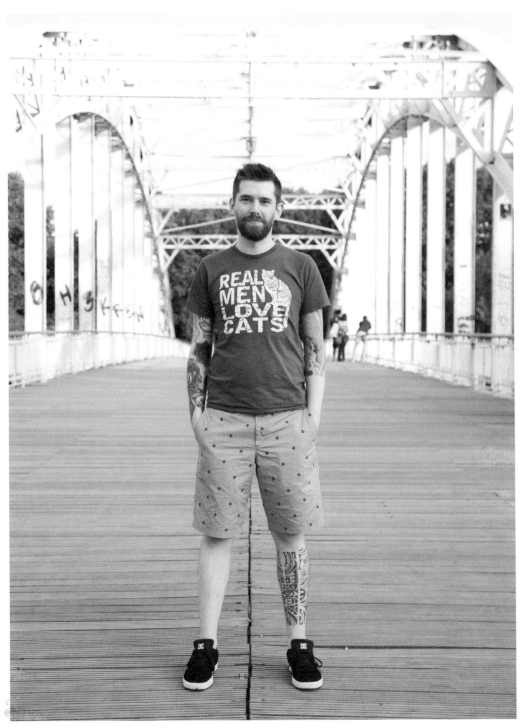

06

THIERRY *at*
VITR'INK TATTOO
in Vitry-le-François

TARMASZ
in Paris

LOCATION
rue Réaumur (Paris)

AVALON

As a graphic design student, Avalon is immersed in the art world. Everything is a source of inspiration for her: the details of a painting, textures, images, and meeting people, as well as the artists and creative people she admires, such as Fanny Latour-Lambert, Romain Le Cam, Gareth Pugh, or Dévastée.

Avalon is fascinated by the association of tattooing with memory, ornamental art, drives, and urges, or even just its role in perfecting a particular look. Her tattoos bring back memories of problematic events in her life which she has managed to overcome.

LOCATION
rue Anatole-France (Levallois)

TATTOO ARTISTS

CARLOS *at*
NO PAIN NO BRAIN
in Berlin

RAQUEL *at*
JOLIE ROUGE
in London

NIEL *at*
ART CORPUS
in Paris

ÉLODIE

Élodie is Parisian to the core (Left Bank, if you don't mind!). She is a fan of pop culture and works as a journalist for *ELLE* magazine. She may have sworn never to get a tattoo, but when she was on holiday in Berlin with friends, she took the plunge! For her, the body is a huge canvas she is in a hurry to fill. She would have no qualms, incidentally, about getting a silly tattoo on an impulse or if she lost a bet (in which case, however, it would be somewhere out of sight).

Her six tattoos derive from fantasy worlds and/or are connected to her childhood (Disney®, Harry Potter), and there's one of a great fashion designer. They were conceived and designed along with friends, by herself, or by fashion designer Jean-Charles de Castelbajac. Her young cousin, who is starting out as a tattooist, was even given a chance. Élodie already knows the tattoos she would like next, but she can't decide between her background and her passions. Perhaps a combination of both?

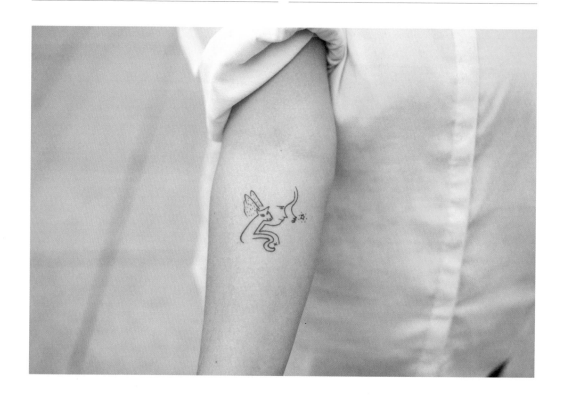

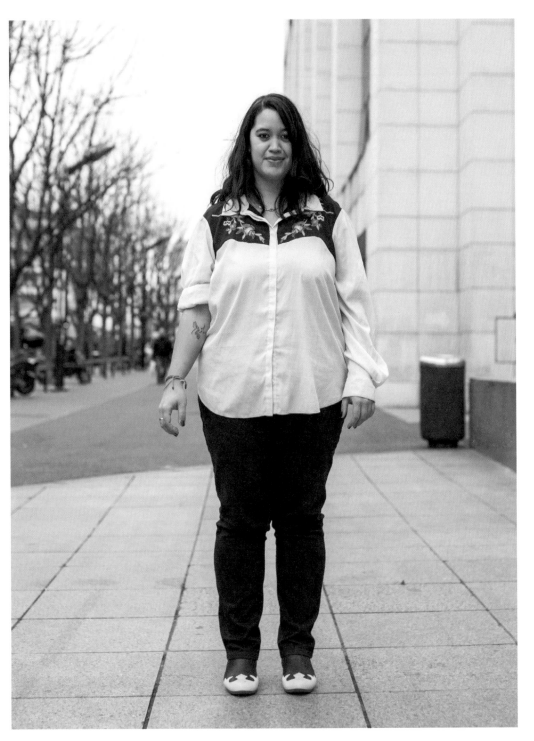

PORTRAIT

08

LOCATION
at Bodkin Tattoo, rue Bernard Ouest (Montreal)

TATTOO ARTIST

NICOLAS DURAND

TATTOOED BY
ALEXANDRE DUMAS *at*
SYMBIOSE TATTOO
in Richelieu, Quebec

A member of the tattoo team at Bodkin Tattoo in Montreal, Nicolas is an artist in his own right. Driven by his painting and tattoo projects, he immerses himself in the world of Dalí and draws creative inspiration from nature in his works. He had his tattoos done on a whim, for pleasure, and above all because he lives life to the full.

09

LOCATION
passage Saint-Bernard (Paris)

PETER

TATTOO ARTISTS

ROYAL TATTOO
in Paris

FRED *at*
MAGIC CIRCUS
then **TRIBAL ACT**
in Paris

Peter has always been passionate about art, and tattooing seemed to be the best way of expressing this passion, inking all the personal moments and symbols that have made him what he is today.

For him, tattoo art is primarily a story and an artistic feat derived from a wide range of different styles and influences. Peter is inspired by street art, comics, Chicano-style typography, and the cult of the dead (in its positive, South American sense) as well as the chiaroscuro paintings of Caravaggio. His main motivation is still to become a tattooist himself.

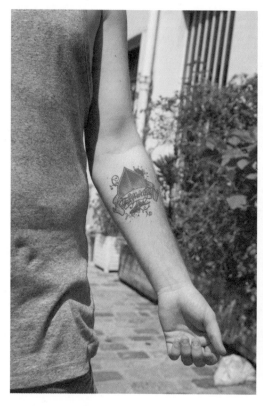

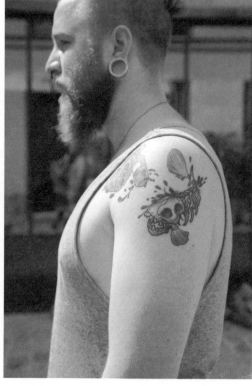

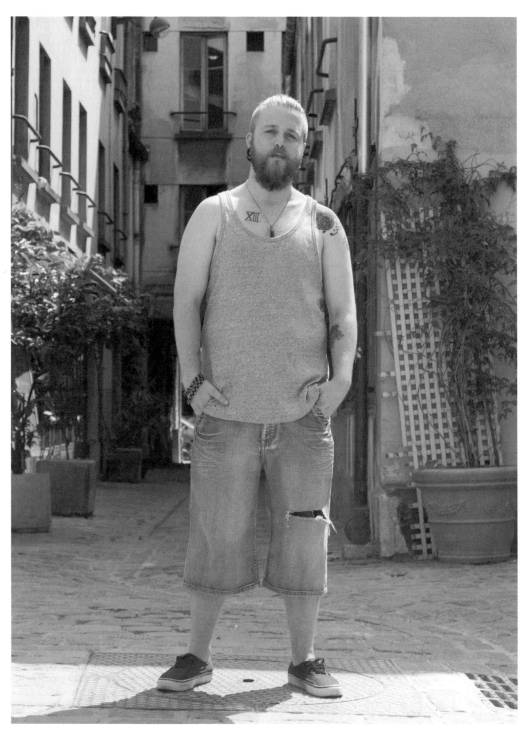

10

LOCATION
place Colette (Paris)

ÉMELINE & LITA

TATTOO ARTISTS

For Émeline

MYLOOZ *at*
TATTOOED LADY
in Montreuil

ROCK'N'ROLL
SPIRIT TATTOO
in Crépy-en-Valois

MISS PUDDING *at*
DREAM ART TATTOO
in Mogneville

ALLISON *at*
DIAMANT NOIR
TATTOO STUDIO
in La Rochelle

For Lita

DIDIER.RA
in Aix-en-Provence

GASTON
and **MÉLANIE** *at*
GRAPHICADERME
in Vaison-la-Romaine

LAURINK
in St Denis

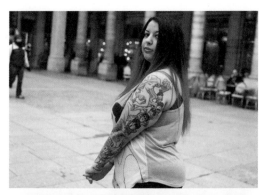

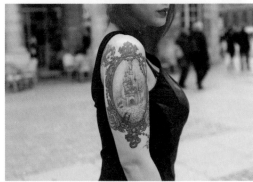

Émeline got the bug for tattoos when she was very young, passed on to her by her tattooed mother. It all clicked when she came across some tattooed bikers. At the time she was still too young to realize her dream, but the desire was always there, and when she turned 18 she decided to get her first tattoo. For her, it is an art form in its own right, worn on the body, but it is also a way of taking control of her own body and her image.

Her tattoos remind her of cartoons from her childhood: Alice's cat, Sleeping Beauty's castle, Sailor Moon's crystal, and even a babydoll representing the femininity of the 1960s. A real nostalgia trip through her youth!

Inspired by the new school and fascinated by colour work, Émeline draws her ideas from art (Mark Ryden, Dalí, Trevor Brown, Miss Van, and so on), history, and of course, children's fairy tales.

It's no coincidence that Lita and Émeline are friends. Lita, too, was fascinated by tattoos when she was young, but the real eye-opener for her was watching wrestlers on television! Since her first "disgraceful" tattoo at just 16 years of age, Lita has been busy designing, and enjoying discovering the many artists who inspire her, like Glenn Arthur, Marco Guaglione, Tim Shumate, Da Vinci, Miyazaki, and Glen Keane. For her, "being tattooed is to be a living work of art"! She loves her different tattoos which never fail to take her back to her childhood: cartoons, iconic personalities, and cult replicas that have made a deep impression on her. An artist to the core, Lita dreams of becoming a tattooist and is looking for the ideal instructor to teach her the art of inking skin.

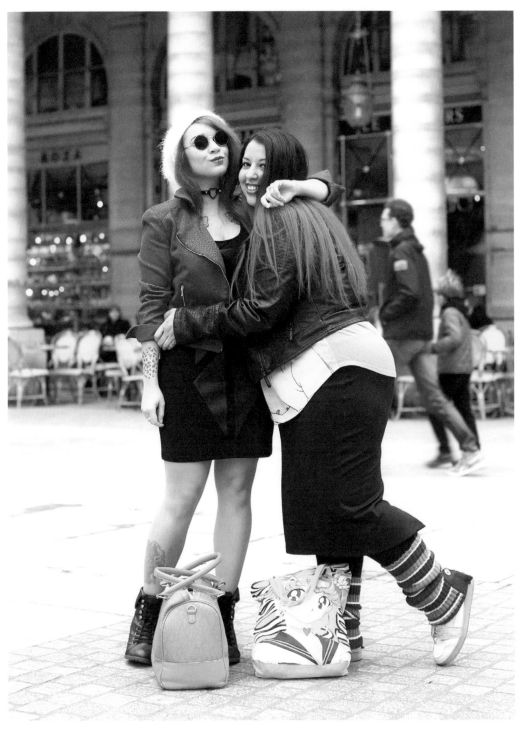

11

JESSI PRESTON *at*
TWO HORSES
in Montreal (p.21)

MAGDALENA
Apprentice tattoo artist

LOCATION
Place des Arts (Montreal)

CAMILLE

A Fine Arts student in Montreal and a blogger, Camille (aka "The Lost Child") got her first tattoos for very personal sentimental reasons, and more recently, just because she wanted to! She put her trust in some great artists, but also had a crush on a tattooist she met in the flea market and immediately put her skin in his hands.

Heavily inspired by the traditional American style, engravings, and esoterism, Camille is also keen on the work of many artists such as Egon Schiele, Albrecht Dürer, Gustave Doré, and John William Waterhouse, as well as the illustrations of Matt Furie. A very creative person, her real dream is to embark on a career in jewellery and writing.

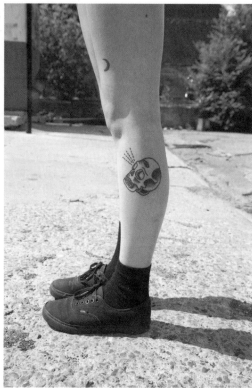

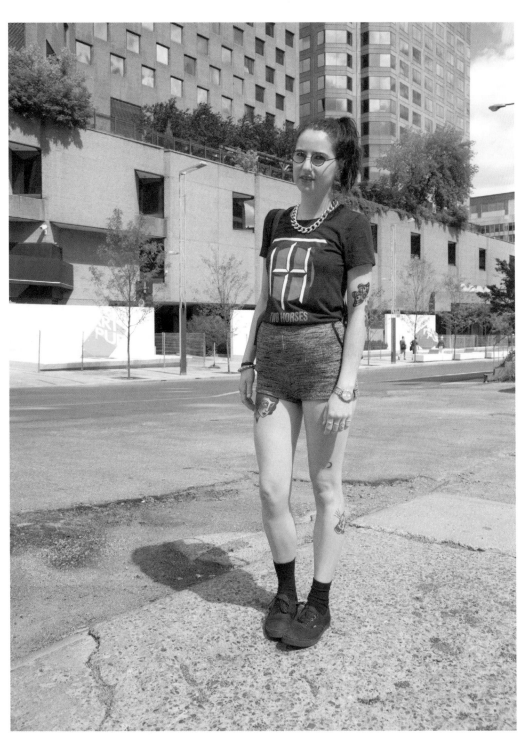

12

TATTOO ARTISTS

COURTNEY O'SHEA
at **BLACK & BLUE
TATTOO**
in San Francisco

ALYX LOTTIN *at*
**BLACK BIRD
TATTOO** *in Paris*

LOCATION
rue des Martyrs (Paris)

SORAYA

Soraya describes herself broadly speaking as a performer. An actress, singer, and dancer, she enjoys life to the full, and has absolutely no intention of letting anyone tell her what to do or how to act.

The night before she left for San Francisco, she had a dream involving deer. That was the moment that marked the start of her love affair with tattoos. So at the relatively late age of 27, she had her first tattoo done, a step she regarded as a real aesthetic revolution. Rather than using her body simply as a blank page on which to write the story of her life, Soraya decorates it with numerous tattoos, which allows her to truly "wear her skin" as a consistent reflection of her identity. Seeking things in tune with her personality, she draws inspiration from everything around her, and is particularly fond of the old school and colour work. Soraya is growing restless after having a rock'n'roll interpretation of the phrase "storm in a tea cup" tattooed on her left thigh: she is now waiting for the right moment to get a new tattoo of her latest idea.

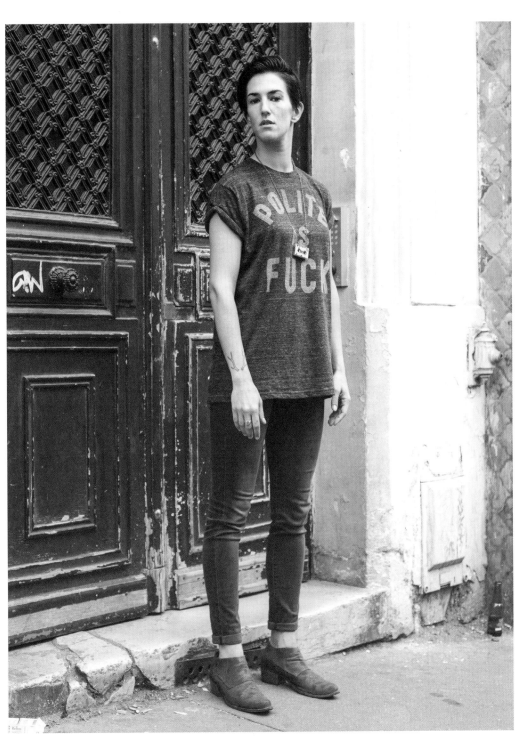

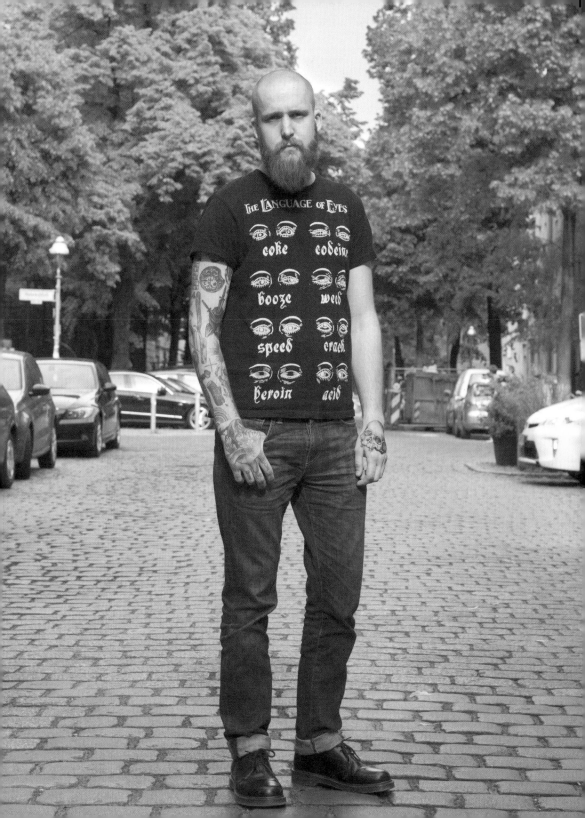

PORTRAIT

13

LOCATION
at AKA, Pflügerstrasse (Berlin)

TATTOO ARTIST

BARBE ROUSSE

TATTOOED BY

MICHELE SERVADIO
at AKA in London

PHILIPPE FERNANDEZ
at AKA in Berlin (p.75)

THOMAS BURKHARDT
at AKA in Berlin

RAPH WZL
in Aix-en-Provence

LIONEL MR. BIZ
in Aix-en-Provence

Barbe Rousse (Redbeard) has been a tattooist for three years. When he began to get tattoos himself, however, it was a way of being part of the art world. His tattoos reflect a session with another tattooist whose work he admires. What Barbe Rousse loves about his job is spontaneity in the creative process and human interaction. He enjoys drawing on people's skin. Tattooing also allows him to develop his art over time and with different people.

His inspiration derives from graphic art which he studied in school and from the old school influences of the tattooist he trained under. A fan of the contrasts in Brassaï's photographs, he also likes the work of artists Mcbess and Jean-Luc Navette. Barbe Rousse appreciates the "simple pleasures in life" and tattooing makes him feel alive.

14

LOCATION
at a bar in Berlin

INARI

TATTOO ARTIST

IRIS LYS *(p.45)*
now at
**IMPERIAL TATTOO
CONNEXION SHOP**
in Montreal

At first Inari saw tattoos simply as a means to stand out from the crowd, but then it became a way of getting closer to and understanding her sister Iris Lys (see p.45), the tattooist who customized all of Inari's tattoo work. Today her tattoos reflect her life and her feelings.

A young self-taught fashion designer, she is mainly inspired by art and Japan. This influence is evident in the cherry blossom and fish tattoos on her back, symbolizing transience and determination respectively.

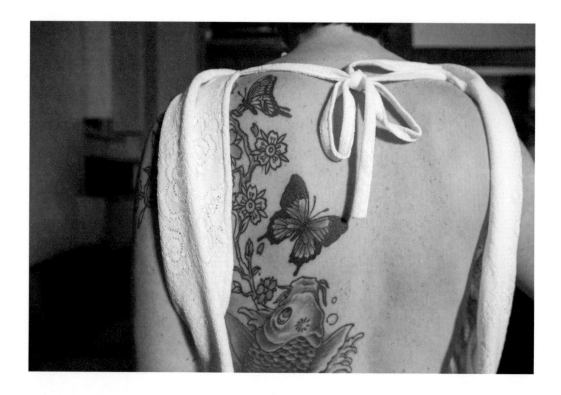

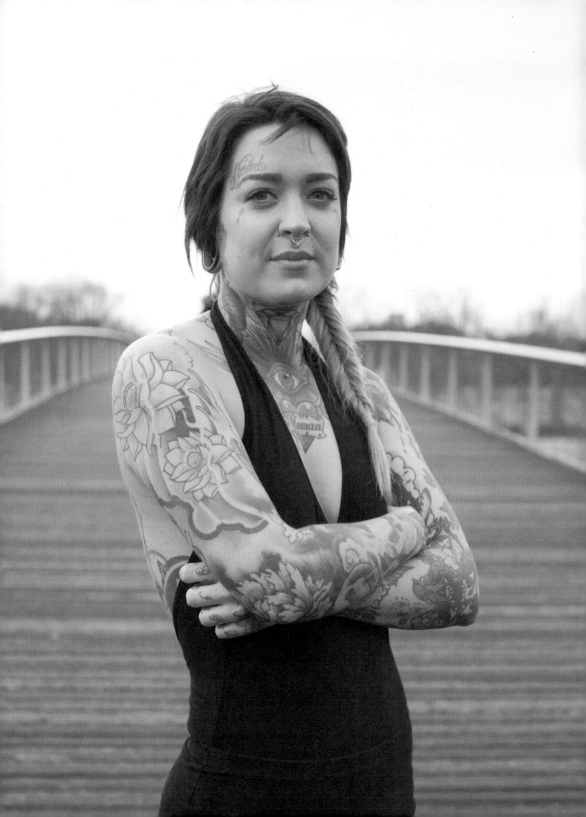

PORTRAIT

15

LOCATION
Simone-de-Beauvoir Footbridge (Paris)

TATTOO ARTIST

IRIS LYS

TATTOOED BY

MISS TINY BECCA *at*
JAYNE DOE TATTOO
in Hornchurch, England

ECKEL *in Brighton, England*

SAILOR BIT
at **ETHNO TATTOO**
in Lausanne, Switzerland

STEVE NG *at*
OLD BOX TATTOO *in Rodez*

GEM LOVE *at* **GEM TATTOO**
in Halifax, Canada

JEAN-PHILIPPE BURTON *at*
DEUIL MERVEILLEUX
in Brussels

Iris is an enthusiastic tattooist who travels the world meeting interesting people in tattoo studios and at conventions. Under the watchful eye of her mother, Iris got her first tattoo at age 17, and then never wanted to stop, as it made her feel more beautiful. Her tattoos now cover 90 per cent of her body. A very talented woman, Iris gets her inspiration from the painters she admires: Frida Kahlo and Finnish artist Akseli Gallen-Kallela. To practice the work she loves, she lives between Finland, the United Kingdom, Switzerland, France, and Canada. All of her tattoos – work by artists she admires which she will proudly wear on her skin for the rest of her life – remind her of a particular moment or feeling.

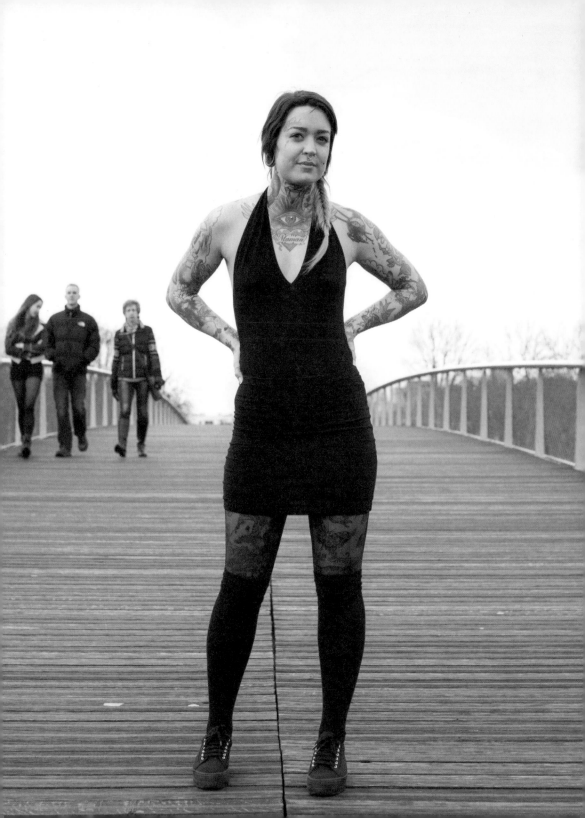

PORTRAIT

16

LOCATION
at the Cour Carrée (Paris)

LORNA

TATTOO ARTISTS

FABRIZZIO MELLO
at **CASA DE LEOES**
in Nantes

ALYX TATTOOING
at **BLACK BIRD**
TATTOO
in Paris

SAN *at* **DEUIL**
MERVEILLEUX
in Brussels

EILO *at*
MTL TATTOO
in Montreal

KURV *at* **LA MAISON**
DES TANNEURS
in Paris

Like a modern-day Mary Poppins, Lorna always brings along her equipment for mobile hairdressing. She decided to get a tattoo after some difficult stages in her life as part of a process of acceptance.

For Lorna, her tattoos are a way of externalizing the feelings that are deep inside her. She cannot imagine herself growing old, sitting in a rocking chair and holding hands with her other half without them.

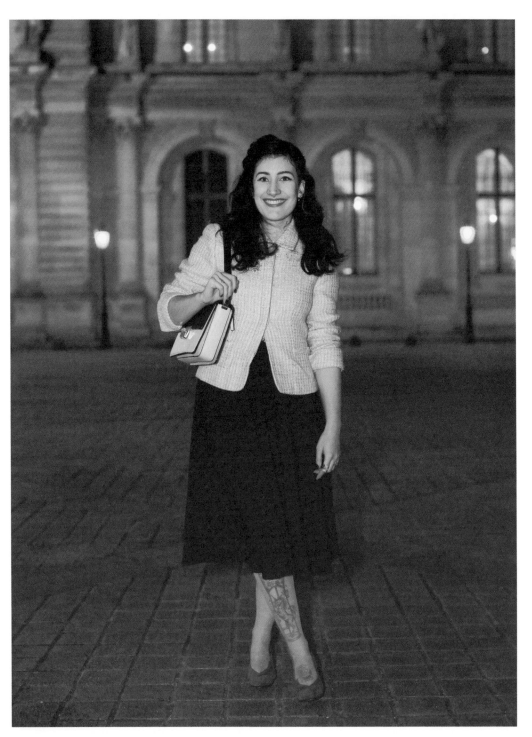

17

OLIVIER

TATTOO ARTISTS

COKNEY *at* **HAND IN GLOVE TATTOO** *in Paris*

RUDY FRITSCH *at* **ORIGINAL CLASSIC TATTOO** *in Trieste, Italy*

LIAM SPARKES *at* **EAST RIVER TATTOO** *in New York*

MXM *at* **EAST RIVER TATTOO** *in New York*

VEENOM *at* **BLEU NOIR** *in Paris*

MARTIN JAHN *at* **AKA** *in Berlin (p.103)*

MORS *at* **CHIALE BABY** *in Lille*

KOADZN *at* **CHIALE BABY** *in Lille*

When Olivier had a tattoo done for the first time, it was an act of defiance. He gave a great deal of thought to going under the needle, which was a final response to the question he asked himself: "Will a tattoo change something in me, more profoundly than just a subcutaneous mark?" Olivier likes to pin down what he sees, either through photography or by taking notes.

Tattooing is an obvious extension of this process: markers in time, a chapter of his life that reminds him where he comes from and the road he has taken. This journalist, who is fond of alliteration, sees tattoos as universal symbols that shake up class codes, a far cry from the period when the first tattoos were a marginal phenomenon.

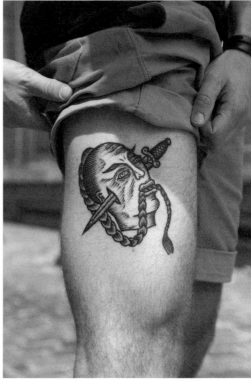

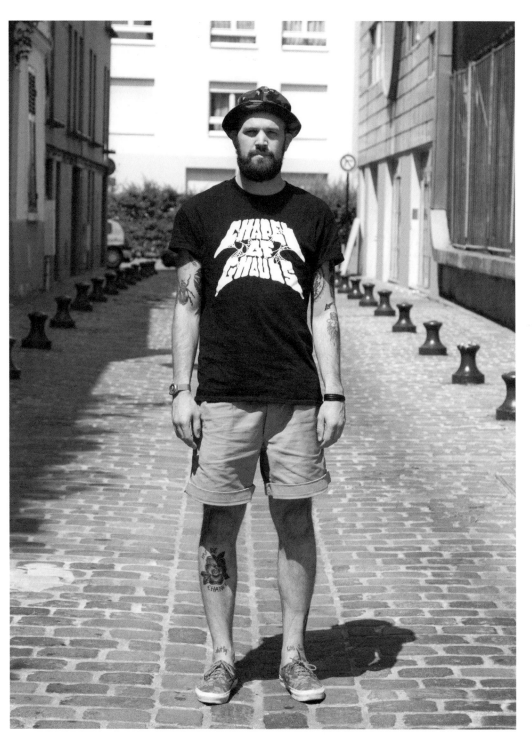

18

LOCATION
at the Grande Halle de la Villette (Paris)

LÉANDRE

TATTOO ARTISTS

FABRICE TATTOO
in Cannes

TOMTOM
in Picardy

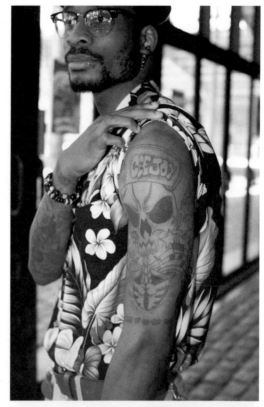

It was great to meet Léandre, an enthusiastic and eccentric guy, in the aisles of the French Tattoo Convention. He sees tattooing as a fascinating art form, from researching the idea and its meaning to the skills of the tattooist. Since the age of 18, Léandre has been inking on his skin the history of his native country, Senegal, illustrating two of his passions, dance and Star Wars, and talking about his family and its suffering.

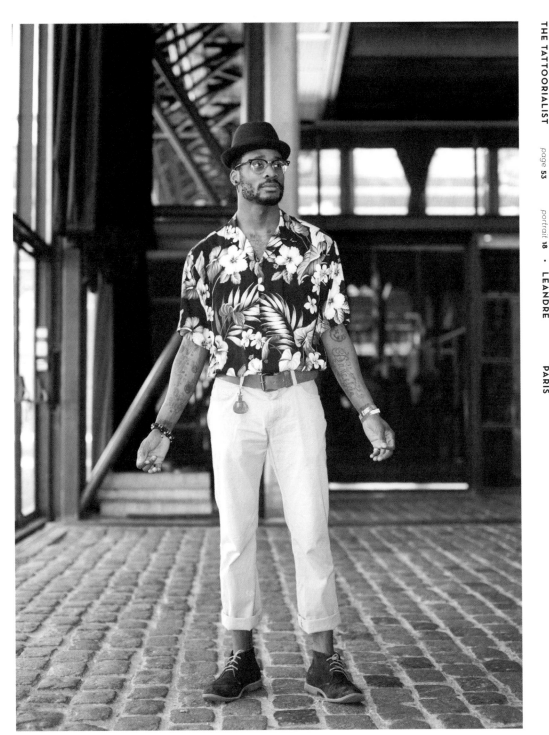

19

MARINE & AX HELL

TATTOO ARTISTS

For Marine

MANU BADET
at Châlon-sur-Saône

CANDY CANE *at*
LADY LUCK TATTOO
in Weert, the Netherlands

DIMITRI HK
in Saint-Germain-en-Laye
(p.173)

**SOUR & SWEET
TATTOO**
in Strasbourg

ALIX GE *at*
681TATTOO
in Lyon

DODIE *at*
L'HEURE BLEUE
in Lyon

LOÏC *at* **ABRAXAS**
in Paris

LINK BOSSMAN *at*
FOUNDRY TATTOO
in Mooloolaba, Australia

GREG LARAIGNÉ *at*
IMAGO TATTOO
in Montreal

For Ax Hell

GREG BRIKO
in Lille

EDDIE *at*
23 KELLER *in Paris*

TOMA PEGAZ
at **LANDSCAPE
ROCKSHOP**
in Paris

Tattooed people speak of the "magical addiction" of the tattooing process, which is the aspect that Marine finds stimulating as well. The idea taking shape, the choice of tattooist, forming a connection with the artist, the painful initiation, and the joy of having it on your skin... it's an art form like no other. Marine is a real chameleon, juggling two separate lives (her job in a private high school and working as a model) which are closely connected through her love of rebels, strangely beautiful things, and nature. For this wild child who never wants to grow up, tattoos express what she has to say.

On meeting Ax Hell, you get the feeling that tattoos are quite simply statements of fact: he transcribes his family history and claims no allegiance, just the desire to be himself. This redhaired rocker who is always impatient and speaks too loudly loves stories about sailors told by his grandfather and old seadogs' tales. Some of this is reflected in his tattoos, which his mother describes as looking like "marker pen on a work of art."

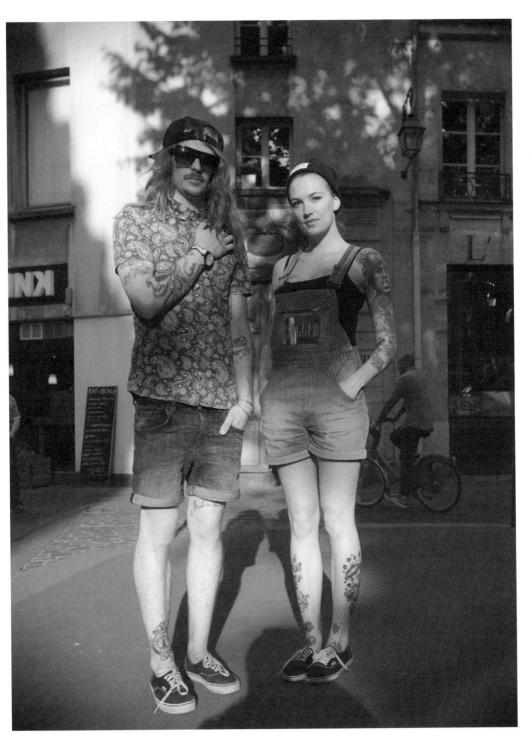

20

LOCATION
Pflügerstrasse (Berlin)

MACHA

TATTOO ARTISTS

RAMONA MASSON
at **INK LADY** *in Liège,*
Belgium

BARBE ROUSSE
at **AKA** *in Berlin (p.41)*

MARCO
SCHMIDGUNST *at*
SCHWARZE HAND
in Berlin

ALEKSANDR
MIHEENKO *at*
KULT TATTOO FEST
in Kraków, Poland

SLAVA KONONOV *at*
KINGDOM TATTOO
in Kiev, Ukraine

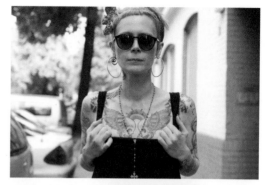

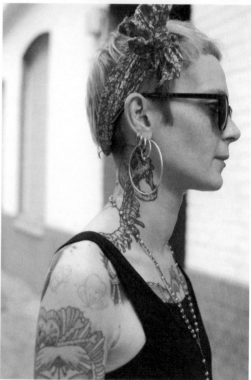

Macha sees tattooing as the most interesting art form of our time. She uses it to gradually create a protective shell made up of the most important stages in her life, "to create armour-plating against the world". Each tattoo is also the result of meeting someone she admires: "an impulse inscribed under the skin". She draws a lot of inspiration for her tattoos from the tattooists around her every day at work, and she even gives some of them a hand occasionally.

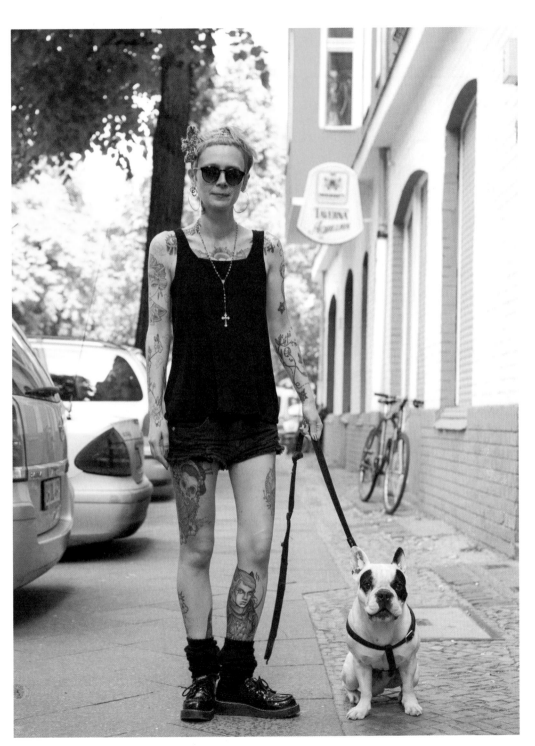

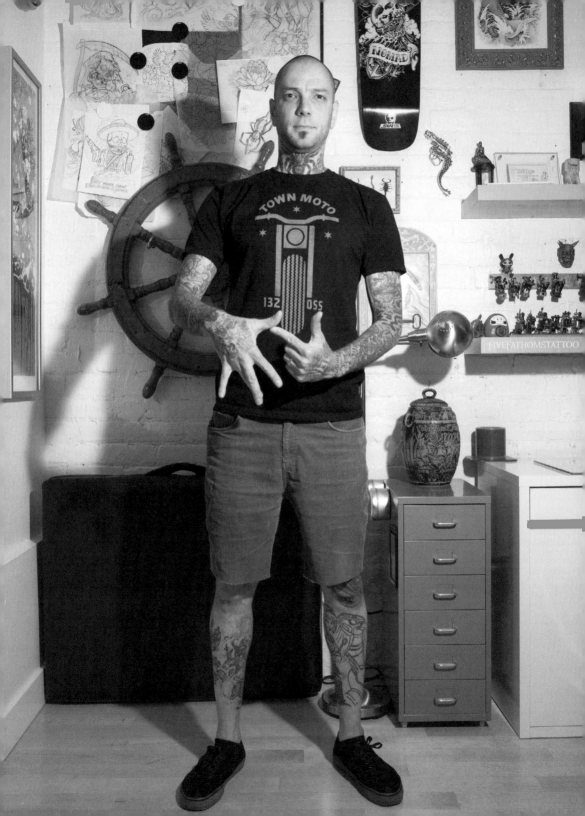

PORTRAIT

21

TATTOO ARTIST

SAFWAN/INTERVIEW

OWNER and **TATTOO ARTIST**
at **IMAGO TATTOO**,

boulevard Saint Laurent (Montreal)

Why did you become a tattooist?
I became a tattooist in the same way you become a pirate – suddenly and irrevocably. It was never a career choice for me, but one of lifestyle. I believe it is my vocation in life; a one-way track I chose to follow with determination and passion. When I realized the potential of tattooing in the early 1990s, I took such an obsessive interest that it soon clicked with me that I had to be involved. It seemed obvious that this area would keep me busy for decades. There is always something new to learn, discover, and perfect. It is a great privilege to be a tattooist and to be able to do it on a daily basis. It really is one of the most satisfying things I could do with my life.

What is your style?
My style is illustrative, often described as neo-traditional, wrongly perhaps... I like clean lines, stark contrasts, and dynamic movement. I am heavily influenced by traditional Japanese tattoo art and Japanese prints.

What is your creative process when working?
I love doing research for my design projects. I have an initial meeting with my clients to discuss their tattoos, ask questions, take notes and measurements, and look at their potential reference works. Then I like to immerse myself in researching my subject. For me it is a chance to learn something new and to think about how I can translate the subject to the tattoo. Then I see my clients again to show them sketches and make adjustments.

Do you have any stories to tell?
I prefer to keep them among friends, like tattooists and drinking buddies. But yes, there are plenty of good stories...

And how do you see the future?
I try to concentrate on my own work and that of the other tattooists in my studio. But I do think the future lies with stylists who specialize, those with a genuinely artistic hand. These days there are so many people who call themselves tattooists that only those who manage to distinguish themselves with a personal touch and flawless technique will succeed in rising above the tide of tattooist clones. I also believe that those who prioritize human interaction when providing tattooing as a "service" will always stay one step ahead. Tattooing is an important activity that needs to come from the heart.

PORTRAIT

22

TATTOO ARTISTS

ROMAIN and **HUGO**
at **HAND IN GLOVE
TATTOO** in Paris

LOCATION
Palais de Tokyo (Paris)

FAB

Fab was late in getting his first tattoo to avoid the kind of adolescent mistake we often regret. He bit the bullet to mark events on his skin that he didn't want to forget.

He drew his ideas from his passion for all things Japanese, including comics and video games. So what was the tattoo? "Ink, Pain, Happiness"!

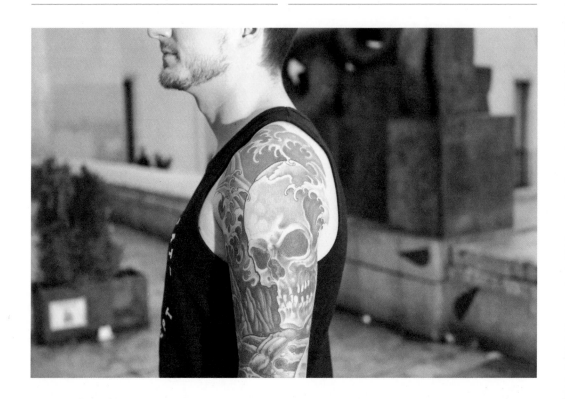

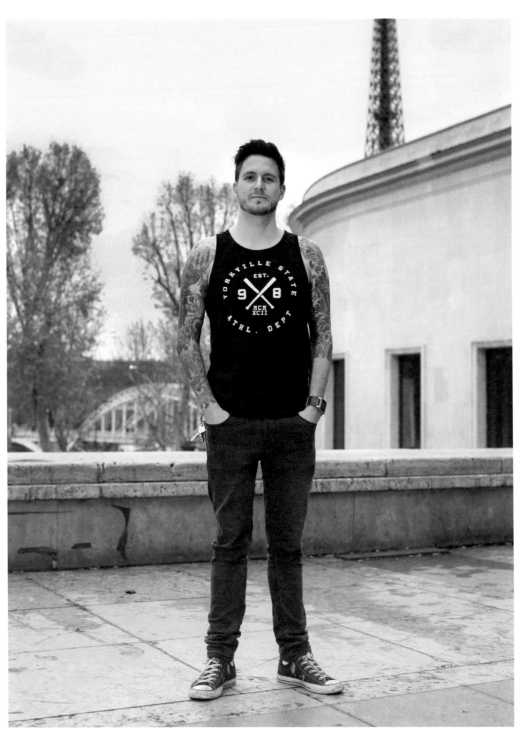

23

LOCATION
at her vintage store, Le 63, avenue du Mont-Royal Est (Montreal)

AMÉLIE

TATTOO ARTISTS

NORMAND OUELLETTE *at*
TOTEM ET TATTOO
in Montreal

ARNO SCHULTZ *at*
PSC TATTOO
in Montreal

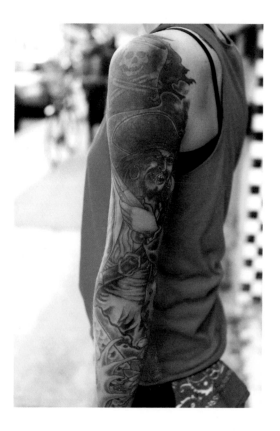

Blessed with an optimistic – and infectious – outlook on life, Amélie finds inspiration in its beauty and lives it to the full. She works in a Montreal store specializing in old school and rock'n'roll, which is in perfect sync with her own look. Amélie always knew that she would get a tattoo one day: she had her first piece done when she was 17. In decorating her body she draws heavily on life, her feelings, and stories she finds fascinating. Some of her tattoos, for instance, depict a siren and a pirate, which reflect her passion for the sea and its tales. Her lower back has swallows and a sacred heart symbolizing freedom and unconditional love in general. Amélie is a dreamer who loves to read stories in books, as well as on her skin.

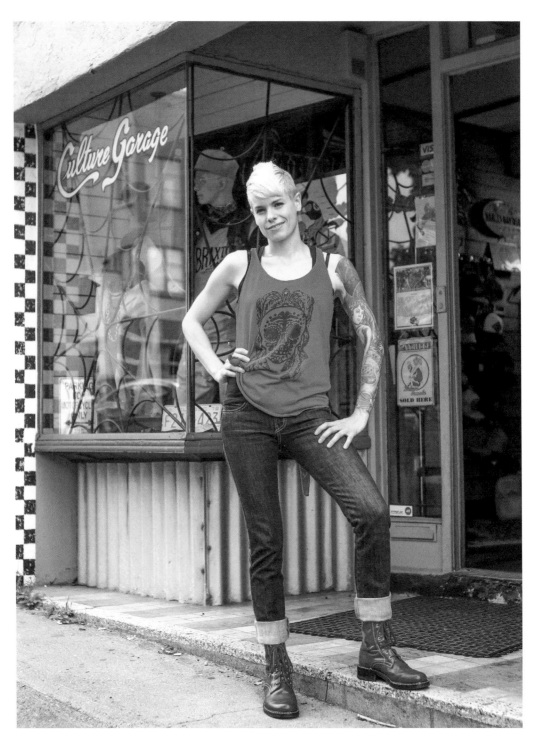

24

ARNAUD & NOÉMIE

TATTOO ARTISTS

For Arnaud

AMY MYMOUSE
in Paris/Montreal (p.207)

LOÏC *at*
ABRAXAS *in Paris*

OSCAR ASTIZ
in Paris

MAMÉ NOÉMIE
in Marseille (p.66)

For Noémie

LUDO *at*
ART CORPUS
in Paris

JEANCHOIR *at*
SOMBRE TACHE
in Marseille

YANN BLACK
in Montreal

GWENDAL OWAN
at **SOUSTONS**
TATOUAGE
in Soustons

JEAN-LUC NAVETTE
at **VIVA DOLOR**
TATTOO
in Lyon

EUGÈNE PWCCA
on the road

A strong bond exists between Noémie and Arnaud through their artistic careers, but also because they love each other like brother and sister – and tattoo each other.

You can tell from his tattoos that Arnaud is both sensitive and deliberately provocative. Tattoos were an obvious choice for him, given the artistic influence of his two jobs as burlesque performer and fashion illustrator. He has always felt a desire to modify his body, to the point where each tattoo started to feel like an achievement. He finds it increasingly difficult to stop, as so many things inspire him: Egon Schiele, art deco, Japanese culture, and Russian prison art. Arnaud defines the relationship between the tattooist and the person being tattooed as a kind of spiritual tension, a communion with the artist who is going to take ownership of and interpret the wishes of his or her client.

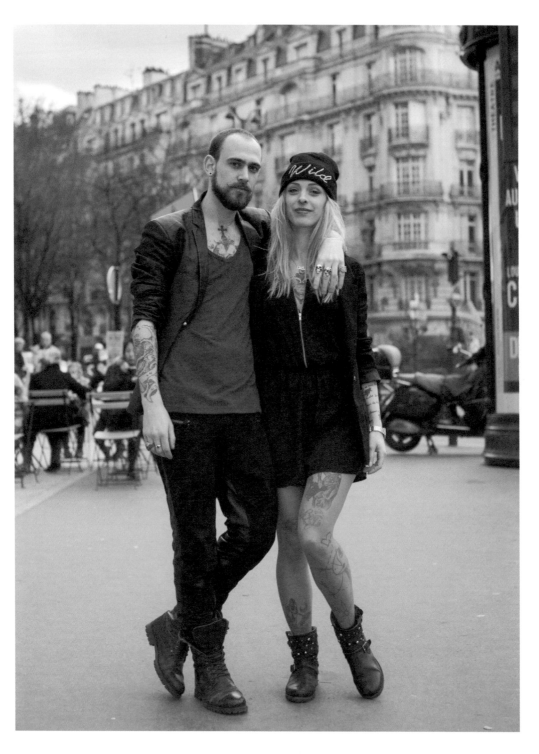

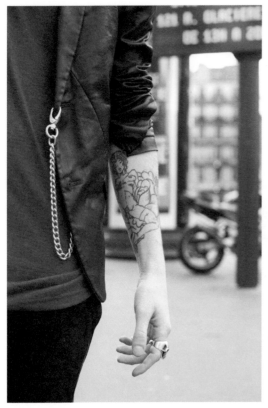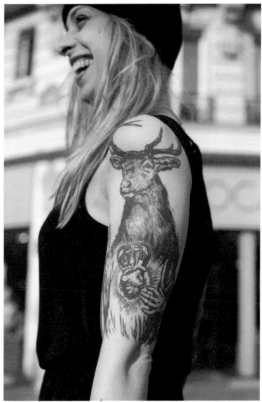

When she was a little girl, Noémie collected decals. She saw *The Lord of the Rings* when she was 13, and knew right away that her first tattoo would be the Eye of Sauron. Then, when she got her first forearm tattoo four years later, tattoos became a natural part of her life.

Noémie is passionate about the other person in the process, the artist she connects with on a human and aesthetic level and to whom she entrusts her skin. Even though each of her tattoos means something, they are really a way of laughing at herself and destroying the sacred aura around her body.

Noémie likes the idea that tattoos "can last forever in a culture of overconsumption in which everything becomes outdated at an ever faster rate". And her passion for tattoos is about to be fully realized, as Noémie – a TV presenter, musician, and model – has plans to open her very own tattoo studio under the pseudonym Mamé Noémie.

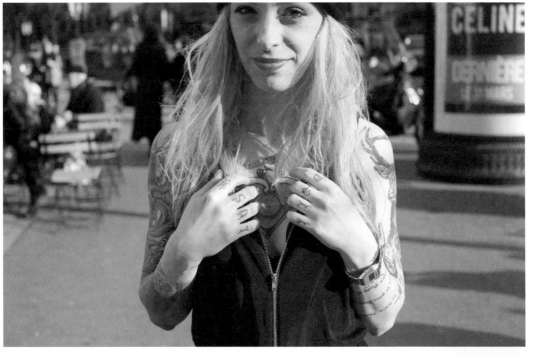

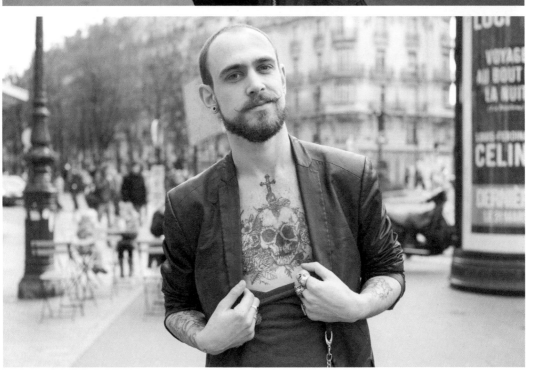

GUILLAUME

TATTOO ARTISTS

*"The biggest bastards on
earth, but I still love them!"*

A renowned pastry chef and artistic director, Guillaume is a bit
of a maverick. His approach to tattooing is the same. For him
the impulse goes beyond anything rational; he doesn't care one
bit what anyone says about it, he does it for himself. His tattoos
are his personal notebook, his way of marking out the different
stages in his life. "I relish wallowing in my mistakes. I like to move
forwards with them." Guillaume is inspired by everything around
him, whether it is the street, people, close friends, or strangers.

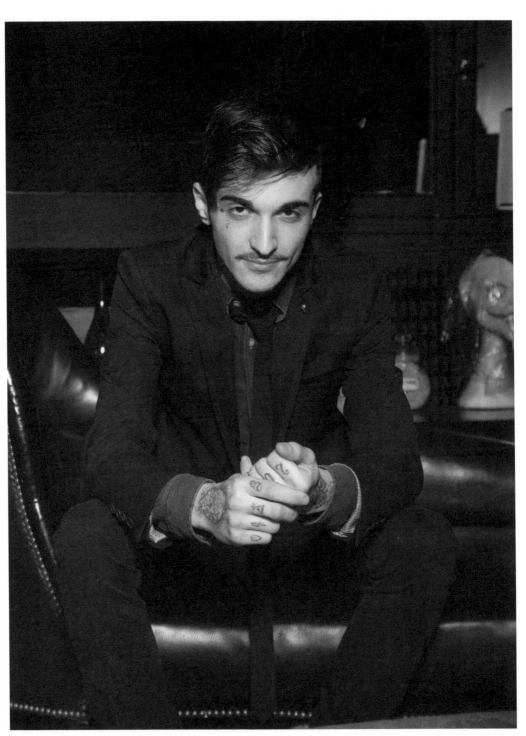

26

LOCATION
rue Jeanne-Mance (Montreal)

ANIK

TATTOO ARTIST
GREG LARAIGNÉ
at **IMAGO TATTOO**
in Montreal

Anik, an enthusiastic young woman who smiles a lot and works in fashion, was definitely seduced by the romantic side of tattoos. Under the guidance of her tattooist idol, Greg Laraigné, she has inked her skin with her love of roses and the key events in her life, like her solo trip to Italy.

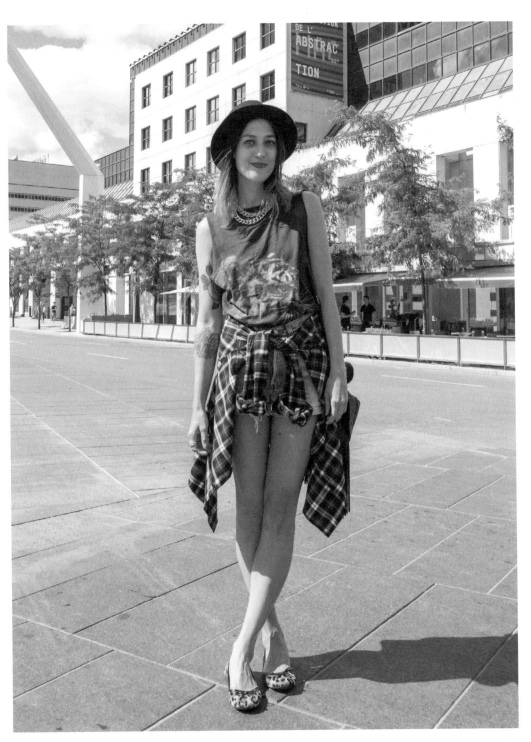

27

FRED

TATTOO ARTISTS

VINCENT BRUN *at*
BODKIN TATTOO
in Montreal (p.133)

CHRISTA ZURICH
at **BODY ART
STUDIO**
in New York

FRANK LA NATRA
at **INTO THE
WOODS TATTOO
GALLERY**
in Dania Beach, Florida

When we met up with Fred on a street corner in Montreal, it was a reminder of what a small world it can be. A flatmate of tattooist Vincent Brun (see p.133), Fred is the founder of the hot dog restaurant Dirty Dogs in Montreal. What he likes most about tattoos is their decorative aspect, and he prefers them multicoloured. His own tattoos are adapted from themes around the sea, which is dear to him because it represents a part of his life.

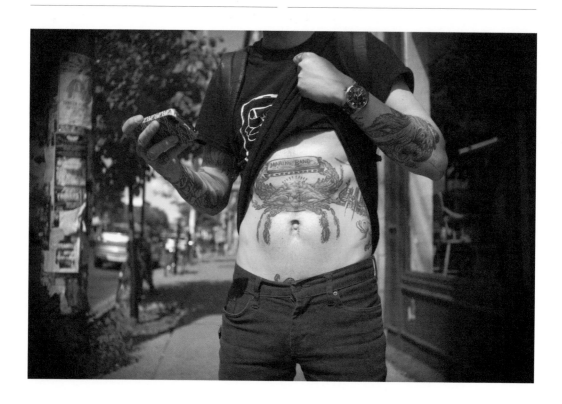

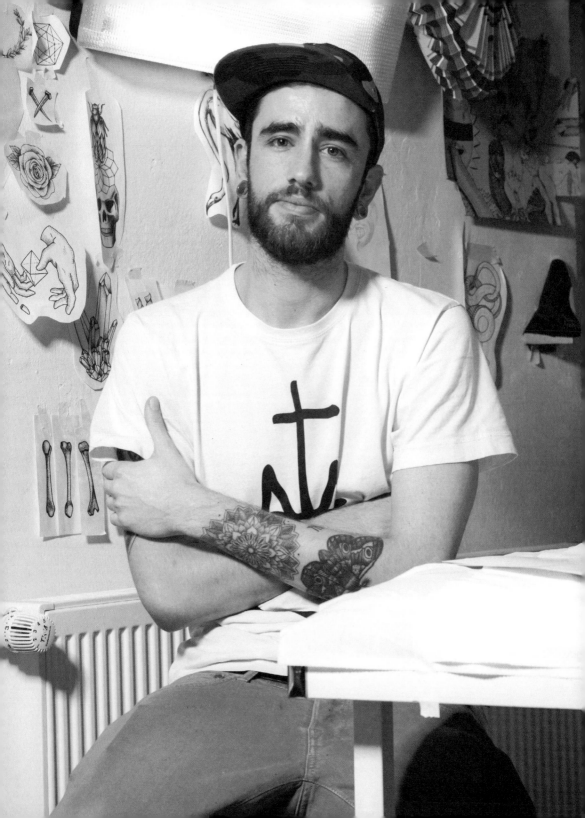

PORTRAIT

28

LOCATION
in the AKA studio, Pflügerstrasse (Berlin)

TATTOO ARTIST

PHILIPPE FERNANDEZ

TATTOOED BY

LIAM SPARKES

RAFEL DELALANDE *at*
EAST RIVER TATTOO
in Brooklyn

VALENTIN HIRSCH
at **AKA** *in Berlin*

GUY LE TATTOOER
on the road

Philippe is a young and extremely talented tattooist in the AKA team in Berlin, one of the best studios in the world. Trained as a graphic designer, Philippe came to tattooing gradually: it's a world in which he feels more at ease and through it he has found the lifestyle that suits him. A man with a zest for life, Philippe draws inspiration from his everyday life, his favourite artists, and things around him. He takes pride in being part of this studio, which allows him to work among the best artists, and be tattooed by them.

29

LOCATION
in the garden of the Sacré-Coeur Basilica (Paris)

MARINE & JULIEN

TATTOO ARTISTS

For Marine

LOUIS EL PIMPTATTOO
at **ABRAXAS**
in Neuilly-sur-Seine

MARTY DEGENNE
at **LANDSCAPE ROCKSHOP**
in Paris

TOMA PEGAZ
at **LANDSCAPE ROCKSHOP**
in Paris

NIKOS *at*
ANOMALY
in Paris

SAILOR XA *at*
STEVE ART TATTOO
in Nancy

For Julien

GORAN IVIC,
NIKOS *and* **TRICKY NIKO** *at*
ANOMALY
in Paris

For Marine, tattooing is a timeless, personal, and addictive art form, a way of expressing yourself more or less explicitly. She regards her own tattoos as a form of therapy. Each one helps her to accept herself and makes her feel that she is fully developing her true self. Her tattoos, inspired by her own experiences, memories, and trying times, are gleaned from the work of illustrator John Tenniel and cartoonist Bob Kane, as well as from the old school and Native American and Buddhist cultures.

Julien believes that tattooing is a philosophy of life. Inking all his passion, joy, and pain comes quite naturally to him. He enjoys discovering the different artists emerging in the tattoo world, which for him is synonymous with having an open mind. His ideas come from everything around him, from the photographs of Robert Doisneau or Anthony Mirial to history.

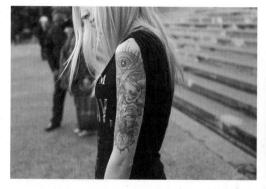

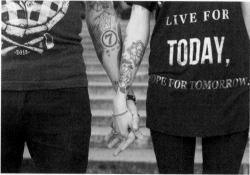

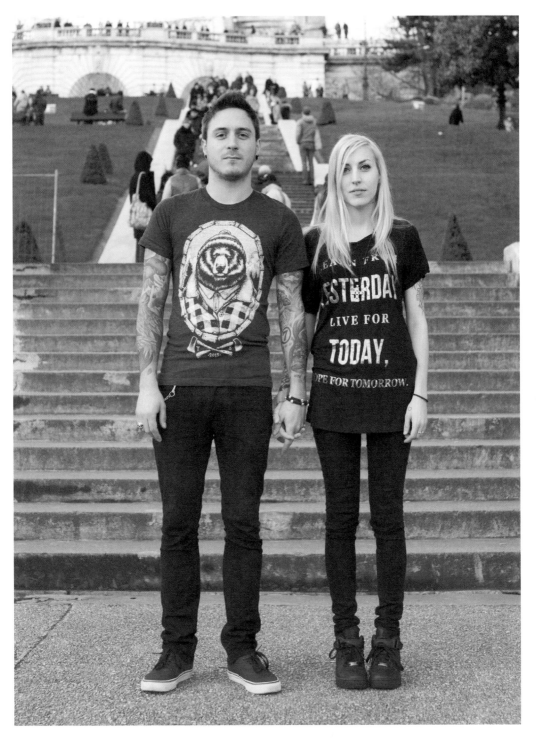

30

LOCATION
rue Française (Paris)

KATIA

TATTOO ARTISTS

STÉPHANIE *at*
ANGEL TATTOO
in Nice

CYRIL *at* **KAHUNA**
in Cannes

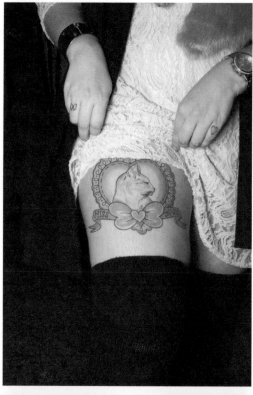

Katia (aka "HeyDickFace") is a fashion blogger. She gets a tattoo if she feels like it, on a whim, or simply because she has been dreaming of it for ages! While she does not attach any importance to symbolism (apart from the diamond dedicated to her father), this fan of unicorns, cats, and Lady Gaga regards her tattoo work as an aesthetic prism.

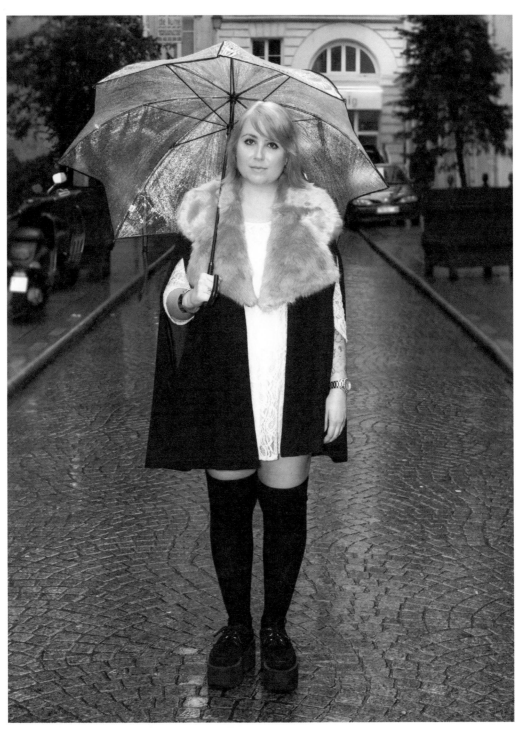

31

ALIZÉE & OTTO-MAN BARBER

TATTOO ARTISTS

`For Alizée`

THIBAUT and **SEB** at
A M'AIME LA PEAU
in Noisy-le-Grand

MIKAËL at
MIKAËL TATOUAGE
in Poissy

**SACHA
MADEWITHLOVE**
at **TRIBAL ACT**
in Paris

JOEY ORTEGA at
**TRIPLE CROWN
TATTOO** *in Austin, Texas*

KURV at **LA MAISON
DES TANNEURS**
in Paris

`For Otto-Man Barber`

**LAURA UNDERSKIN
BASTARD** at
LA MAISON CLOSE
in Paris

SADHU LE SERBE
in Perpignan

WILLIAM at
**L'AIGUILLE
TATOUAGE**
in Marseille

RUDY DE AMECIS
at **BLOOD AND
MILK** *in Termoli, Italy*

ROMAIN at
**HAND IN GLOVE
TATTOO** *in Paris*

KOADZN at
CHIALE BABY *in Lille*

MOJITO TATTOO
in Toulouse

FATALITAS
in Montreuil

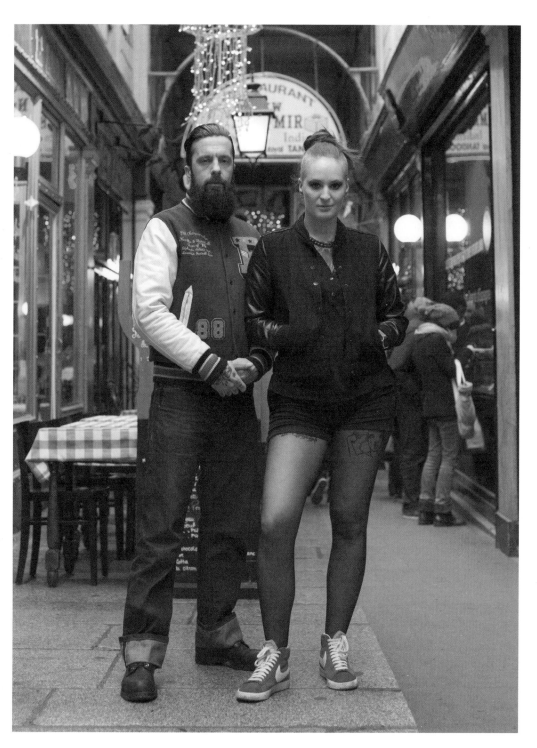

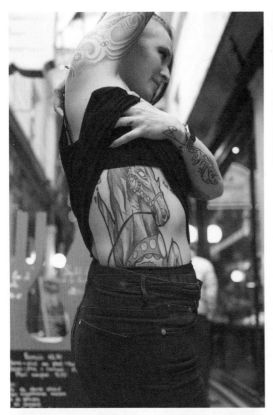

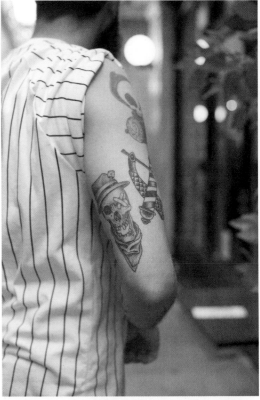

"Giving substance to my philosophy of life, for the sake of passion and art" is how Alizée responds when asked about her tattoos. Some pieces, which she began when she was 17, remind her of intimate moments. Inspired by her favourite artists, from Banksy to Gustav Klimt via Yves Saint Laurent, her tattoos sometimes elicit a baffled response from those around her. To the much-touted question "So what will your tattoos be like when you are old?" she replies enthusiastically that she will be one of the coolest grannies of her generation!

Beneath his bear-like exterior, Otto-Man Barber is really a softie who was goaded into getting his first tattoo at age 19. Today he sees tattoos as the artistic expression of a tattooist on his body, as well as the re-writing of his own story in images. Tattoos give him the freedom to rejoice in his skin in his own way.

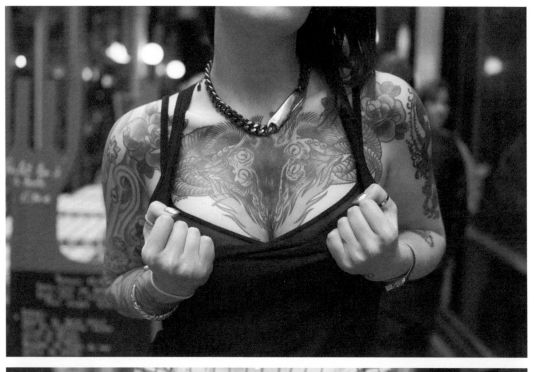

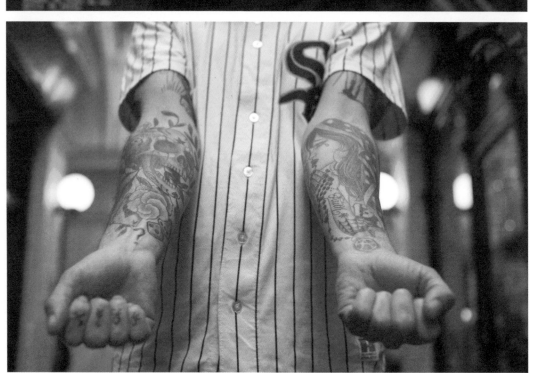

32

LOCATION
at AKA, Pflügerstrasse (Berlin)

HANNAH

TATTOO ARTISTS

BRODY POLINSKY
at **AKA** *in Berlin*

KELLY VIOLET
on the road

BRIAN KELLY *at*
LOXODROM TATTOO
in Berlin

PHILIPPE
FERNANDEZ
at **AKA** *in Berlin (p.75)*

ANGELIQUE
HOUTKAMP *at*
SALON SERPENT
in Amsterdam

MICHELE
SERVADIO *at* **AKA**
in London

BARBE ROUSSE
at **AKA** *in Berlin (p.41)*

MARTIN JAHN
at **AKA** *in Berlin (p.103)*

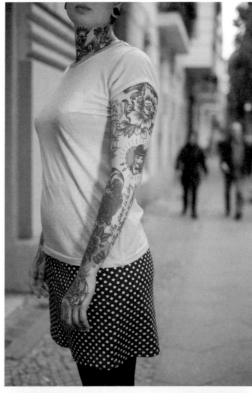

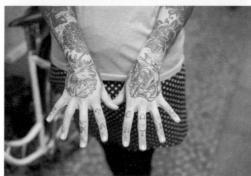

Hannah always thought of tattoos as a sign of rebellion. She often admired women covered in tattoos and longed to be one of them. For Hannah, tattooing is a world where you never get bored. Inspired by the people she works with, she gets tattoos which are autobiographical and set her apart.

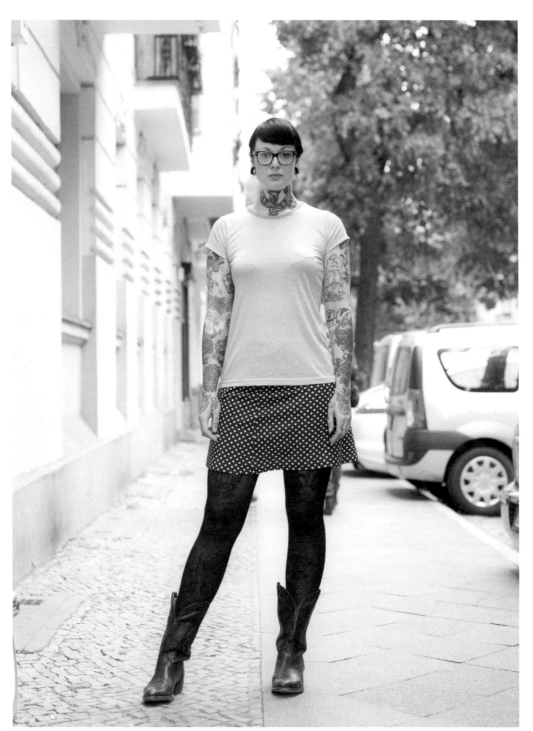

33

LOCATION
at McGill University (Montreal)

SIMON

TATTOO ARTISTS

DAVID KNIGHT

DAVID CHOQUETTE
at **BODKIN TATTOO**
in Montreal (p.229)

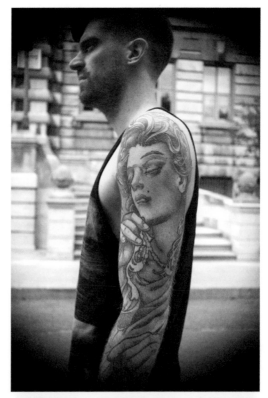

Simon wanted a tattoo from a very young age because "it makes you look tough". A guy with a positive outlook on life, he draws his strength from the love of the people around him, his fiancée, friends, and family. Each tattoo has a quite specific story which he prefers to keep to himself. Some tattoos have even been done during furtive encounters of an evening.

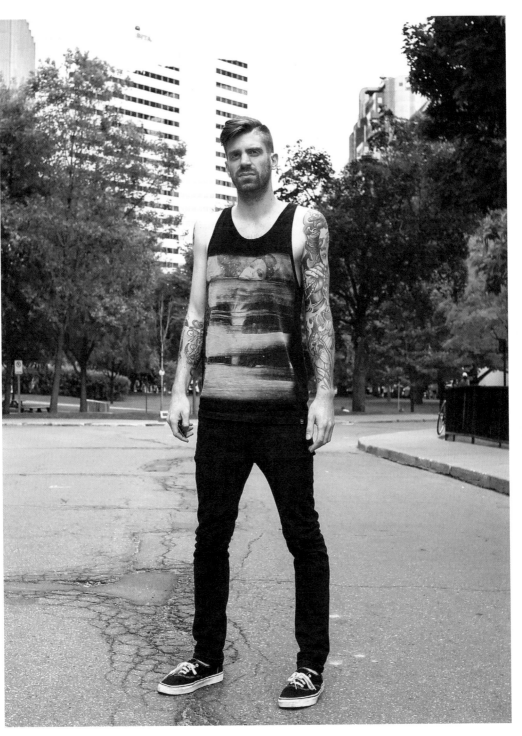

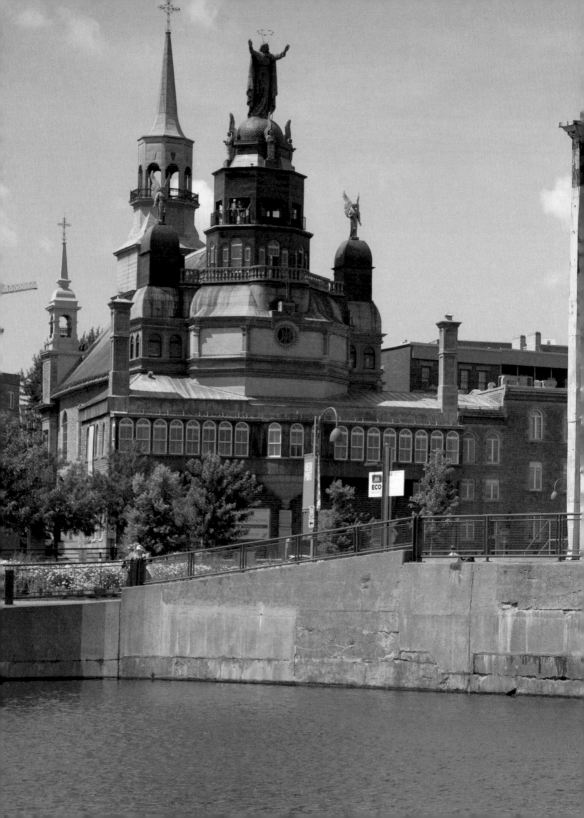

MONTREAL

WRITING
on the body with a needle

**MARIE-ANNE
PAVEAU**
Linguist

Writing is done everywhere, and always has been: on stone, marble, terracotta, paper, cardboard, and plastic, as well as on screens, in sand, even in the air – and on the body. The tattoo machine is a writing tool just like the stylus or nib, acting as an extension of the hand so that it can fulfil the ancient act of transferring the spoken word to written form on the skin, entering the realm of "graphic reason", to use the seminal description of British anthropologist Jack Goody.

There are plenty of written words in the world of tattooing, which encompasses practices, genres, and styles. From Vincent's single letter (p.94) to the long extract of literary text, and in between, a word, a proverb, or a few lines of a tune, we find all sorts of typography in every language and alphabet. American artist and teacher

THE "TRIBUTE TATTOO" IS A MAJOR MOTIF IN MODERN TATTOOING

Ina Saltz has devoted an entire book to the subject, entitled *Body Type: Intimate Messages Etched in Flesh*, followed by a second volume, *Body Type 2: More Typographic Tattoos*. Her research around the world has proved so fruitful that a third volume is in progress. But why do we write on our bodies, or rather call on the tattooist, a very specialized writer, to write words on our skin for us?

I would like to reply to this question from a personal perspective, as tattooees are the ones speaking here, and the best way to know about tattooing is to listen to them. As someone with tattoos of her own, my view is that tattooing is a "knowledge object" that must be personally experienced. On this point, I agree with Ina Saltz, who bases all her work on the discourse of tattooees, as does the French writer Anna Mazas, author of the wonderful book *Life Under My Skin* which is built entirely on the accounts of people with tattoos. So my viewpoint is that of someone who has spent dozens of hours under the tattooist's machine herself and has had writing done on her body with a needle.

Narrative. Words on the body are the story of an individual. For many tattooees, writing on the body means telling a story, wearing one's own biography, albeit in a fragmented and allusive way, but with a definite presence nevertheless. "My

body becomes my biography," states Maéva (p.190), who has a line of Greek text in the middle of her back. Élodie (p.122) also has a phrase between her shoulderblades, explaining that for her it is all about "giving concrete form to an invisible scar." The personal story of the individual crops up repeatedly when interviewing tattooees: after all, this form of marking represents the passing of time for an individual, and for my own part, I talk about my self-inflicted wrinkles.

Memory. Writing is about pinning down words. So writing has always been the privileged place of memory, a feature which is also found in tattoos. The "tribute tattoo" is a major motif in modern tattooing, a kind of portable memorial. After 9/11, many American firefighters got tattoos of this date, sometimes along with the names of their dead colleagues; many individuals bear the name of a

WORDS CREATED BY THE NEEDLE ARE WRITTEN IN ORDER TO LIVE

deceased person they are grieving for, like a father, mother, friend, lover, or someone they admired. It is a way of having them with you, preserving their memory, and maintaining their human presence. Present in the tattoo, he or she is a dead person among the living.

Sign. People also write on their bodies to define themselves: to announce their membership of a group, or the opposite, their independence and refusal to be part of something. We use tattoos as a mark of what we are, or what we want to be for others. Vincent's "V" (p.94) is his "tag", as he puts it; Cédric (p.138) wears the extract from a song by a metalcore group on his chest, "If you don't live for something, you'll die for nothing", an indication of both his musical affiliation and his philosophy. The encircled A of Alcoholics Anonymous is used by its members to "recognize and address each other"; military mottos and regiment numbers are signs of their integration, dissolution almost, within the group. We mark ourselves voluntarily, we identify ourselves, and we stamp ourselves. We give ourselves meaning.

Choosing words for our skin, whether they are to be displayed or hidden (sometimes the words are of such a personal nature that no-one can see them) is therefore a highly-motivated gesture. But there is one outstanding question which to my mind seems impossible to answer: who are these words for? To whom are they addressed? This question was the subject of my first article on the issue. One day someone pointed to the phrases written on my arms, asking: "But how can people read them?" Somewhat baffled, I thought about it, and actually, I don't get people to read them, and I don't think I even read them myself. These are words for me alone, even though they were written by other people, and I do not use them to communicate. The testimonies of tattooees gathered by Nicolas Brulez, as well as Ina Saltz and Anna Mazas, all say the same thing: the words created by the needle are written in order to live, perhaps even to survive. Writing to exist.

REFERENCES

Goody, Jack: *The Domestication of the Savage Mind*, Cambridge University Press, Cambridge, 1977.

Mazas, A.: Life Under My Skin. 40 portraits de tatoués, Paris, MkF éditions, 2011.

Paveau, M.-A.: "Une énonciation sans communication : les tatouages scripturaux", *Itinéraires ltc*, 2009, pp.81–105.

Saltz, Ina: *Body Type: Intimate Messages Etched in Flesh*, Abrams Image, New York, 2006.

Saltz, Ina: *Body Type 2: More Typographic Tattoos*. Abrams Image, New York, 2010.

34

LOCATION
rue d'Argout (Paris)

LOUIS

TATTOO ARTIST

SEB *at*
AMERICAN BODY ART
in Paris

"Getting tattoos so you no longer go through life alone." Louis's tattoos chart his personal story. Each one has a special meaning, representing someone he has loved or a state of mind. The only piece that was done for purely aesthetic reasons is the forearm dedicated to the work of Haruki Murakami, the Japanese author. This critic of fashion shows, hat designer, and Shaquille O'Neal fan sees his tattoos as Post-its on a fridge door, and enjoys getting tattoos on a whim.

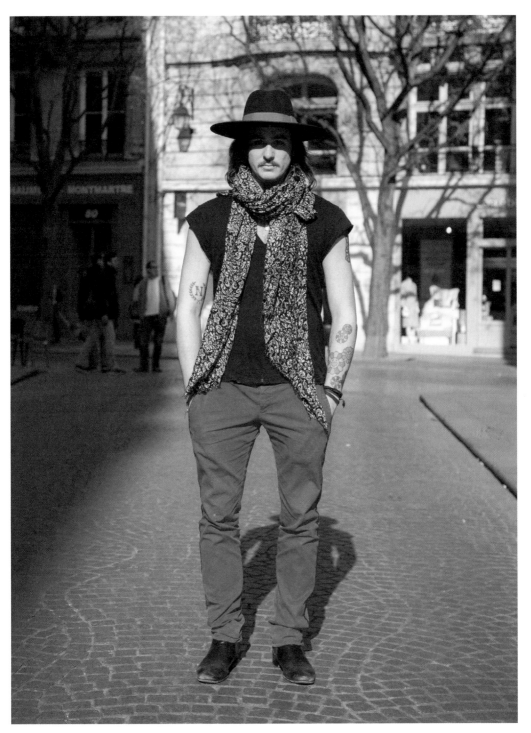

35

VINCENT

TATTOO ARTISTS

DOMINIQUE BODKIN
at **BODKIN TATTOO** *in Montreal (p.185)*

VINCENT BRUN *at* **BODKIN TATTOO** *in Montreal (p.133)*

DAVID CHOQUETTE *at* **BODKIN TATTOO** *in Montreal (p.229)*

ISSA *at* **TIN-TIN TATOUAGES** *in Paris (p.239)*

Vincent is a versatile artist (musician, graphic artist, stylist, and more) who sees his passion for old school tattoos as an adventure. He attaches particular significance to each memory they trigger: who did it, what day it was, what he was thinking about, the music he was listening to, etc.

Vincent draws his artistic inspiration from the work of the film director Alfred Hitchcock, the musician Hanni El Khatib, and sculptor Hannah Höch.

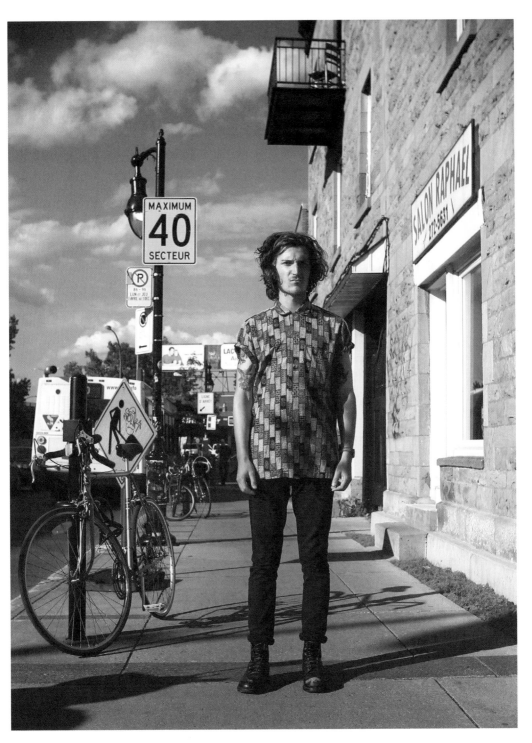

36

LIZ & ANTHONY

TATTOO ARTISTS

For Liz

MISTERICOL
on the road

MAUD DARDEAU *at*
TIN-TIN TATOUAGES
in Paris

WALTER HEGO
at **L'ENCRERIE** *in Paris*

For Anthony

LAURA SATANA *at*
EXXXOTIC TATTOO
in Paris

WALTER HEGO
at **L'ENCRERIE** *in Paris*

MAUD DARDEAU *at*
TIN-TIN TATOUAGES
in Paris

DAVID SENA
at **SENA SPACE**
in New York

RULER *at*
SILK CITY TATTOO
in Hawthorne, USA

Liz and Anthony both adore the artistic side of tattooing, seeing this art form as work they will keep on their skins for the rest of their lives. Some of their tattoos are done in the style of old religious engravings which inspire them.

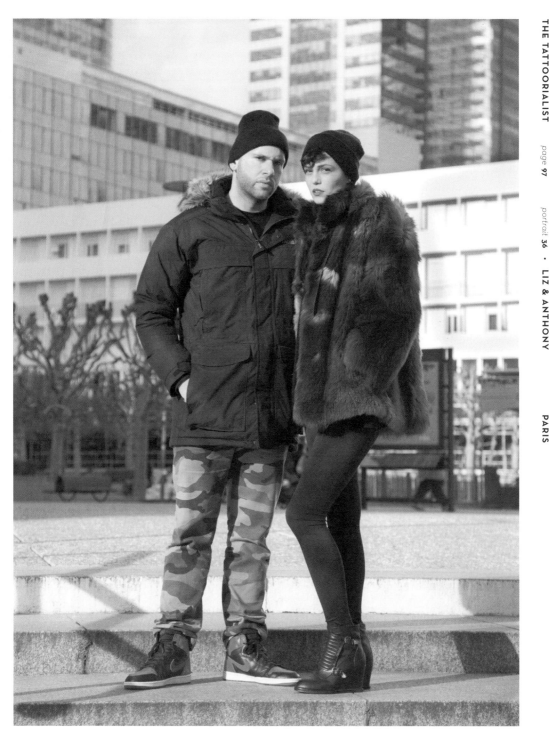

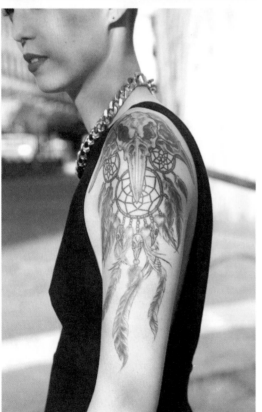

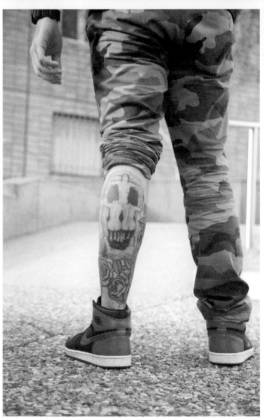

Liz realized her dream of getting her first tattoo as soon as she reached the legal age. She was fascinated by the aesthetic look it would give her body. Liz draws her inspiration and strength from her dreams, as well as from religious icons and the work of the painter Caravaggio.

Anthony discovered tattoos ten years ago through the work of the artist Mister Cartoon. Anthony's own tattoos do not necessarily mean anything. He puts the things he loves onto his skin, from Dalí's painting *In Voluptate Mors* and the images by photographer Philippe Halsman to characters from *The Simpsons*.

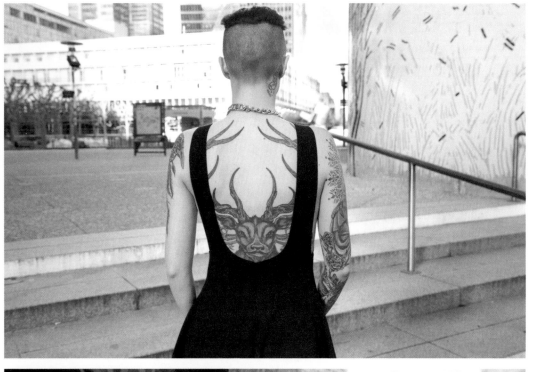

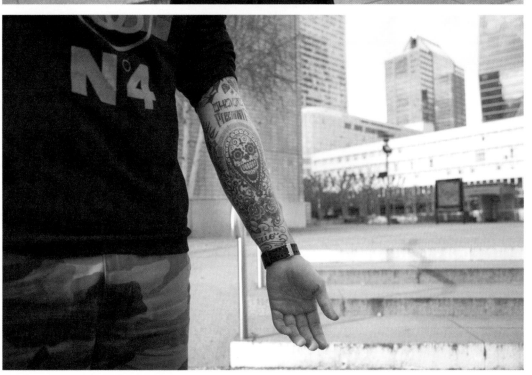

37

LOCATION
avenue de Tourville (Paris)

MISS GLITTER
PAINKILLER

TATTOO ARTISTS

SUNNY BUICK
in Paris

LAURA SATANA *at*
EXXXOTIC TATTOO
in Paris

ANGÉLIQUE
HOUTKAMP *at*
SALON SERPENT
in Amsterdam

BENJI *at*
LA BOUCHERIE
MODERNE
in Brussels

JULIE BRUNA
in Paris

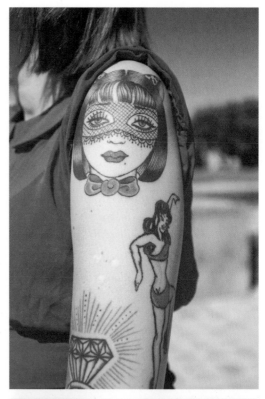

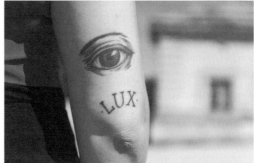

Miss Glitter was window-shopping around tattoo parlours when she was as young as 14, and she finally plucked up the courage to go inside when she was 20, much to her mother's annoyance. What she likes about this art form is the feeling of freedom to do what she wants with her own body: she gets a tattoo in both happy and difficult times as a way of marking a particular moment in her life. A bubbly Burlesque stripper, Miss Glitter is a fan of simple, coloured tattoos of the 1950's old-school style and religious iconography.

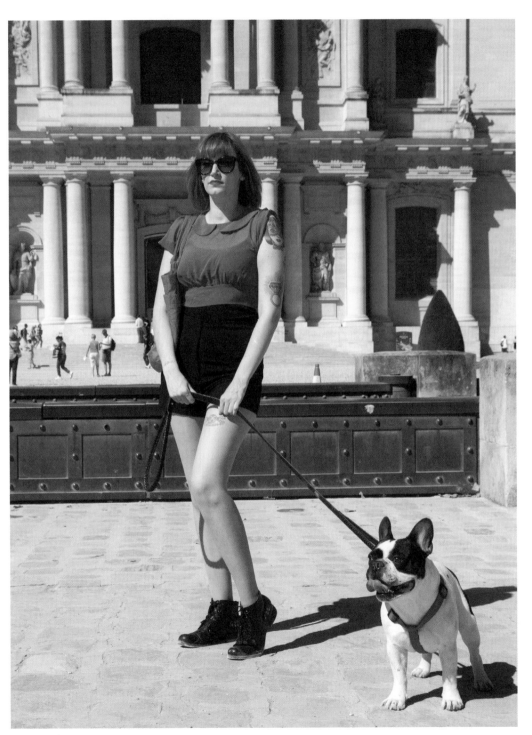

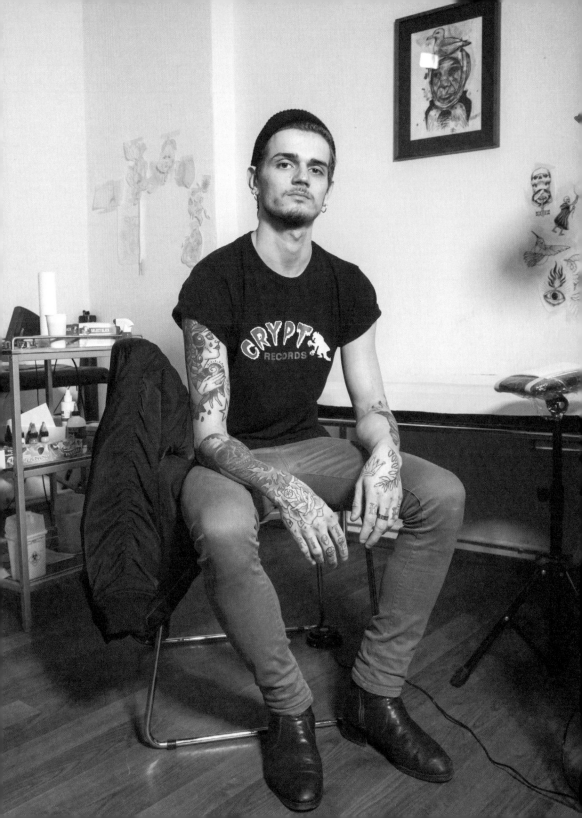

PORTRAIT

38

LOCATION
in the AKA studio, Pflügerstrasse (Berlin)

TATTOO ARTIST

MARTIN JAHN

TATTOOED BY

BJÖRN LIEBNER *at* **RED CHAPEL TATTOO STUDIO**
in Berlin

PHILIPPE FERNANDEZ *at* **AKA**
in Berlin (p.75)

HIMSELF

Martin is a tattooist who is always open to the world around him. Tattoo culture gives him endless opportunities to meet great new people, with new artists starting out all the time. Influenced by the work of Philip Yarnell, his counterpart in the London branch of AKA,

Martin bases his work on his own life and everything in the environment around him, whether it is a street, a building, or a place where he feels good. Martin had tattoos done because he was "tired of putting on different jewellery every day".

39

KIRKIS

TATTOO ARTISTS
VINZ *and* **MANON**
at **BODY STAFF**
in Vincennes

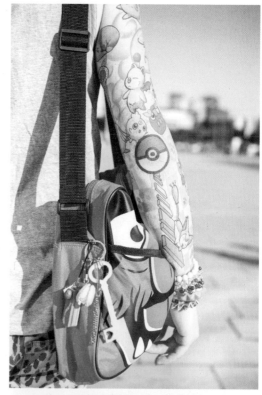

For Kirkis, body modification - all the tattoos and piercings he
has had done on his body - is a way of asserting his freedom.
Through tattoos, "an injection of coloured ink under the skin",
he can enjoy the motifs which are close to his heart. He adorns
himself with designs representing characters from video games
and Japanese anime culture, which fascinates him.

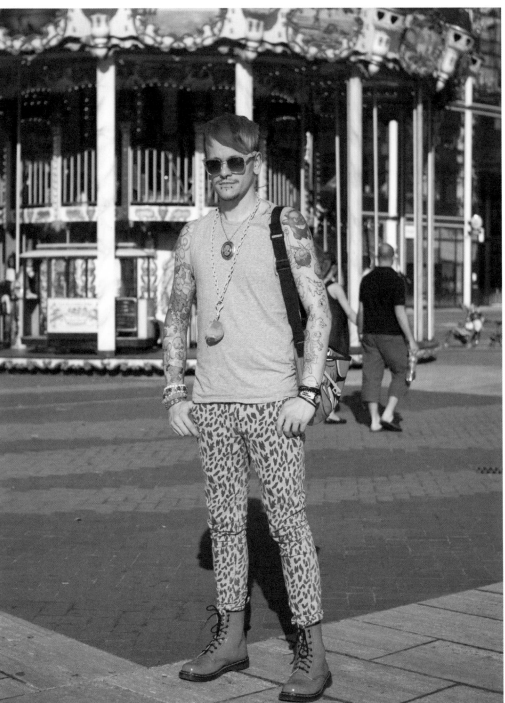

LOCATION
her home, rue Sainte-Catherine (Montreal)

RACHEL

TATTOO ARTIST
PIERRE
at **TATTOOMANIA**
in Montreal

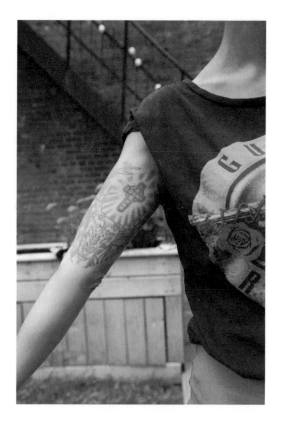

Rachel is a young Canadian fashion designer who has her own range of ethical furs: all her pieces are "recovered" or sourced locally. Although she prefers to keep her own story private, Rachel had her tattoos done years ago, fascinated by this expressive art form which is accessible to everyone, something she finds quite wonderful and intriguing. Rachel is inspired by everything around her, her family, designer friends, and arts and crafts.

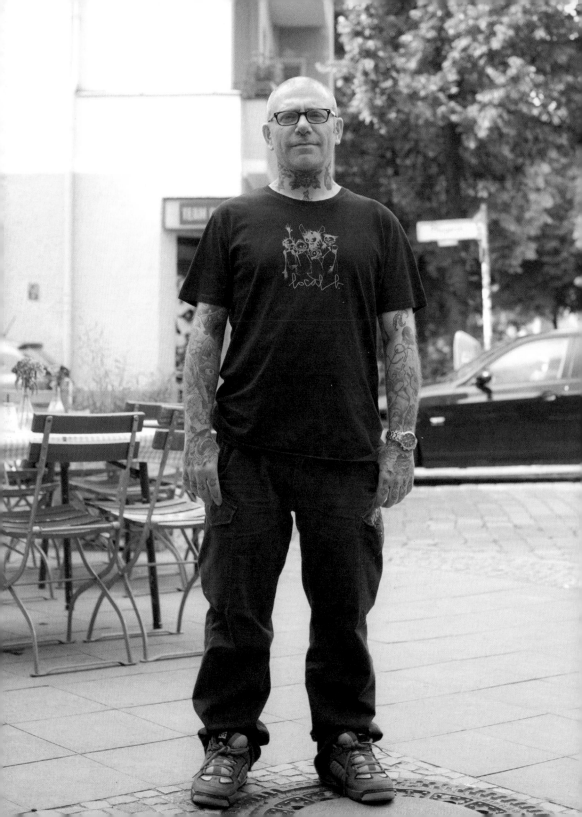

PORTRAIT

41

LOCATION
Hobrechtstrasse (Berlin)

TATTOO ARTIST

DAVID DARK BIRD

TATTOOED BY

JORRE *at*
THE BLACK LOTUS
in Antwerp, Belgium

JOE DYNAMITE
in Antwerp, Belgium

MACHE
in Brussels

PEDRO SOOS
on the road

JEF TODD NOBLE
in the Netherlands

GREG BRIKO
in Lille

PIETRO RIZZO
at **PIXEL TATTOO**
in Italy

This Belgian tattooist has been mad about tattoos since childhood. David wanted his various pieces to preserve a permanent history of his experiences and the people he loves on his body.

He is keen on traditional tattoos and those done in prison and an urban environment. He is interested in the way they tell the story of the person wearing them. David sees tattooing as a craft form which allows everyone to assert their own identity.

42

TATTOO ARTISTS

LA GRIBOUILLE *at*
L'ÉCORCHÉE BELLE
in Nancy

HIMSELF

*In small studios on holiday in
Spain, Italy, or London*

LUCAS

With tattooed parents, Lucas has been steeped in the world of tattooing for as long as he can remember. He got his first tattoo when he was 19, at a key moment in his life. Quite a few more followed; they are a way for him to stand out from the crowd and to embody what he wants to be in a profound way, right down to his skin. He draws his inspiration from music, cinema, literature, painting, culture in general, and tattooing in particular, which is an art form in its own right as far as he is concerned. Tattoos are not a fashion statement for Lucas, but rather a supremely elegant expressive tool.

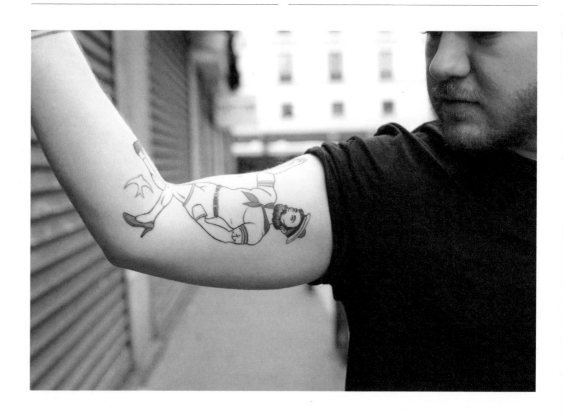

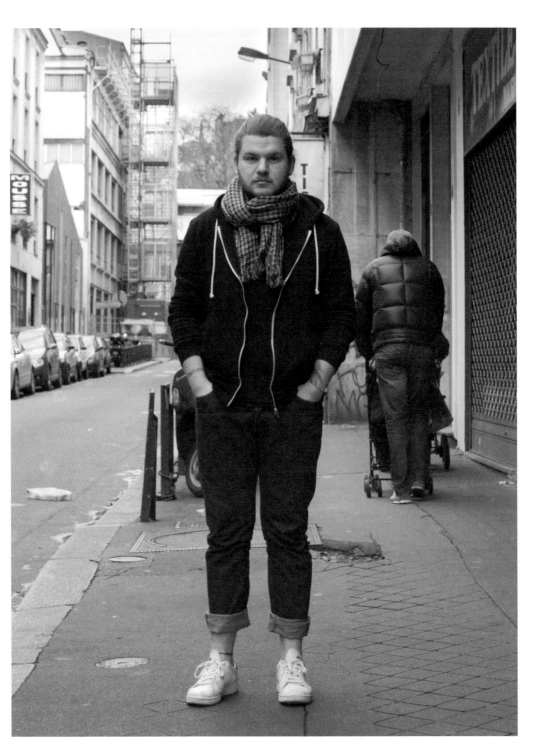

43

LOCATION
place Ville-Marie (Montreal)

DANIK

TATTOO ARTIST
KAT *at* **TATTOO**
MANIA *in Montreal*

We met up with Danik at the Mode & Design Festival in Montreal after the catwalk show featuring his trademark DYDH (Die Young Die Happy) Productions, which was founded in 2012 with Dina Habib. His designs and tattoos reflect his enthusiasm and quiet eccentricity.

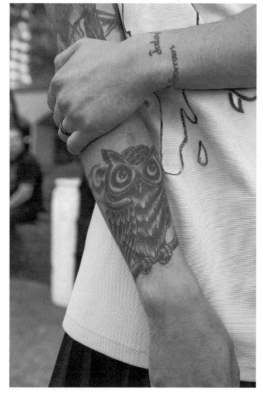

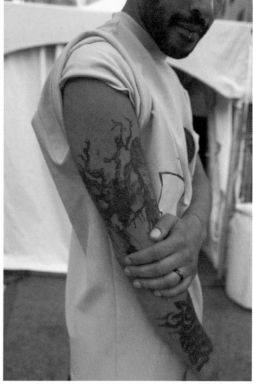

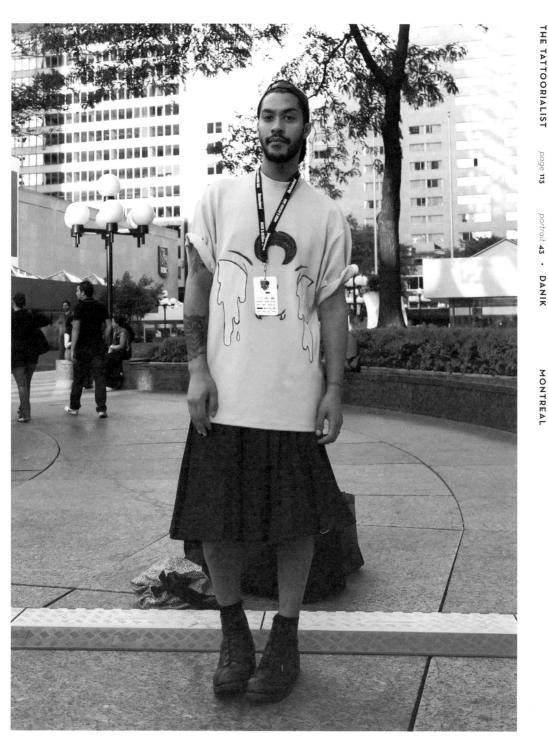

PORTRAIT

44

LOCATION
in the Gallery Vero-Dodat (Paris)

MARION & GUILLAUME

TATTOO ARTISTS

For Marion & Guillaume

LÉA NAHON
at **ART CORPUS**
in Paris

**LA BOUCHERIE
MODERNE**
in Brussels

DAVE SANCHEZ at
**YER CHEAT'N HEART
TATTOO** *in Los Angeles*

We met Marion and Guillaume, who make a good-looking couple, in a Paris arcade. She is a journalist and fashion blogger, while he is a digital projects manager and rock guitarist. Marion likes to get a tattoo when she goes on holiday. Each of Marion's tattoos represents a particular time in her life, as expressed in "I Woke Up In a Car", a song by Jack Mannequin in which the young girl "has tattoos of the homes she loved". They pin down unforgettable moments for ever. From the anchor that reminds her of her Catalan roots to the H-shaped cross (her mother's initial), they reflect a specific state of mind for her: "I like being able to think of it as a real work of art you can own for ever!"

For Guillaume, who is more of an introvert, his tattoos are a true means of expression. He too likes the aesthetic they give his body. Like Marion, he is attached to the moments represented by each tattoo: a reason, a place, a memory, for instance. Some of his pieces even echo his little brother's or his partner's tattoos. For this music lover, tattoos must have a symbolic thread running through them. He actually finds his tattoos soothing, as they represent a hymn to cheerfulness and a zest for life for him.

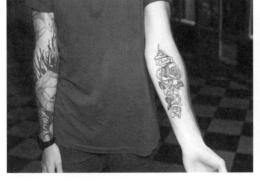

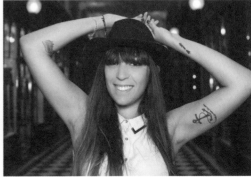

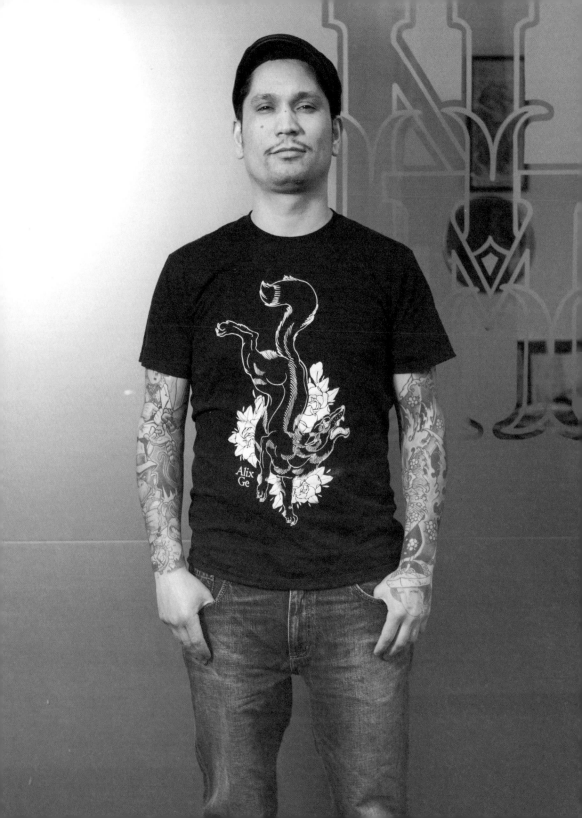

PORTRAIT

45

LOCATION
in the Nuevo Mundo studio, avenue Pasteur (Bagnolet)

TATTOO ARTIST

DAGO

A talented tattooist and owner of the Nuevo Mundo studio, Dago came to the profession gradually through his love of skateboarding and graffiti art. He has worked as a tattooist since 2007, but sees it as a way of life rather than a job.

Dago is a jack-of-all-trades who trained with established tattooists. He does not have a particular style, but likes to be creative and knows how to do everything. His favourite area is definitely Japanese culture, which he sometimes mixes with the Latino style of his Chilean background. His work is inspired by African, Mexican, and Asian art, as well as cinema and music. Recently he has developed a passion for the specialist technique of silk-screen printing.

For his own tattoos Dago likes to inscribe the passing of time on his skin. Each tattoo is associated with a meeting that has had an impact on his life. When he gets his body tattooed, the motif is not that important: the main thing is the time spent with the tattoo artist. Dago cites José Guadalupe Posada, Robert Crumb, Charles Burns, Hiroshige, and Thomas Ott among his favourite artists.

LOCATION
rue des Colonnes (Paris)

CAMILLE & JON

TATTOO ARTISTS

For Camille

GUY LE TATTOOER
on the road

LELE *at*
FAMILY BUSINESS
in London

MIKE *at* **PER**
SEMPRE TATTOO
in Meulan

KLAIM *at* **STREET**
TATTOO *in Franconville*

For Jon

GUY LE TATTOOER
on the road

VEENOM *at*
BLEU NOIR *in Paris*

KORÉ SANKOZU *at*
BODY STAFF
in Vincennes

GUILLAUME *at*
MYSTERY TATTOO
CLUB *in Paris*

Camille and Jon share a passion for English bull terriers and tattoos. They both took the plunge and got a tattoo at the tender age of just 15!

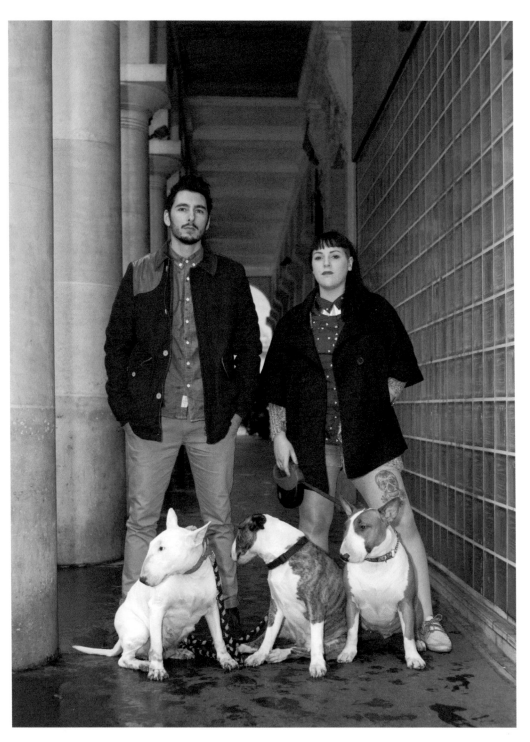

Jon is a fan of cartoons (Greg Capullo, Sean Murphy, Nobuyoshi Araki, Robert Crumb), which provide inspiration for his tattoos. He takes time to think carefully about each of them because they are a bookmark of his life. All of them are associated with a specific time and feeling.

Camille finds the artistic side of tattoos fascinating, as well as the session, the sensation, the buzz, and the pain. She is building up her tattoo work into a kind of jigsaw puzzle. Each tattoo represents a precise moment in her life. For her, "tattooing is the art of translating fleeting abstraction into a personal and immutable graphic representation."

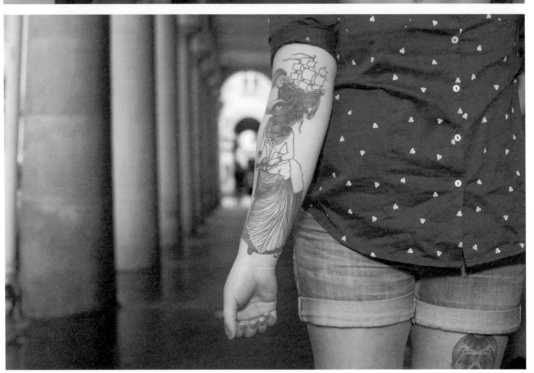

PORTRAIT

47

LOCATION

place d'Armes (Montreal)

TATTOO ARTIST

LA GUEUSE
at **BODYFIKATION**
in Talence

ÉLODIE

Élodie moved to Montreal over a year ago, starting a new life in which tattoos are a symbol of her desire to move on. Before she left France, her tattoo work was done by an artist who understood her: Élodie felt completely at ease about putting her skin in her hands. Élodie's second tattoo, done eight years after the first one, is a phrase from Antoine de Saint-Exupéry's children's book, *The Little Prince*: "So the thorns, what use are they?" The phrase had been in her head for so long that she just had to see it on her skin. Tattoos for Élodie are a way of asserting herself and taking control of her own body again, as if symbolizing an invisible scar. Élodie likes the stories told by tattoos, and what is concealed behind this form of expression; a revolution of a sort in a society where appearances are paramount.

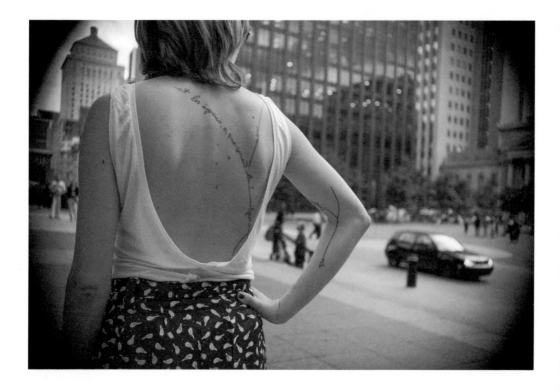

PORTRAIT

48

LOCATION
Saint-Honoré (Paris)

CAMILLE

TATTOO ARTISTS

MIKAËL *at* **MIKAËL TATOUAGE** *in Poissy*

BAXTER *at* **DOUBLE TROUBLE TATTOO** *in Rouen*

SM BOUSILLE *at* **LE SPHINX** *in Paris*

WALTER HEGO *and* **DIZZY** *at* **L'ENCRERIE** *in Paris*

Camille's "metaphorical" tattoos are both intimate and clearly visible to everyone. However enigmatic, they represent episodes or key people in her life, drawing inspiration from religion, architecture, the Renaissance, and the works of Delacroix, Magritte, and Rembrandt. As most of her other tattoos are quite melancholic, Camille turned her thighs into a more light-hearted celebration with tattoos representing her favourite season, summer.

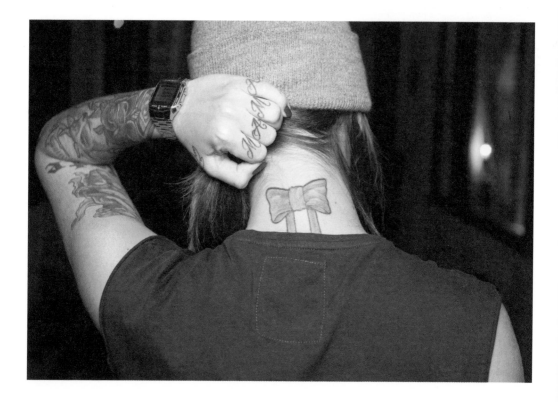

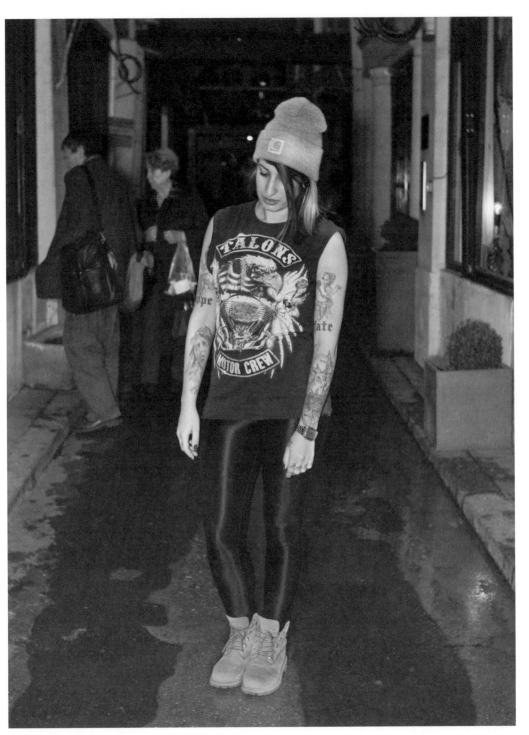

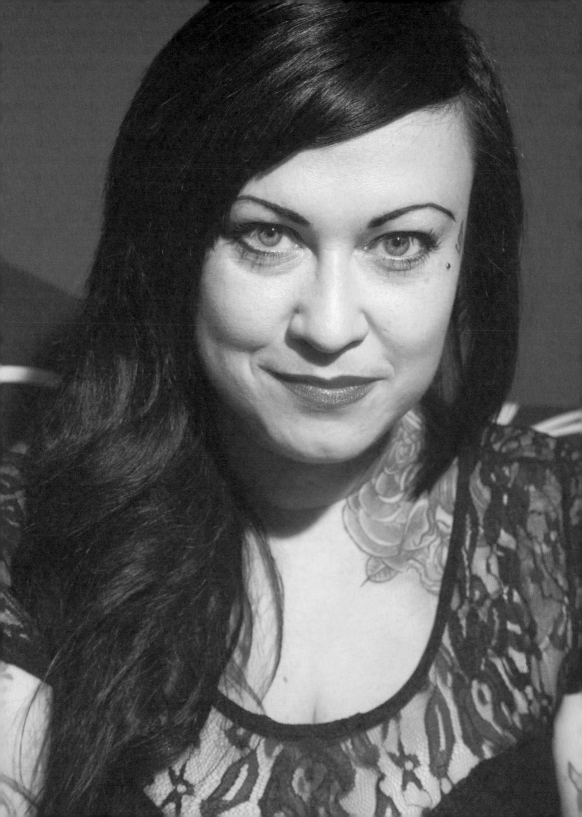

PORTRAIT

LOCATION
Imago Tattoo, boulevard Saint-Laurent (Montreal)

TATTOO ARTIST

VAL DAY

TATTOOED BY

PEPE *and* **POL** *at* **POL TATTOO**
in Montreal

ÉRIC DUFOUR *at* **ART CYNIQ**
in Montreal

MARIE-ÈVE BOYER
at **SYMBIOSE TATTOO**
in Richelieu, Canada

NIMA JOLAN *at*
IMAGO TATTOO
in Montreal

MIGUEL LEPAGE *at*
SAVING GRACE *in Montreal*

BIANCA *at* **ATOMIK TATTOO**
in Quebec

VINCENT *at*
GLAMORT TATTOO PARLOR
in Montreal

MÉLISSA VALIQUETTE
at **SIN CITY** *in Montreal*

HER SON

For Val Day, a tattooist with Imago in Montreal, the choice of career was an obvious one. Happy to get up every morning to meet new people and work alongside talented and inspirational colleagues, she loves to create unique pieces every day and in this way express herself through her art. Val makes sure to set aside some time each day for designing; the morning when she arrives at the studio, or in the evening when she gets home, immersing herself in what inspires her from her personal experience and the world of neo-traditional tattooing. This way she has peace and quiet to work on new tattoos to suggest to her clients. For her own tattoos, Val enjoys meeting great new people, and collects these experiences in the same way that others collect paintings.

TATTOO ARTISTS

EILO *at*
MTL TATTOO
in Montreal

ÉRIC DUFOUR *at*
ART CYNIQ
in Montreal

HUGUES *at*
IMAGO TATTOO
in Montreal

FLORENCE

"It's a bit like living with your own ghosts." Florence has her skin inked with tattoos to embed an impression, idea, or emotion in a specific moment. These tattoos allows her to combine these periodic aspects of her life with her daily routine, under the banner of art.

Whether it is a memory involving her sister or an adaptation of Dalí's crucifixion painting, which she loves, the meanings of her tattoos are both personal and varied. Florence likes old watercolours, Magritte, and Enki Bilal. Her knowledge of art will provide the inspiration for her next tattoos.

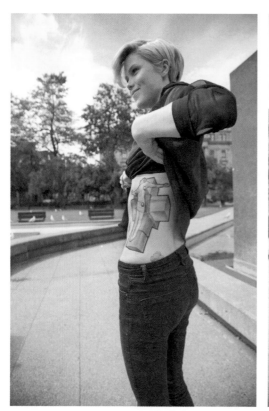

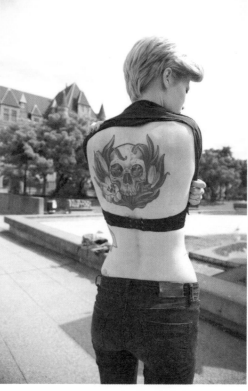

51

**TIN-TIN
TATOUAGES**
in Paris

YANN *at*
BUZZ TATTOO
in Vannes

LOCATION
in the offices of WAD
magazine (Paris)

BRUNO

Editor of the specialist magazine *WAD* for several years, Bruno lives in Paris, hopping between planes for his work. Inspired by the 1950s and its different trends, Bruno envisaged his tattoos as a very personal form of decoration, writing the story of his life onto his skin. A big fan of pop art and urban fashion, he likes the element of surprise, most notably in the way he reveals his latest tattoos to his entourage. His next piece, a reflection of the fact he is "always on a plane", will be his passport number!

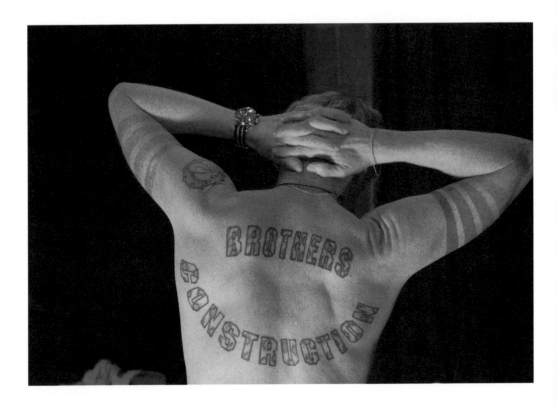

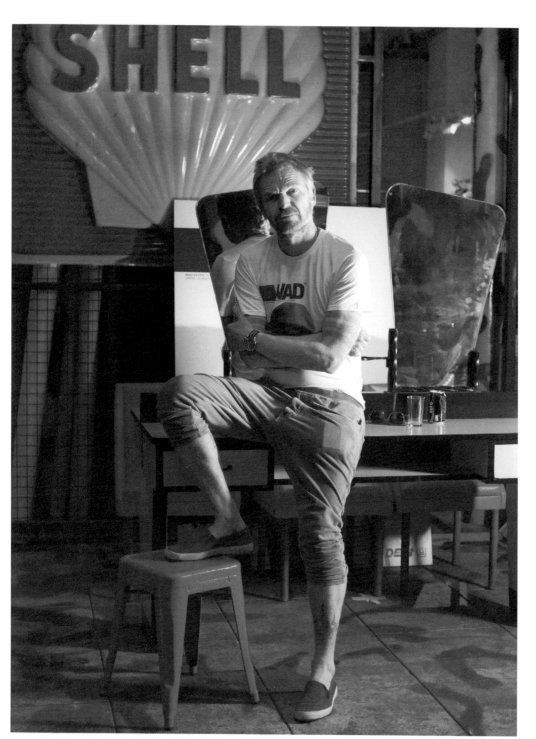

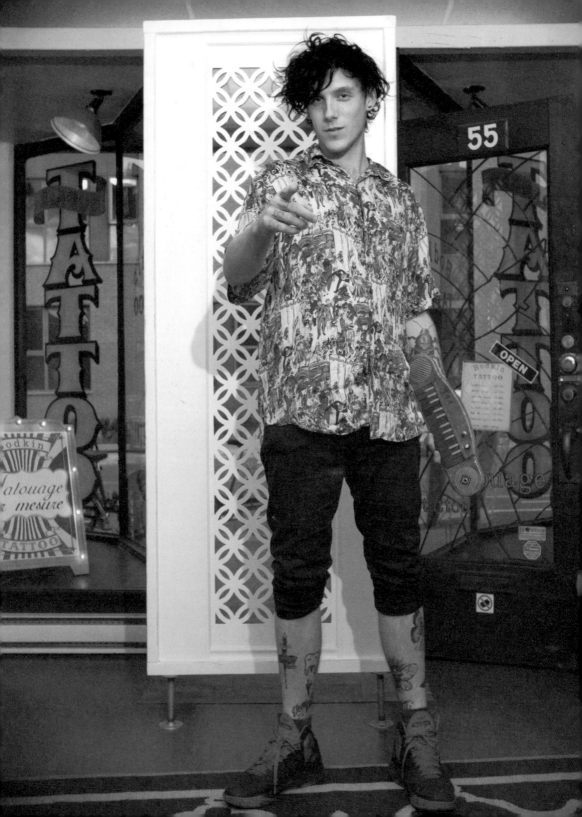

PORTRAIT

52

LOCATION
at Bodkin Tattoo, rue Bernard Ouest (Montreal)

TATTOO ARTIST

VINCENT BRUN

TATTOOED BY

SYLVAIN PROULX *at*
TATTOO LOUNGE *in Montreal*

GIL CROCKER *at*
JOLLY ROGER'S TATTOO
in Montreal

A tattooist in the Bodkin team in Montreal
and an astronomy student, Vincent is full of
crazy energy and highly disciplined at the
same time. He does this job because he likes
meeting clients and tattooing nice people.
Fascinated by his studio colleagues, he
models himself on them as a way of finding his
own style and steeps himself in the world of
his favourite artists, Egon Schiele and Simon
Talbot. With pretty insects scattered over his
body, Vincent got his tattoos done "because
I'm really into little bugs!"

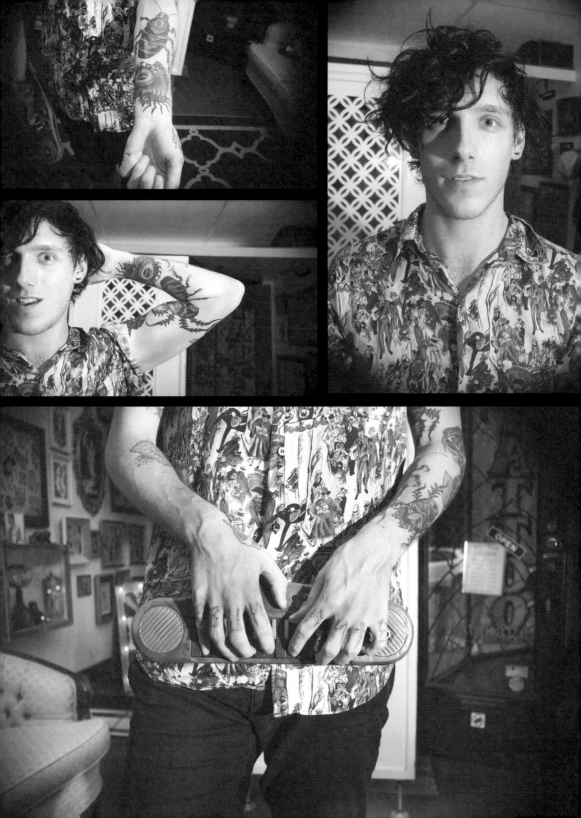

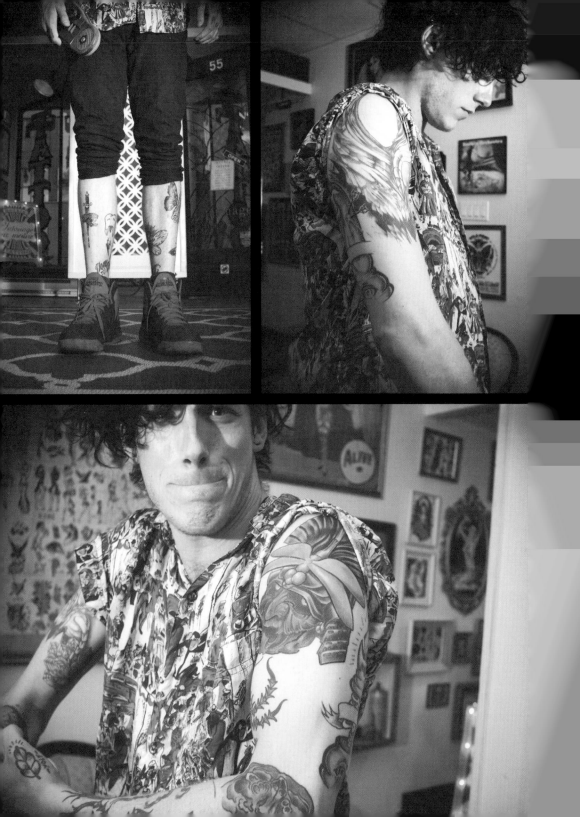

53

ANNE-SOPHIE & JULIEN

TATTOO ARTISTS

For Anne-Sophie

YANN BLACK
in Montreal

SAILOR ROMAN
in Paris

LIONEL FAHY *at*
OUT OF STEP
in La-Roche-sur-Yon

CHARLIE LACROIX
at **LE SPHINX**
in Paris

For Julien

TARMASZ *in Paris*

YANN BLACK
in Montreal

LIONEL FAHY
at **OUT OF STEP**
in La-Roche-sur-Yon

Anne-Sophie and Julien are both highly motivated to discover new artists and graphic worlds when it comes to tattooing. When they went to meet Yann Black, whose studio is in Montreal, they undertook a long journey to give a free hand to the tattooist, whose work they love. Forget meaning and stories: the session with the tattooist is what matters! They want to turn their skins into their personal art galleries, and some of their works complement each other perfectly.

Anne-Sophie took the time to think things through before getting her first tattoo. Four years passed between her initial visit to a studio and finally going under the needle. Since then her time spent contemplating each new tattoo has reduced considerably! For Julien, he was desperate to get the work done as soon as he has reached legal age. He wanted to become a "cool rock'n'roll guy" like Max Cavalera (singer in the group Sepultura) and Phil Anselmo (singer with Pantera), both of whom he admired at that time. Today his sources of inspiration are still artists, such as Jesse Jacobs, Aaron Horkey, and Jon Fox. As for Anne-Sophie, she is keen on the work of Edward Hopper and Jean-Philippe Delhomme.

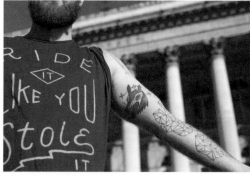

54

LOCATION
rue Quincampoix (Paris)

CÉDRIC

TATTOO ARTISTS

DAGO *at*
NUEVO MUNDO
in Bagnolet (p.117)

CLAIRE *at*
OCTOPUS TATTOO
in Pontoise

"I like the idea that they make me unique at first glance." The indelible and arbitrary nature of tattoos drove Cédric to submit to the needle in order to carve his desires onto his body. For his first step on this journey his inspiration came from his favourite themes (old school, neo-traditional, typography) but he gives the tattooist free rein to be creative.

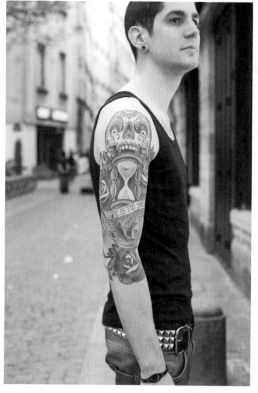

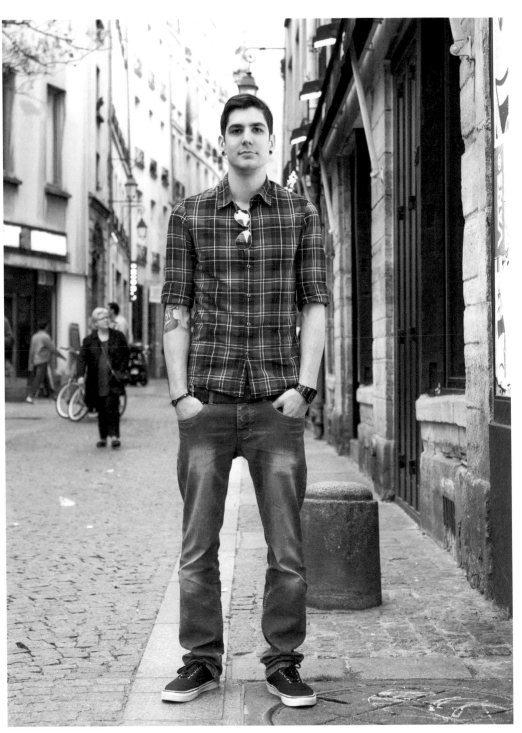

PORTRAIT

55

LOCATION
rue du Renard (Paris)

STEF & ALEX

TATTOO ARTISTS

For Stef

MORGANE at **SOUR
& SWEET TATTOO**
in Strasbourg

TOPSITURBY
at **VIVA DOLOR
TATTOO** *in Lyon*

DIMITRI HK
*at Saint-Germain-en-Laye
(p.173)*

*A Philipino in the Philippines,
where she used to live*

For Alex

LUDO *at*
ART CORPUS
in Paris

JEAN-LUC NAVETTE
at **VIVA DOLOR
TATTOO** *in Lyon*

A Lao Buddhist monk in Laos

Stef and Alex are young parents who were fascinated from a very early age by the mysterious and aesthetic side of tattooing all over the world.
For Stef, it is one of the best forms of self-expression, a reason for acquiring a cultural symbol, or getting a personal or purely aesthetic tattoo. So she delved into old school and geometric designs which she skilfully managed to combine with the help of tattoo artists she met on her travels.

Alex is passionate about the meaning of tattoos. He gave plenty of thought to his own, choosing the tattoo artist carefully in order to find the perfect balance of karma. He often finds out more about the tattoo culture he finds so fascinating, discovering new artists or organizing private viewings, because for him tattooing is unquestionably an art form in its own right.

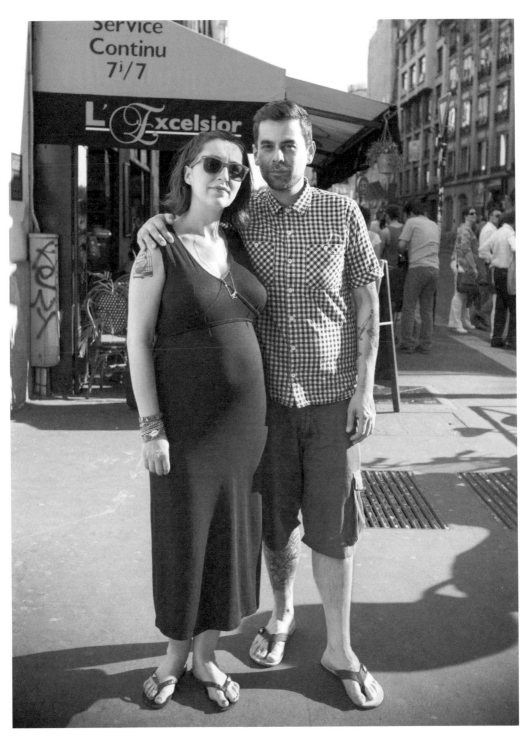

56

DAN

TATTOO ARTISTS

HIS RUSSIAN UNCLE

EDDIE *at* **23 KELLER**
in Paris

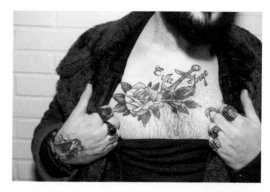

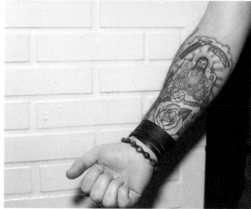

Dan inherited the tattooing tradition from the men in his family: his grandfather, his uncle, and his father. Skin marking has been handed down the generations in this Russian clan, who tattoo each other. Heroically, Dan did his first tattoo himself when he was just 9 years old! This rebellious streak has never left him, and now proves useful in his job as a bouncer at the legendary Paris rock venue The Bus Palladium. Dan tells the story of precise moments in his life through his very personal tattoos, so that he will never forget and will be able to tell his grandchildren about his life.

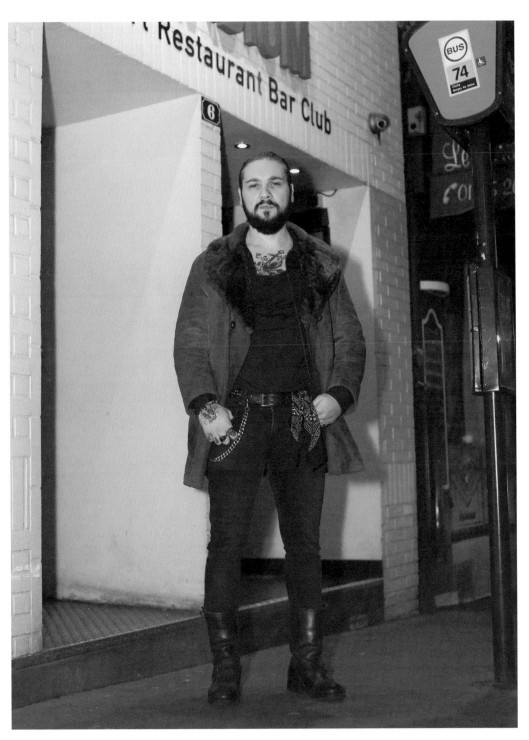

57

LOCATION
Place des Arts (Montreal)

CALIX

TATTOO ARTISTS

ALEX *at*
ENIGMA TATTOO
in Montreal

NICK OAK *at*
MTL TATTOO
in Montreal

A fan of soldiers' tattoos and the bold, crude, old-school style of sailors, Calix immersed himself in this world when it came to getting his tattoos. They represent important points in his life that he wants to remember; he also likes to look at them any time, sometimes to give himself the strength to go on.

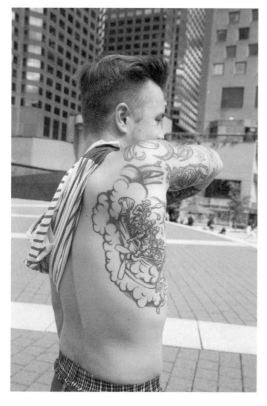

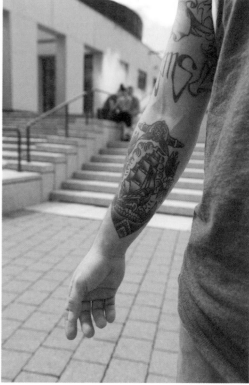

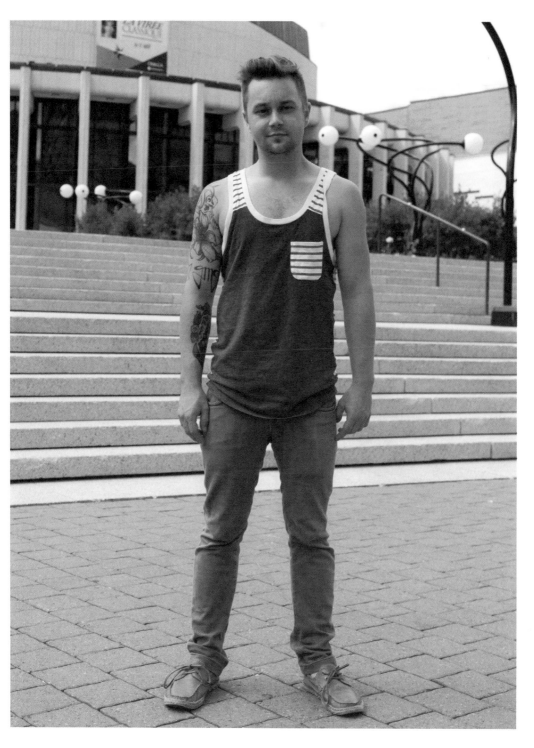

58

LUCY

TATTOO ARTISTS

CHARLES SAUCIER
at **IMPERIAL TATTOO
CONNEXION**
in Montreal

RALF NONNWEILER
in Neunkirchen, Germany

CHRIS BLOCK *at*
FALLOUT TATTOO
in Münzenberg, Germany

JÉRÉMY ZIMMERMAN
at **MAGIC
MOON TATTOOING**
in Erkelenz, Germany

VINCE DION *at*
**QUEBEC TATTOO
SHOP** *in Montreal*

VINCE BRASS *at*
TATTOO SHACK
in Quebec

MISTER P
in Brussels

TONY SCIENTIFIC
at **INKSTAINED
TATTOO STUDIO**
on Staten Island

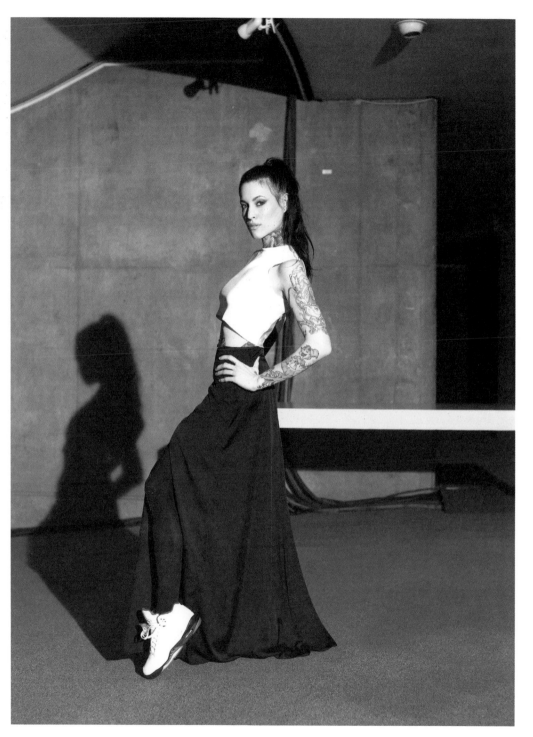

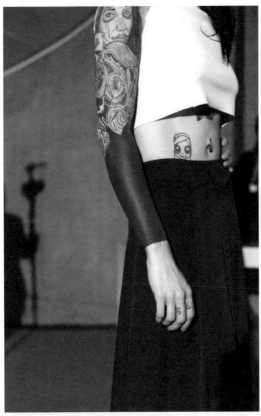

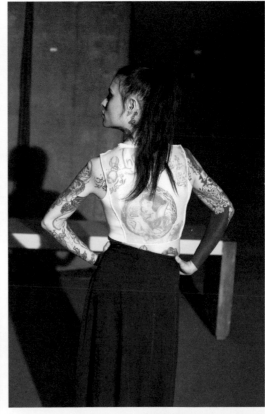

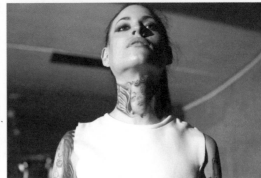

Getting tattoos is like being an artist's canvas for life. It is a decision not to be made lightly, but for Lucy it came quite naturally when she turned 16. Driven by an aesthetic impulse – and inspired by a family member she saw getting a tattoo when she was a little girl – she believes that tattooing is an "art of living" which affects life in one way or another every single day. She draws inspiration from her childhood and Disney® characters, as well as religion, classical art, the Florentine artist Botticelli, mythology, and the people around her. All of these worlds allow Lucy to transcribe the key moments in her life onto her skin.

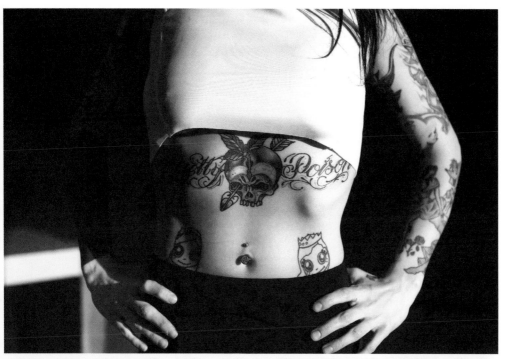

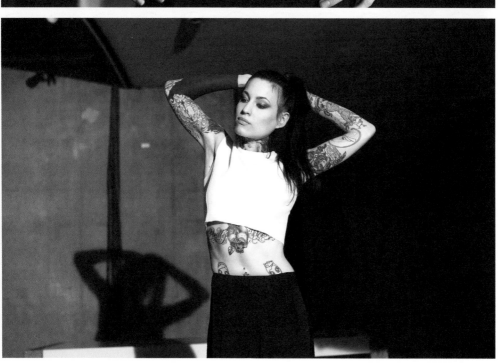

59

ANDY

TATTOO ARTISTS

DIMITRI HK
*in Saint-Germain-en-Laye
(p.173)*

LUCHO MORANTE
on the road

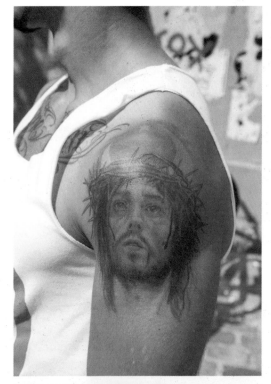

A cultured and ambitious young student, Andy thinks of his tattoos as messengers, mainly for others rather than just for himself. The head of Christ is combined with the Muslim crescent moon on his shoulder, both a reference to his parents and a call for open-mindedness. Whether it's a doctrine or a date, Andy leaves nothing to chance when marking the important points in his life. He gets ideas for his tattoos from his favourite Japanese and Latino imagery. He likes discovering one side of his personality through revealing the other.

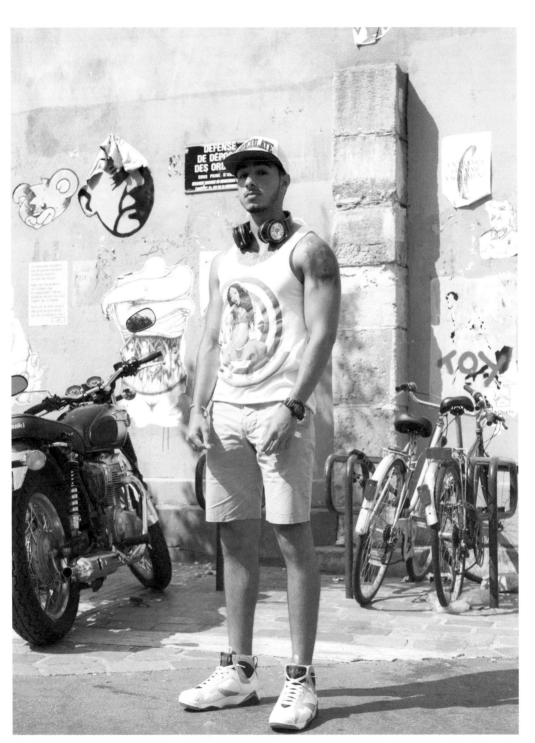

LOCATION
in the gardens of the Palais-Royal (Paris)

MARION & GUILLAUME

TATTOO ARTISTS

`For Marion`

AUDREY *at*
VIVA DOLOR
in Lyon

ROMAIN *at*
TOMEKVANROTTEN
in Lyon

`For Guillaume`

LOÏC *at* **ABRAXAS**
in Paris

Guillaume and Marion epitomize the chic elegance of a couple who look conventional yet are a little offbeat. They see tattoos as body decoration illustrating the story of their lives.

For Guillaume tattoos represent a true rite of passage into adulthood. Though he did not necessarily realise the profound nature of what he was doing at the time, aged 25, he decided to have a tattoo done over his whole right side of Lucas Cranach's depiction of Adam and Eve in colour. For him this artistic expression of free will represents a break with convention that allows him to represent his personality in images and convey his feelings. He already sees himself having a work by Gustave Doré inked on his body.

Since the Neolithic age, tattoos have been the art of embellishing the body for therapeutic, symbolic, artistic, or religious reasons, or to express identity. The various artistic and spiritual aspects of this practice are also significant for Marion, who got her tattoos to scuff her over-perfect image somewhat.

Marion is intrigued by the notion of breaking moral codes, and her tattoos are like glimpses of her private diary, offering us the expression of the darkest (as well as the best) periods in her life on different parts of her body.

When she was 17 her mother treated her to her first tattoo, a permanent memory of a person who was dear to her heart but is no longer with her.

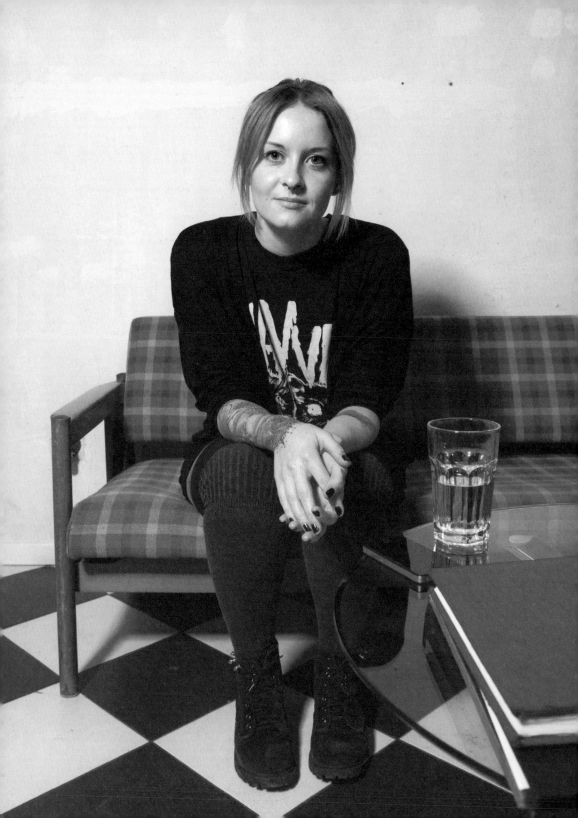

PORTRAIT

61

LOCATION
in the AKA studio, Pflügerstrasse (Berlin)

TATTOO ARTIST

GEORGIE HARRISON

TATTOOED BY

GUY LE TATTOOER

HERSELF

WARREN AT EMPIRE TATTOO
in Adelaide, Australia

A tattooist by trade, Georgie is enthralled by the process of creating art on a daily basis and meeting talented artists all over the world through doing what she loves. Her reason for getting tattoos lies in a fascination with the idea of depositing pigments permanently in the skin. She gets her inspiration from her immediate environment, surrounded by her studio colleagues who teach her about many things in the fields of traditional and modern art, including paintings by her favourite artists, Lucian Freud and Alex Kanevsky.

LAURINE & LÉO

TATTOO ARTISTS

`For Laurine`

SAILOR XA *at*
STEVE ART TATTOO
in Nancy

KURV *at* **LA MAISON**
DES TANNEURS
in Paris

INK TEMPLE BAR
in Dublin

JUST *at* **MYSTERY**
TATTOO CLUB
in Paris

CARNIVALE
TATOUAGE
in Brussels

`For Léo`

TOMM *at* **CLASSIC**
INK TATTOO STUDIO
in Dublin

JUST *at* **MYSTERY**
TATTOO CLUB
in Paris

MIL MARTINEZ *at*
13 DIAMONDS
TATTOO SHOP
in London

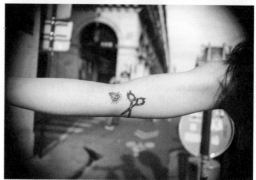

Laurine and Léo are wildly passionate about tattoos, which they sometimes like to get on a whim, just for the fun of it!
Laurine went into a studio to get her first tattoo on her eighteenth birthday. She has moments in her life "inked" for aesthetic reasons, for the pleasure of having a unique piece on her skin, the immediate adrenaline rush, and the precision in the skilled work of the tattooist.
A fan of the old school, she gets ideas for her tattoos from the people in her life: her father and Léo, people she meets, and her favourite artists, William-Adolphe Bouguereau, John William Waterhouse, and David Hamilton.
Léo likes the image of himself projected by his tattoos, and the idea that they allow him to stand out from the crowd. For him, tattoos define a person and mark an important stage in his or her life. When thinking up ideas for tattoos, he immerses himself in his everyday life and his favourite artists such as Neville Page, Katsuhiro Otomo, or Sailor Jerry.

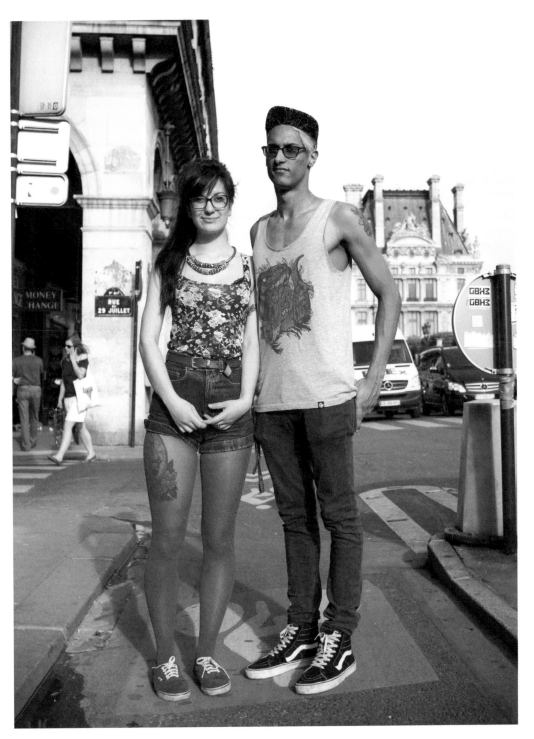

PORTRAIT

63

LOCATION
at Two Horses (Montreal)

FRANÇOIS

We met up with François in the Two Horses tattoo studio, where he was working on one of his pieces with Jessi Preston. This art aficionado likes to turn his body into a canvas on which artists can express themselves through their work. He likes the idea of the permanent nature of tattoos, and the power he can convey through a message or design. This gentle dreamer draws inspiration from his favourite artists like Frank Miller, Thomas Hooper, Guy le Tattooer, Hannah Pixie Snow, Lain Freefall, and Henry Charrière, and thinks up tattoos based on the theme he always returns to, the ocean.

64

LOCATION
rue des Martyrs (Paris)

LUSSI

TATTOO ARTIST
RICHARD SORENSEN
at **ONE MORE**
in Luxembourg

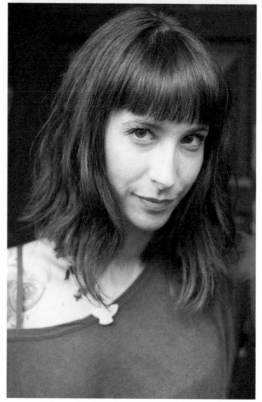

Lussi has music in her heart and on her skin. She gets a tattoo at every stage in her career and life. She is inspired by her favourite artists, Pierre Soulages and Helmut Newton, but mainly by her everyday life. For Lussi tattooing is an art form on a par with painting and music, which make her life whole.

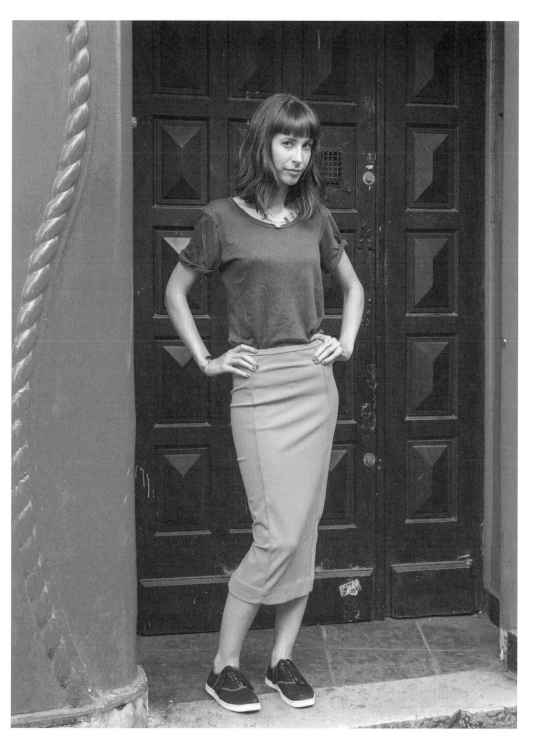

FANNY & JULIEN

TATTOO ARTISTS

For Fanny

JACK RIBEIRO *at*
BY JACK *in Thionville*

PAUL ACKER *at*
DEEP SIX TATTOO
in Philadelphia

ULRICH KRAMMER
at **FACE THE FACT**
in Austria

ALIX GE *at* **681**
TATTOO *in Lyon*

ALEXIS CALVIÉ *at*
BLACK HEART TATTOO
in Saint-Raphaël

RAPHAËL TROVATO
at **FRESH INK TATTOO**
in Mulhouse

TWIX *at* **FATLINE**
TATTOO CLUB
in Bordeaux

ALEX WUILLOT *at*
LA MAIN BLEUE
in Mons, Belgium

For Julien

RAPHAËL TROVATO
at **FRESH INK**
TATTOO *in Mulhouse*

JAMES *at* **BLACK**
HEART TATTOO
in Saint-Raphaël

HIMSELF

Fanny is a makeup artist, Julien is a model, they love art in general and tattooing in particular, they are hard-working, and they were destined to meet each other.

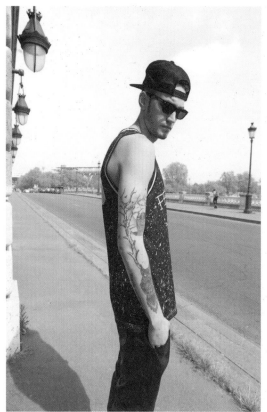
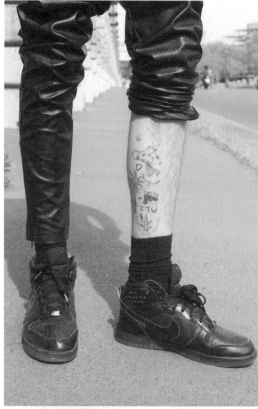
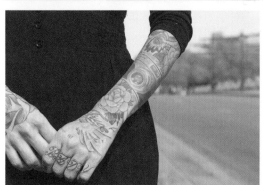
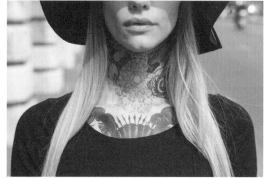

As a result of her career in the art world, Fanny empathizes with the work of the tattooist. Most of her tattoos are the result of her infatuation with the session itself. Often they have no particular meaning, apart from some pieces dedicated to her parents, brothers, and uncle, who is no longer with them. By nature a determined and passionate person, Fanny got all her tattoos done within a short period of time, and she even passed the bug on to her father – he took the plunge at age 50!

Julien travels a lot for his work and in his personal life. In the course of his worldwide trips, he has discovered different types of tattoo, and met a great many artists. Since getting his first tattoo aged 18, he has chosen a specific spot to mark the occasion at each new encounter. Motivated by the artistic side of tattoos, Julien's natural curiosity means that he is interested in their meanings.

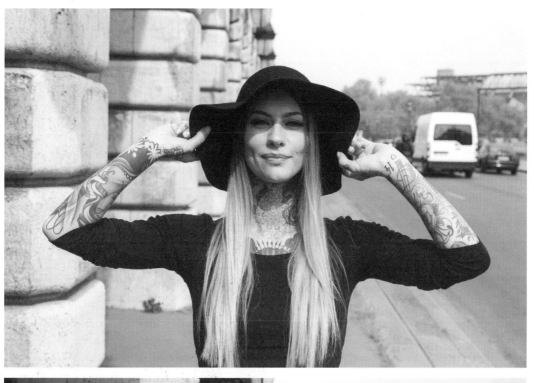

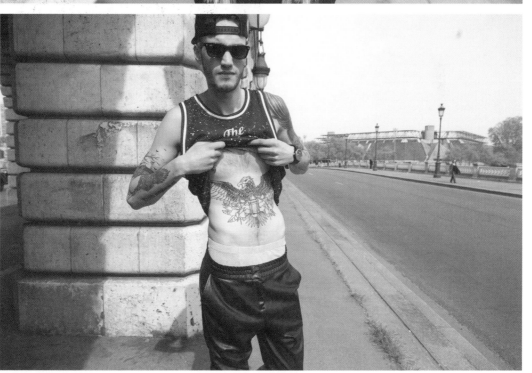

LOCATION
in his recording studio (Montreuil)

TÉTÉ

TATTOO ARTISTS

HUGO *at*
HAND IN GLOVE
TATTOO *in Paris*

BRAD
in Portland, Oregon

ARMELLE *at*
TATTOOED LADY
in Montreuil

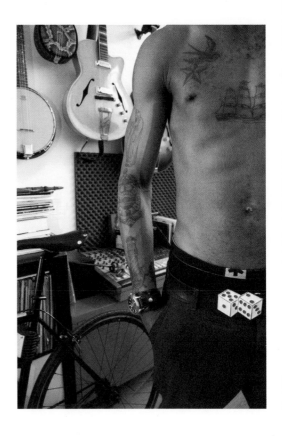

A talented artist midway through a tour, Tété is a big fan of great stories, journeys, meetings ... and tattoos. Honorary president of a recent Mondial du Tatouage convention along with Tin-Tin, and founder of the web TV programme *Tattoo By Tété*, which deciphers the meaning of traditional tattoos, he wears his personal story on his skin. "Symbolism and the lives of men who have earned their spurs in this art" are what fascinate him and encourage him to decipher this special world.

Tattooed for the first time at the age of 27 after suffering heartbreak, he went on to write the pages of his personal story on his skin, one step at a time: "You know, the star-shaped scars, that's a man's life summed up ... indelible Dantesque frescoes illuminated, drunken sailors of the past", *Frères de sang* (one of his songs, meaning "blood brothers").

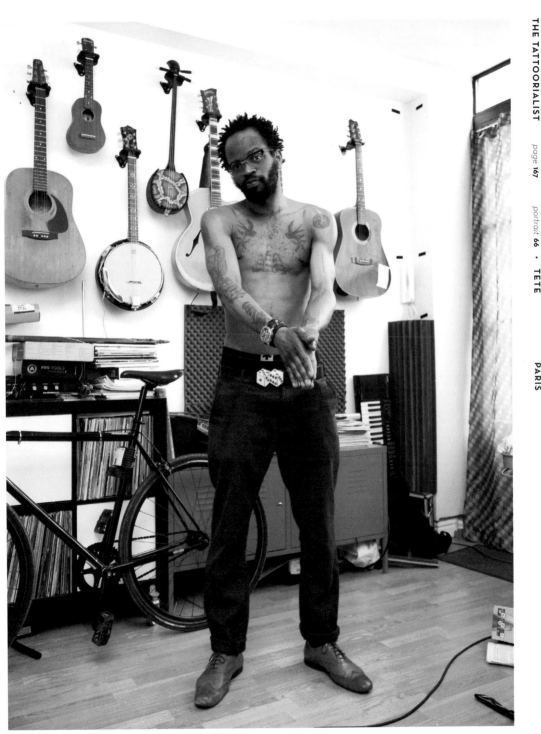

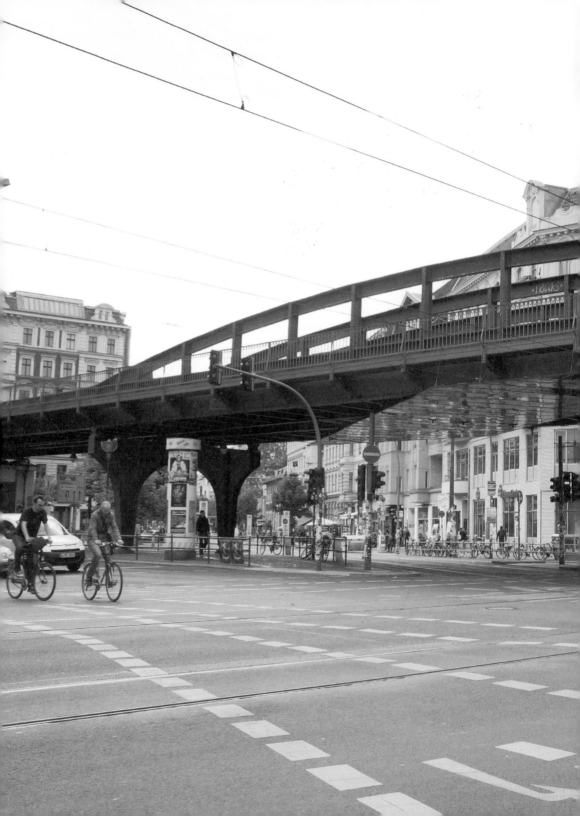

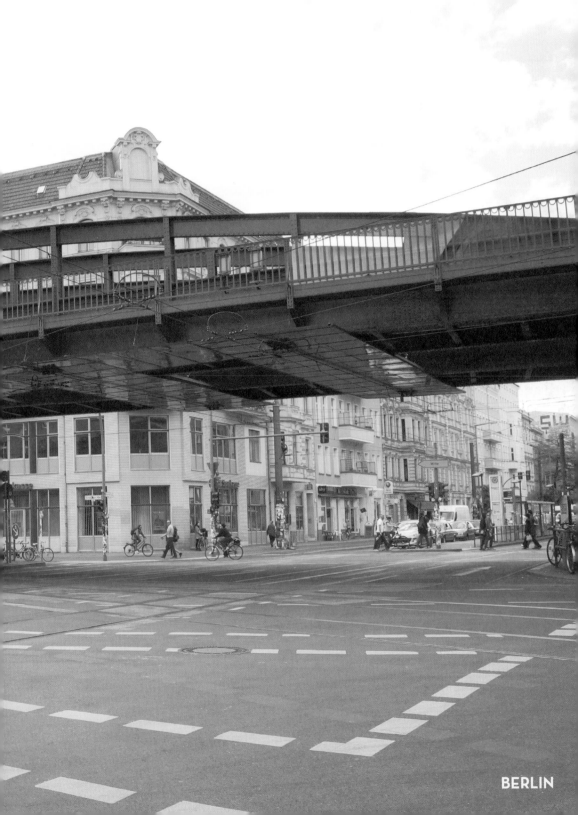

BERLIN

HIDDEN
in plain view

EIRINI RARI
Clinical psychologist

WHAT IS DEEPER IN MAN IS HIS SKIN – TO THE EXTENT THAT HE KNOWS HIMSELF
Paul Valéry, L'Idée Fixe, 1933

Intimate in the extreme yet also openly on display, worshipped and disdained, sexual and identity-forming, tattoos are riddled with paradox and ambiguity. This interpretation is based on the meaning of what they conceal rather than what tattoos symbolize, show, or make visible. In fact there is an untranslatable aspect to tattooing, deriving not only from its purpose as an "encrypted universe" as Flo suggests (p.14), but also in the discourse associated with it: evasive, avoiding, incomplete, "a side issue", as if a tattoo speaks of things that cannot be said, presenting an enigma as much to the person looking at it as to its wearer. Highly personal, the seductive side of tattoos derives notably from the fact that we do not really know what we are looking at when we see a tattoo, whether it is actually a mirage or a dream that always refers to something else.

TATTOOS CAN BE UNDERSTOOD AS A SYMBOLIC OR EROTIC INSCRIPTION

Tattoos can be understood as a symbolic or erotic inscription: a sign of belonging, in a positive or negative way, as the affirmation of membership and a gesture of disenfranchisement at the same time. While it may suggest the search for a body that can be shaped according to personal desires, the tattoo has a dual function. On the one hand, it strikes a blow against "the indebted body", to use Simone Wiener's term, the body "given by the mother" [1] and by extension other family members – Charline's tattoos (p.226) spring to mind, synonymous with discord within the family circle, or parents reacting to tattoos with suspicion, worry, disagreement, or anger. At the same time, a tattoo taps into the same bonds – as shown in the practice of dedicating tattoos to family members, marking either births or deaths, or even identifying with the line of relatives with tattoos, as mentioned by Dominique (p.185) and Émeline (p.34), who equates it with a "virus".

So as Vincent Estellon observes, in a dual movement that is both centrifugal and centripetal, both expelling and incorporating, the tattoo raises the issue of ownership [2]. They expel in the sense of destroying, putting something outside oneself, or rather on one's surface, an excessive arousal (Vincent Estellon refers to this as a "discharge through the skin"); and incorporate in the sense of keeping something for oneself, inside oneself, an indelible stigma "a form that will not become deformed" [2] , "timeless", as Maéva puts it (p.190).

The idea is that of a breach, a violation, which must be re-worked, negotiated, and reappropriated, but it is also about the fear of imminent loss. As such, the

tattoo can have a healing quality, acting as a physical imprint on memory "so that you do not forget anything" as Louis says (p.196), either good or bad. The scar is an indication of this process of repossessing or reappropriating something for oneself: as what Laurie Laufer calls the "instinctual place", it makes it possible after the event to "acknowledge the composition of a psychic place" [3]. For instance, some tattoos conceal physical scars, and thus are responsible for psychosomatic "healing". Jean-Bertrand Pontalis saw the creation of a fetish (though we believe it to be equally applicable to tattoos) as "the need for it to be my little possession, my secret, concrete evidence for me alone of this contradiction: exercising power over what controls me." [4].

By drawing a unifying identity marker, tattoos facilitate a reconstitution of the subject of one's own identity – they are a medium embodying a

THE ACT OF LOOKING AT THE BODY IS MEDIATED BY THE TATTOO

different form of identification and gesture of power over the image, and as such can become a "factory of the self" [1]. Linked to this (re)construction of identity is the process of inscription within a period of time: condensing the past, present, and future in a curious way, tattoos make the person literally the wearer of his or her own history. Having the indelible mark of an event "in one's skin" [2] it also, paradoxically, paves the way for the possibility of forgetting it.

As Didier Anzieu observes, behind the fantasy (necessary for developing towards psychological autonomy) of having one's own skin is often "the prior fantasy that to have it for oneself, you have to take it from another, and that it is even better to allow oneself to be taken by the other, to give pleasure and thus to eventually get it oneself." [5] Specifically, with a few exceptions including tattoo artists, individuals do not tattoo themselves; they have it done to them, an enforced period of (self-) passivity which instantly involves the other person, creating a dual complicity. The act of tattooing itself, the tattooist, the needle, and the ink, is a moment in which the intimacy and violence are reminiscent of a quasi-sexual scene. The erotic and seductive component of tattooing is also inherent in its function as ornament or jewellery, paradoxically hiding the body and at the same time displaying it. After all, with a tattoo, you will never be completely nude again; an extreme of nudity that for some people reflects a primary state. In the words of Claude Lévi-Strauss quoted by Marc and Maéva (p.217): "It was necessary to be painted in order to be a man: anyone who remained in a natural state was not differentiated from the savage" [6].

So if it is a matter of creating one's own skin – equipped with protection against excitement and psychological packaging – this second skin with its protective and ornamental appeal [7] simultaneously introduces distance: the act of looking at the body is mediated by the tattoo, whether by the attention being focused on this new physical place (like a new erogenous zone?) or in absentia, because the person who has the tattoo knows and the other person does not (in the case of hidden tattoos). This pertains to the onlooker as much as to the tattooed person. This distance – the psychological differentiation introduced by the tattoo – becomes greater as more marks are made, removing the subject from what can be collectively shared. At its most extreme, this distance can assume a purely sensory function: as John Irving [8] observed, in the absence of any medical reason, many large-scale tattoos are cold.

REFERENCES

1 • Wiener, Simone: "Le Tatouage, de la parure à l'oeuvre de soi", Champ psychosomatique, 2004, No. 36, pp.159-170.

2 • Estellon, Vincent: "Tatouage sur corps ou l'envers de l'expression", Champ psychosomatique, 2004, No. 36, pp.145-158.

3 • Laufer, Laurie: "L'Événement traumatique – Une transe mélancolique et silencieuse", Revue Psychologie clinique, 2003, No. 18, Penser, rêver, créer, pp.141-156.

4 • Pontalis, Jean-Bertrand: Introduction, Nouvelle Revue de Psychanalyse – "Objets du fétichisme", Autumn 1970, No. 2, Gallimard, Paris, pp.5-18.

5 • Anzieu, Didier: Le Moi-Peau, 1985, Dunod, Paris, 2nd edition, 1995, p.135.

6 • Lévi-Strauss, Claude: Tristes Tropiques, Plon, Paris, 1955, p.216.

7 • The word "tattoo" derives partly from the Tahitian word for "spirit" (atouas).

8 • Irving, John: Until I Find You, Random House, Inc., New York, 2005.

PORTRAIT

67

TATTOO ARTIST

DIMITRI HK/INTERVIEW

OWNER and **TATTOOIST**
at **DIMITRI HK TATTOO**
in Saint-Germain-en-Laye

Try to describe yourself in a single sentence.
I'm not very tall, I talk a lot, I'm always doodling – so like a hyperactive little tattoo on caffeine.

What interests you about tattooing?
The creative and artistic side. I'm addicted to design – on paper, skin, canvas, all media. Of course when I began, tattooing was an underground activity, and that was definitely an appeal, as was the possibility of realizing my designs and being my own boss.

What are your artistic influences?
I have so many: a large proportion derives from European cartoons (Maester, Franquin, Loisel, Cromwell, Margerin, Jano, Bilal, Liberatore) and American ones (Angel Medina, Capullo, Frank Miller, Bisley), street art including Banksy's work. I find inspiration in everything around me: classical painters, advertising, a walk round the zoo, or a joke.

Can you tell us a bit about your tattoos?
I started getting tattoos a long time ago, when I was probably too young to make intelligent decisions. As a result I have a lot of "botched jobs", as well as more recent good ones. I was lucky enough to meet famous people like Guy Aitchison who did my tattoos, and Bugs, who

did my first one in London in 1984 or 1985 (my memory's a bit hazy) and even Bernie Luther. At that point I spent some time at Marcel's studio, the legendary Parisian tattooist in the 1990s, so I have lots of great memories of him on my skin, as well as of Patrick, a tattooist at Tréport, where I hung about around 1986 or 1987. The tattoos I had done during that time are nothing special, but they bring back great memories for me. I always thought of tattoos like a photo album: each piece reminds me of a journey, a meeting, a time in my life, so I have absolutely no regrets about getting them.

What is your style?
I enjoy a range of genres, from biomechanical to cartoons, realism, trash polka, graphic art, etc. I also mix styles like Japanese animes or biomech steam-punk. Like many tattooists of my generation, I dabbled with lots of trends. When I started out, there were fewer requests than there are now, so in order to work I would do whatever I was asked.

How long have you been tattooing?
I began in the early 1990s. I loved tattoos from a very young age and before long I wanted to become a tattooist. I thought about being a cartoonist, so I started doing them on people.

PORTRAIT

68

LOCATION
in the Easy Ink studio (Paris)

LORENZI

TATTOO ARTISTS

MARION *at*
EASY INK *in Paris*

JERRY ONE *at*
EASY INK *in Paris*

LAURA SATANA *at*
EXXXOTIC TATTOO
in Paris

SNOOPERSTAR
in Paris

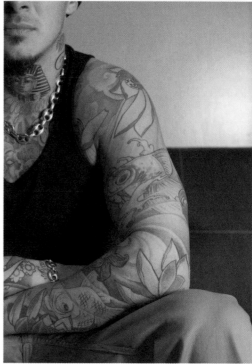

An eternal dreamer, Lorenzi likes to see his tattoos (he calls them "his works") following the rhythm of his body and its movements. His tattoos hark back to a particular moment in his life, good or bad, which he never wants to forget. They can tell us about the path he has taken in life, his passions, and his dreams, as well as things that he could not express aloud, out of modesty. Lorenzi is fuelled by the imaginary world deep in his mind when realizing his tattoos.

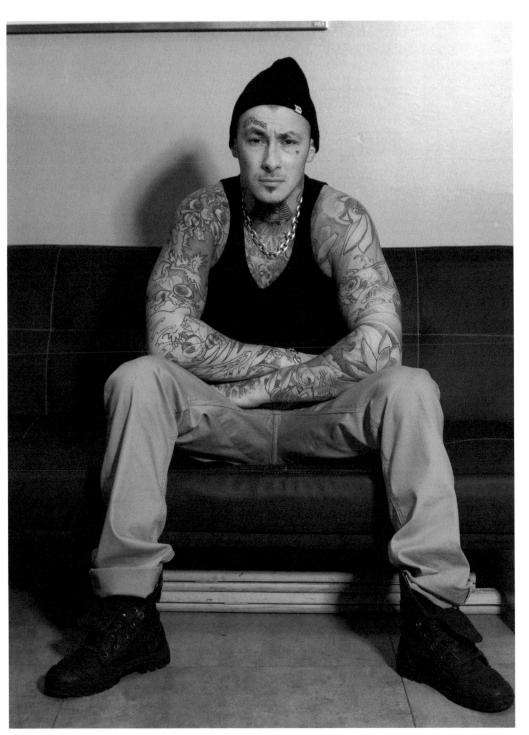

SARAH & MEHDI

TATTOO ARTISTS

For Sarah

EMILY *at*
BLACK SHEEP
in Grenoble

KURV *at* **LA MAISON**
DES TANNEURS
in Paris

LAURINK
in Saint-Denis

SEBASTIAN
BRIGHTBLACK *at*
MIKADO
TATOUAGES *in Nantes*

KLAIM *at*
STREET TATTOO
in Franconville

For Medhi

OLY ANGER
in Montreal

FRANCIS GOSSELIN
in Saint-Hyacinthe

MARTY DEGENNE
at **LANDSCAPE**
ROCKSHOP *in Paris*

VINCE BRASS *at*
TATTOO SHACK
in Quebec

HIMSELF

Sarah and Mehdi are huge fans of tattoos and graphic art. Trained as web developers, they both gave into the temptation to get a tattoo as soon as they reached legal age. Admitting their first few tattoos were done for aesthetic reasons, which they now see as a celebration of their adolescent years, they managed to develop their approach and for them these many illustrations are now a way of etching in their memories and remembering important things.

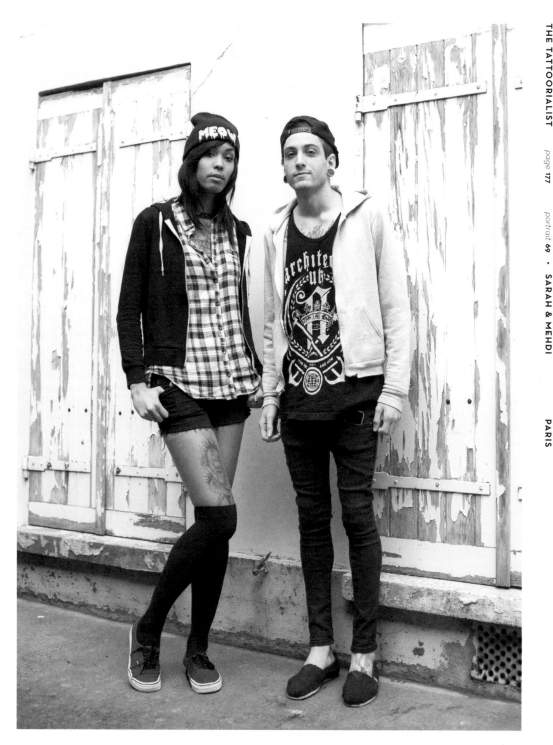

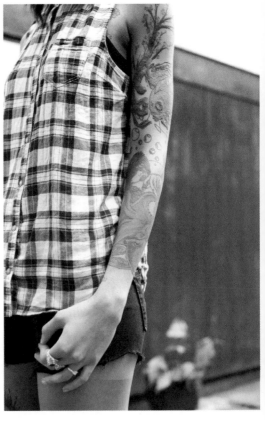

So far Sarah has treated herself to a dozen or so pieces. Most of them contain a really profound meaning about her outlook on life and the values she inherited from her mother. A small "FUCK" on the inside of her lip and a few adolescent symbols are signs of a different era, though these days she has no regrets whatsoever about it. "When I'm old? I will look as if I'm dressed when I no longer have the strength to put my clothes on!"

Mehdi is inspired by the neotraditional style, telling his personal story through his tattoos. Each design reminds him of a particular time in his life, though his tattoos don't necessarily have any deep meaning. Those he had done abroad are an indirect reference to his various travels, a kind of postcard carved on his skin forever. "When I'm old? It will be something to read to my grandchildren."

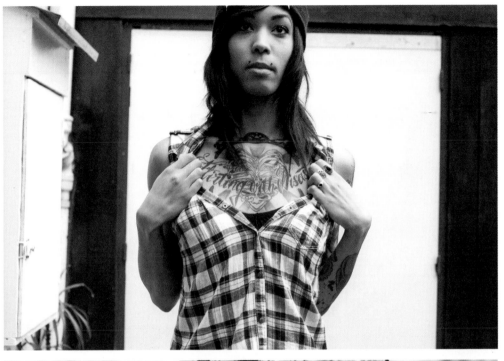
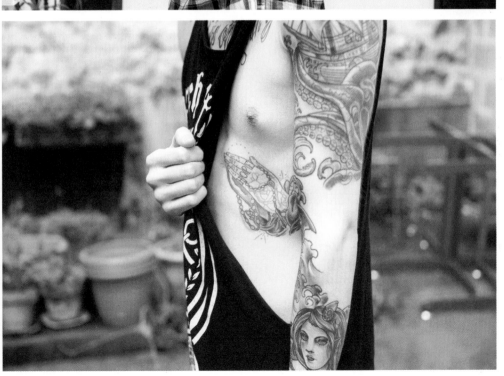

70

PRISCILLA

TATTOO ARTISTS

MYLOOZ *at*
TATTOOED LADY
in Montreuil

FUZI UVTPK *in Paris*

TRIBAL ACT *in Paris*

When she first started getting tattoos, Priscilla saw it as a way of marking her skin so that she would remember important things. Now she simply wants to "colour in" her skin on a spontaneous whim, wherever she is in Paris among friends. Priscilla looks on the bright side of life, to say the least, dreaming as she does of bikes, trips, and tattoos!

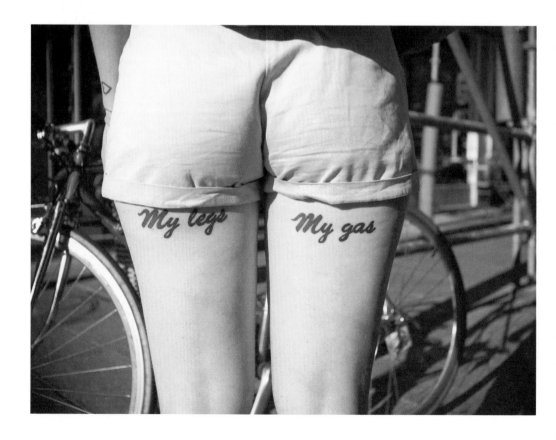

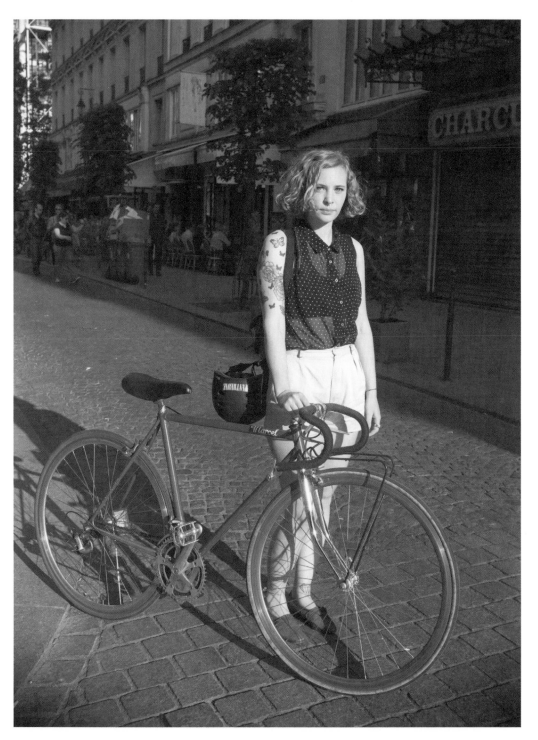

71

LOCATION
*Pont Charles-de-Gaulle
(Paris)*

LOÏC

TATTOO ARTIST
**JULIEN "JULAO"
PERRON**
on the road

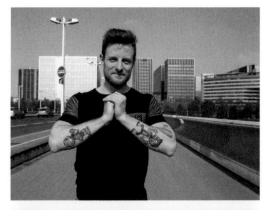

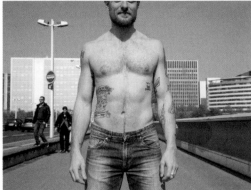

Loïc, a jack-of-all-trades who lives life at full throttle, describes himself as "5'7", on the edge". He drives around Paris in his brightly-coloured food truck. Amused by the paradoxical nature of a very personal process that everyone can see, he was tempted into getting a tattoo when he had just received his first pay cheque at age 18. Since then he has had significant moments inked onto his skin and now sports about 20 illustrations. Though he has no real interest in art, he does like the work of Basquiat: "a talent that is pure, creative, and free". He also pays tribute to him in the form of a tattoo of a crown (the artist's personal signature) on his side.

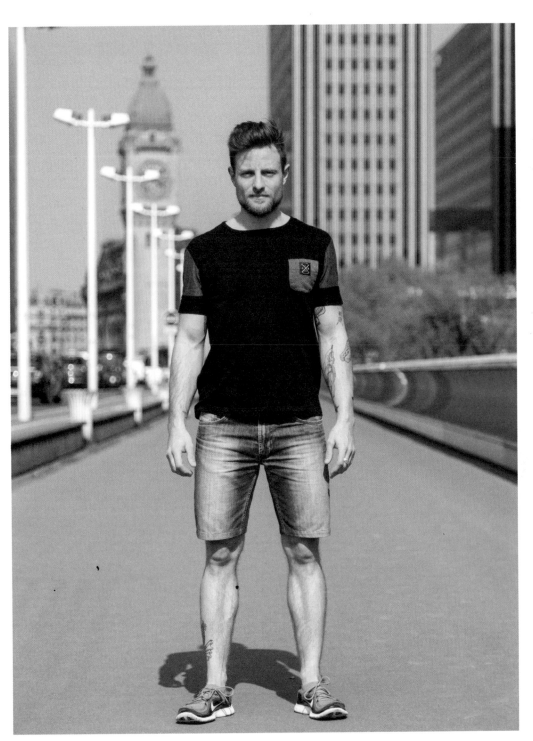

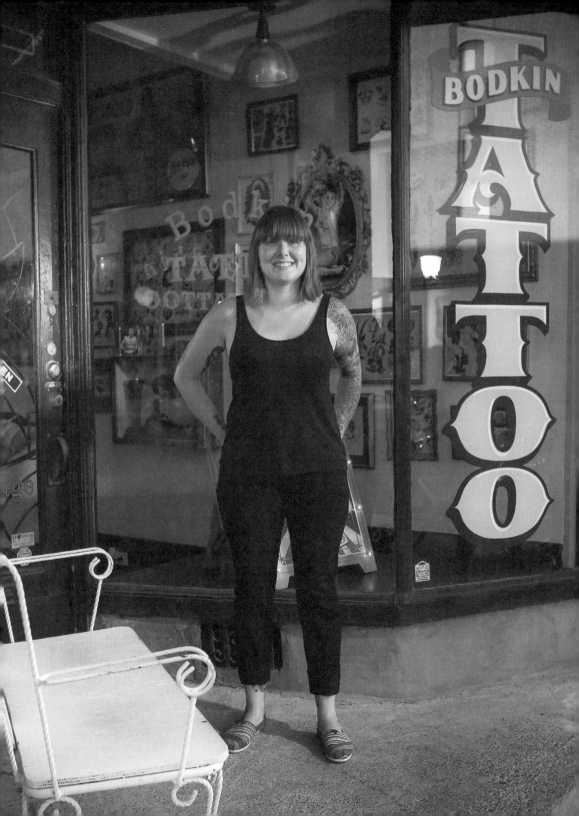

PORTRAIT

72

LOCATION
at Bodkin Tattoo, rue Bernard Ouest (Montreal)

TATTOO ARTIST

DOMINIQUE BODKIN

TATTOOED BY

BRUCE BODKIN,
VINCENT BRUN
and **DAVID CHOQUETTE**
at **BODKIN TATTOO**
in Montreal (p.133 and 229)

POL TATTOO
in Montreal

JESSI PRESTON
at **TWO HORSES**
in Montreal (p.21)

Bodkin Tattoo is a niche studio in the heart of Mile End, a family neighbourhood in Montreal. It is owned by Dominique, who comes from a family of tattooists (her grandfather and then her father Bruce Bodkin). She regards tattooing as the most beautiful form of artistic expression ever.

Dominique is a person with a big heart. This is evident in the tattoos she has, which are frequent reminders of the people she loves. Time spent in her studio is a guarantee of good down-to-earth conversation. She enjoys meeting people, and draws inspiration from those who are brave enough to reinvent themselves using tattoos as freedom of expression.

A fan of the traditional pop culture of North American tattoo art, and tattoo artist Cindy Ray in particular, Dominique also loves French cinema, and her job and studio allow her to combine her passion for design and the art of tattooing.

73

PRISCILIA

TATTOO ARTISTS

BEN *at*
HAND IN GLOVE
TATTOO *in Paris*

FABIEN *at*
HAND IN GLOVE
TATTOO *in Paris*

MATHIEU *at* **ZAZEN**
TATTOO *in Deuil-la-Barre*

Priscilia is fascinated by art and tattooing in particular. Carving her passions, feelings, and pet phrases into her skin is a way of presenting herself to others for this young rebel. Priscilia likes displaying her works of art, which are inspired by her unconditional love of music. She also has great admiration for the work of tattooists, who are true artists as far as she is concerned: Alix Ge, Kat Von D, Mikael de Poissy, and Raphael Trovato, to name but a few.

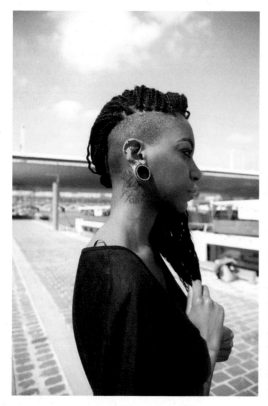

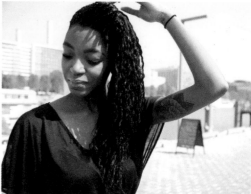

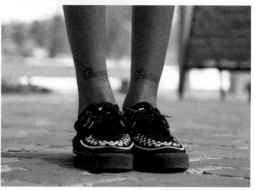

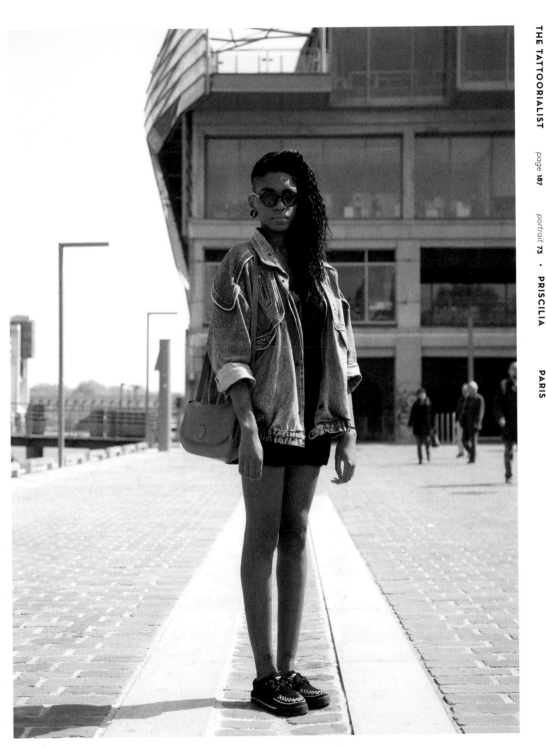

TATTOO ARTISTS

MIKE *at*
CHIALE BABY *in Lille*

KOADZN *at*
CHIALE BABY *in Lille*

BRUNO *at*
SORRY MAMA *in Lille*

JULIE

"I ran out of paper so I drew on my arm." Julie adopts a fun approach to tattooing. A fan of Steven Seagal and Jean-Pierre Madère, she got her first tattoo when she was 18, to "show off". Julie may be fascinated by the history of tattoos throughout the ages, but her own are purely aesthetic and were all done for fun: a very Sixties-style pink flamingo; a Mexican skull that she found in a book of illustrations and reworked with her tattooist; and a "PiM" dedicated to her grandparents.

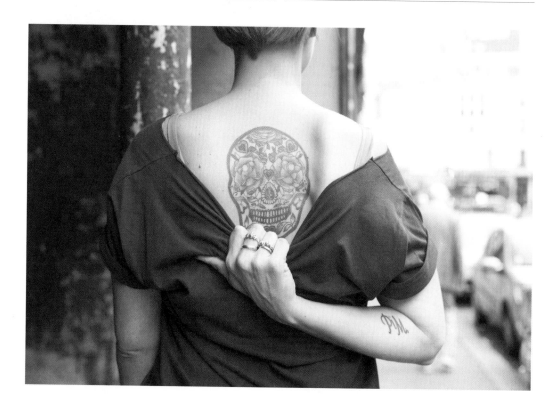

75

LOCATION
Place des Arts (Montreal)

MAÉVA

TATTOO ARTISTS

MOANA TATTOO
in Haute-Savoie

ARTRIBAL *in Lyon*

KAMALEON
in Lloret del Mar, Spain

**THOMAS
LEFEBVRE**
in Montreal

DODIE *at*
L'HEURE BLEUE
in Lyon

HERSELF

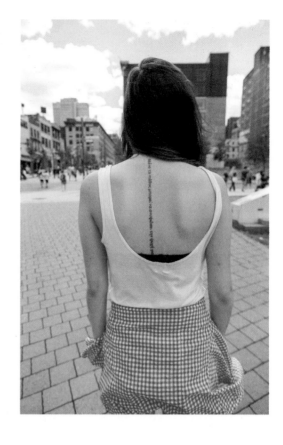

Tattoos are a form of expression which allow Maéva to exteriorize her thoughts and decorate her body as she sees fit. She immortalizes the periods in her life that she does not want to forget, whether good or bad. She chooses her tattooists on a whim, and entrusts them with her ideas unconditionally, as she did with Dodie, a tattooist who is now her favourite artist.

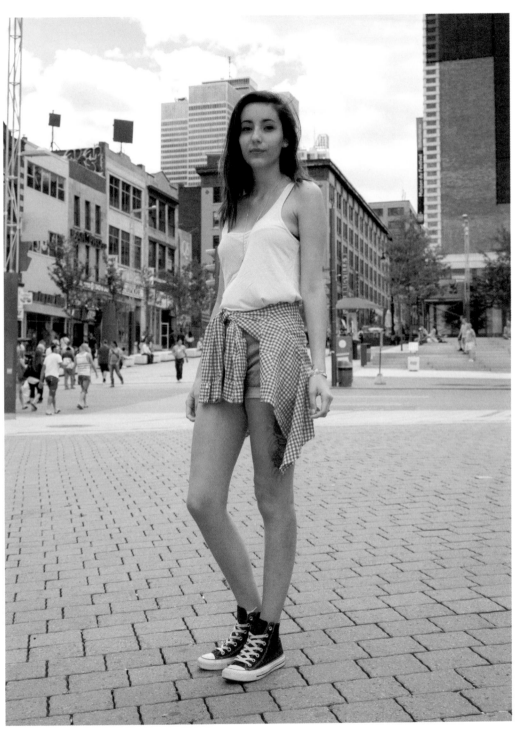

76

JIMMY, ROMAIN, & CHRISTOPHER

TATTOO ARTISTS

For Romain

J. JACK *at* **J. JACK
& BRUNO TATTOO**
in Poitiers

BRUNO *at* **J. JACK
& BRUNO TATTOO**
in Poitiers

KRISTOVUS *at*
OMBRE ET LUMIÈRE
in Niort

For Jimmy

JULIEN *at*
TATTOO SHOOT
in Niort

KRISTOVUS *at*
OMBRE ET LUMIÈRE
in Niort

DAF VADOR *at*
LA MAIN BLEUE
in Montmorillon

TWIX *at*
**FATLINE TATTOO
CLUB** *in Bordeaux*

FAT MANU
in Tours

For Christopher

KRISTOVUS *at*
OMBRE ET LUMIÈRE
in Niort

NORM WILL RISE
in Los Angeles

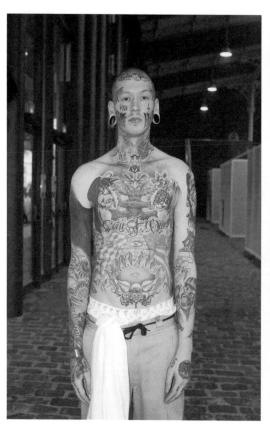
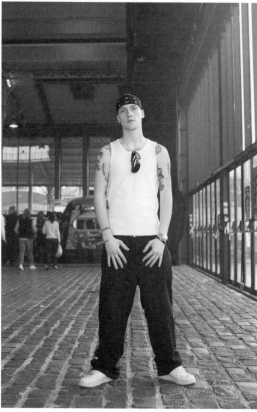

We came across Romain, Jimmy, and Christopher at the Mondial du Tatouage convention in La Villette, and you certainly can't miss them. These three terribly nice guys with tattoos are passionate about street culture in all its forms.

Romain was fascinated by ink from a very young age, and soon immersed himself in the American rap culture of the 1990s, which is reflected in his dress code and tattoos. He sees the customization of his body as a way of asserting himself and moving on with his life. Inspired by hip-hop and graffiti art, Romain got his first tattoo when he was 18 as a way of standing out from the crowd and inking the things he likes on his skin. Tattooing is an art form that deserves respect, producing "that strange sickly sensation which then gives way to great satisfaction."

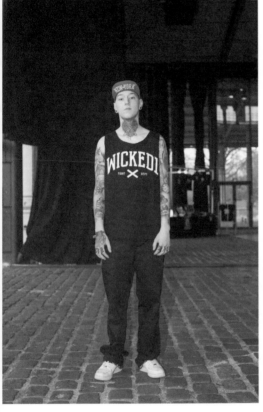

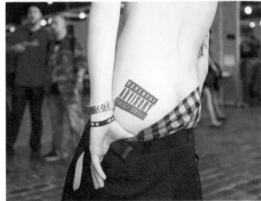

Jimmy's desire to get tattoos derives from extreme sport which he has been crazy about since childhood. He likes to customize everything he touches, and his body is the living proof. Jimmy draws his inspiration from street culture, with its graffiti, hip-hop, and skateboarding, and writes his passions and his own story onto his body. For him, tattoos are "an aesthetic and philosophical art form" through which he expresses himself.

What Christopher likes about tattoos is the culture of Chicano gangs. He is motivated by the idea of carving memories in his skin, the prime drivers of life and freedom. His tattoos represent close moments among friends, his love of pirate culture, and his own way of living life to the full.

77

LOCATION
at the Divan du Monde concert space (Paris)

LOUIS

TATTOO ARTISTS

SUZANN GRIMM
in Lille

THOMAS HOOPER
at **SAVED TATTOO**
in New York

BAILEY HUNTER ROBINSON
in Brooklyn

HORIZAKURA *of* **THE HORITOSHI TATTOO FAMILY**
in Japan

BRUCE BODKIN *at* **BODKIN TATTOO**
in Montreal

The first thing we noticed about Louis was his amazing voice. A writer, composer, and performer in various groups – and most importantly, a passionate person in general – he always wanted to get a tattoo. This gentle dreamer who would love to buy a zoo was envious of the "highly-decorated animals", so he got his first tattoos at a very early age, as a way of remembering good and bad moments in his life, not forgetting anything, and being able to tell great stories to his grandchildren. Louis loves the indelible nature of tattoos "in this world of built-in obsolescence", and has them done out of a purely aesthetic desire not to be monochrome.

His sources of inspiration come from traditional American tattoo art, as well as the European traditions of prison inmates and sailors. He actually did his first tattoos himself at the age of 17, using a sewing needle and Indian ink. Yet now he is conscious of the fact that it is still "quite a brutal art form that should not be entrusted to just anyone." His tattoos include: many animals, like the toucan inspired by the one he saw in Saint Louis Zoo in Missouri; memories of trips and meetings; and pieces dedicated to his parents, brothers, and pals. His dream is to keep on covering himself with other animals, such as a fox, bison, bear, and stag!

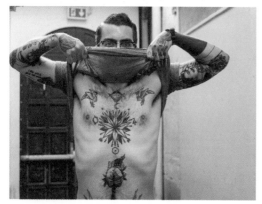

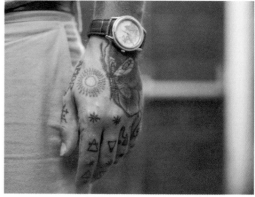

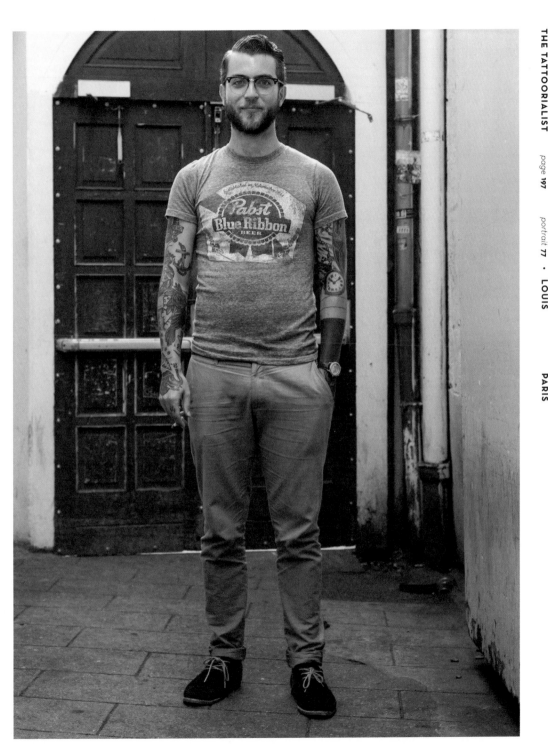

ARNOLD & CAPUCINE

TATTOO ARTISTS

For Arnold

LOÏC *at*
BLINDESIGN
in Grandson, Switzerland

JESSYINK *at*
TINTA TATTOO
in Strasbourg

AT M'AIME LA PEAU
in Noisy-le-Grand

For Capucine

STEFF8 *on the road*

**SEBASTIAN
BRIGHTBLACK**
at **MIKADO
TATOUAGES**
in Nantes

LAURENT ZTATTOO
at **L'ENCRE NOIRE**
in Aix-en-Provence

LAURINK *in Saint-Denis*

SEB *at*
TATTOO ATTITUDE
in Gap

KIM ZOO *in Paris*

Capucine and Arnold share an absolute passion for photography, and both took the initial plunge into tattooing at very early ages: 14 and 12 respectively.

An epicurian with a profound view of the world, Arnold's tattoos have meaning and aesthetic interest, so that he will not forget key moments. He does not have one particular style, as he likes to take a close look at all the latest trends in tattooing when he has an idea in his head that he wants to illustrate. At the moment the most important thing for him is to "keep some space" for the years and events still to come.

For Capucine tattoos are "a way of wearing the art in your soul on the skin". She doesn't have any particular source of inspiration, other than the artists she admires, such as Robert Doisneau and Edgar Allan Poe. When she has an idea, she works on it and realizes it with her tattooist. The magic word for her tattoos is always symmetry, a real obsession of Capucine's. When she "inks" her memories onto her body, she is mesmerized by the needles making contact with her skin and the pain it produces.

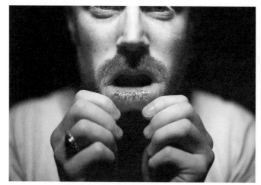
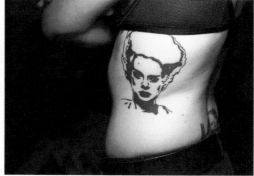

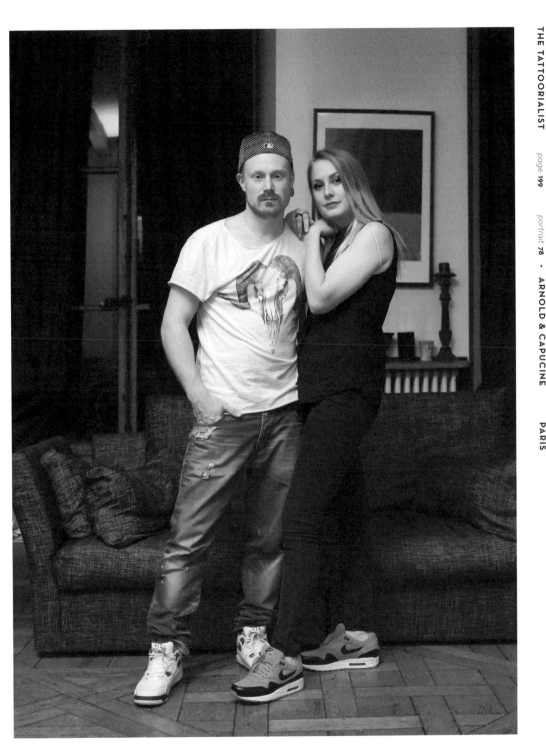

JON

TATTOO ARTISTS

ISSA *at*
TIN-TIN TATOUAGES
in Paris (p.239)

DAN SANTORO *at*
TATTOO PARLOR
SMITH *in Brooklyn*

SM BOUSILLE *at*
LE SPHINX *in Paris*

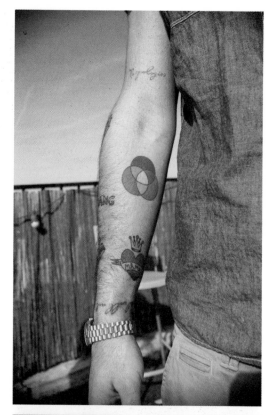

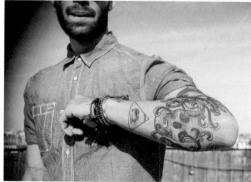

Jon is an all-round, resourceful adventurer with several lives and jobs. Tattooing allows him to slow down the pace of his life by making him "lay down a lasting marker in this age of zapping". Jon does not sleep much, as he is constantly travelling and setting up projects; he is not short of inspiration, which is obvious from his tattoos.

LOCATION
rue Sainte-Anne (Paris)

LILOU & PHILIPPE

TATTOO ARTISTS

For Lilou

"It's a secret..."

For Philippe

MYLOOZ *at*
TATTOOED LADY
in Montreuil

Philippe and Lilou are sensitive about their image and appreciate aesthetic quality, using their tattoos to distinguish themselves from others. Both unique and personal, they see tattoos as a way of carving the story of their lives permanently in their skin.

Lilou, a photo stylist and blogger, immortalizes the key moments of her life in tattoos. Inspired by her Asian origins and the few years she spent in California, she treats her body playfully, regarding it as a personal work of art that has been constantly evolving since she was 18. She has one rule: each illustration, in such a variety of different styles, is located above her legs. In time she will be able to illustrate her life experiences through this human fresco, and tell her story to her grandchildren. To date, her body is decorated with seven tales and short stories.

Philippe, an enthusiastic photographer, has been attracted to tattoos since he was a little boy. After days on end spent drawing crosses on his arms, he went on to the real thing and treated himself to his first tattoo at the age of 21. It is a way for him to choose who he is and to customize his body in a timeless way. Deep down he is a pragmatist who defines tattooing in universal terms, describing it as "an injection of ink under the skin, which may or may not have meaning, but is definitely aesthetic." It is an intensely personal act "owned" by each individual. His favourite one is the camera on the inside of his left arm, next to his heart. In years to come his children will laugh at his rather old-fashioned tattoos, and already that brings a smile to his face.

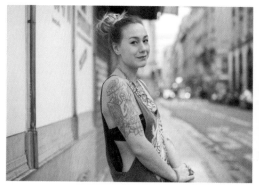
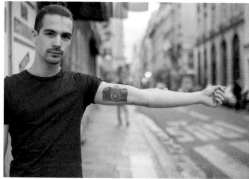

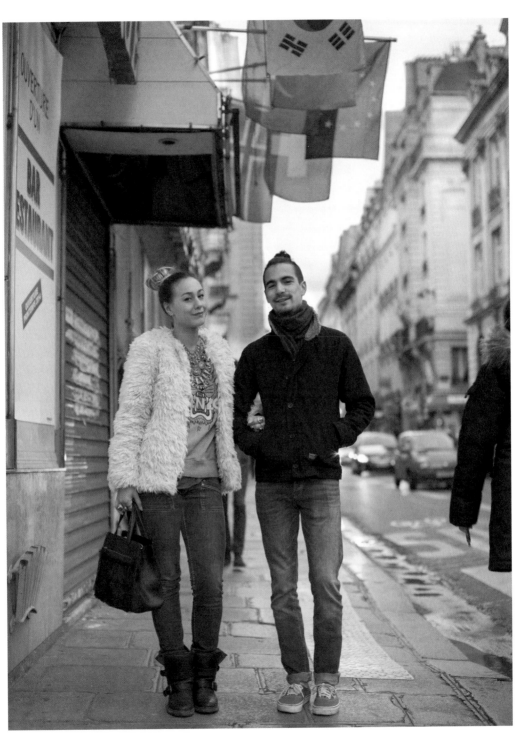

LOCATION
avenue Duluth East (Montreal)

ÉLODIE

TATTOO ARTISTS

ARNO *at*
PSC TATTOO
in Montreal

GREG LARAIGNÉ *at*
IMAGO TATTOO
in Montreal

LAURA SATANA *at*
EXXXOTIC TATTOO
in Paris

JEE SAYALERO
at **HUMANFLY**
TATTOO STUDIO
in Madrid

WILL *at*
PSC TATTOO
in Montreal

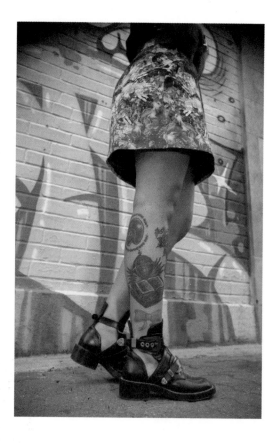

Based in Montreal, Élodie is a journalist and blogger who had dreamed of getting a tattoo since childhood. Inspired by images of the 1980s and 1990s, she admits to a strange passion for pistols and roses, and even did her first sketch in blue pen on her arm when she was 5 years old. Élodie was bound to get a tattoo one day, no doubt about that!

She had her first tattoo done a few months before her eighteenth birthday, to carve into her skin the lessons life had already taught her and that she did not want to forget. She likes the idea of permanently marking her body with her personal stories and mantras, as if writing an autobiography.

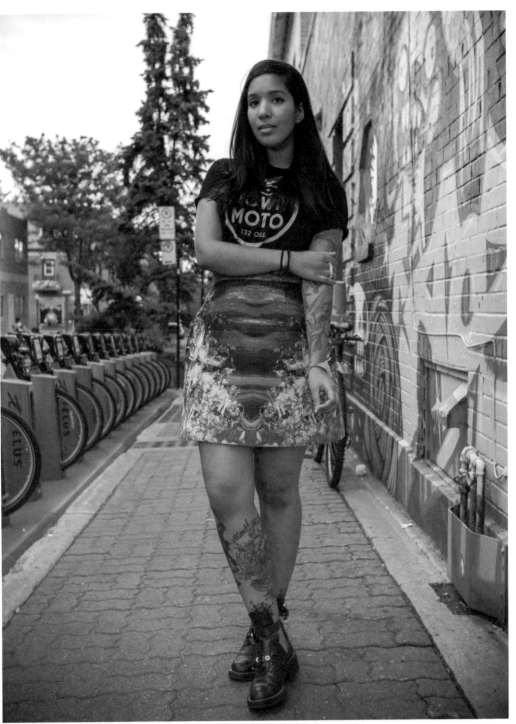

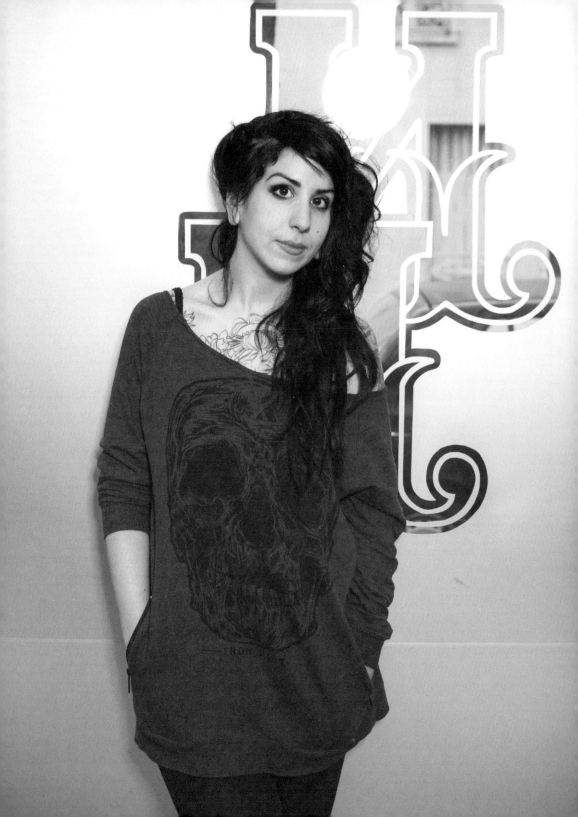

PORTRAIT

82

LOCATION
in the Nuevo Mundo studio (Bagnolet)

TATTOO ARTIST

AMY MYMOUSE

TATTOOED BY

ALIX GE *at* **681 TATTOO** *in Lyon*

MISTER P
in Brussels

ALEX WUILLOT *at*
LA MAIN BLEUE
in Mons, Belgium

OLIVIER *at*
GLAMORT TATTOO PARLOR
in Montreal

CHRISTINE *at*
GLORIOUS INK
in Berlin

JIMMY LAJNEN
at **FISHEYE INK**
in Sweden

PAULINE TABUR *at*
NUEVO MUNDO
in Bagnolet

Amy MyMouse – her tattooist name – wanted to become a tattooist for love of the art form as well as for the special relationship connecting the client and tattoo artist. She is an accomplished artist in her own right, steeped in the various artistic worlds of illustration and cartoons, including the work of Alessandro Barbucci and Didier Crisse, the strange world of Miyazaki, of which she is a huge fan of, not to mention the paintings of Rossetti, Botticelli, and Delacroix.

Amy MyMouse proudly imagines that through her creations, part of her is on a little journey around the world. On the other hand, getting a tattoo is intimately linked for her with the desire to own a work of art which she will always have and be able to carry with her anywhere. Her tattoos are the product of an impulse that is both artistic and human. She needs to really love the work of the artist who is tattooing her.

83

MARKUS & ANNA

TATTOO ARTISTS

For Markus

LUDO *at*
ART CORPUS
in Paris

DAVID *at*
ART CORPUS
in Paris

For Anna

DAVID *at*
**WATERPROOF
TATTOOS**
in Örebro, Sweden

LUDO *in*
ART CORPUS
in Paris

PAT *at*
ART CORPUS
in Paris

DAVID *at*
ART CORPUS
in Paris

Markus and Anna are a couple for whom tattoos are both a passion and a way of life. Whether for aesthetic reasons or to tell a partial story of their lives, they like to cover their skins with the work of artists they appreciate.

Anna fell in love with tattoo culture when she was a teenager. Fascinated by tattoo artists, she delved deep into all the magazines and books she could find. She took the plunge the day after her eighteenth birthday. Her tattoos are now her private diary, and her many influences give her a regular supply of new entries: the music of Patti Smith, Monet's paintings, or simply the people around her. A tattoo for her is primarily a piece of art, part of herself which may or may not have significant meaning.

For Markus, tattoos act as an outlet for his defiant personality, as well as complementing it. He believes that tattooing is an art form unique to each individual, which can be used to convey a particular message, such as a feeling, experience or event. The aesthetic side is also a driving force for Markus, who enjoys entrusting his skin to the artists he likes. When he gets a tattoo, he goes for what inspires him at the time, from Mark Ryden's paintings to the work of Liam Sparkes, who does "patches" he adores - small pieces that complement each other, though not necessarily in terms of structure.

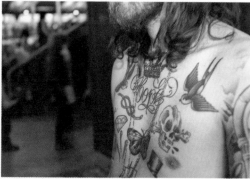

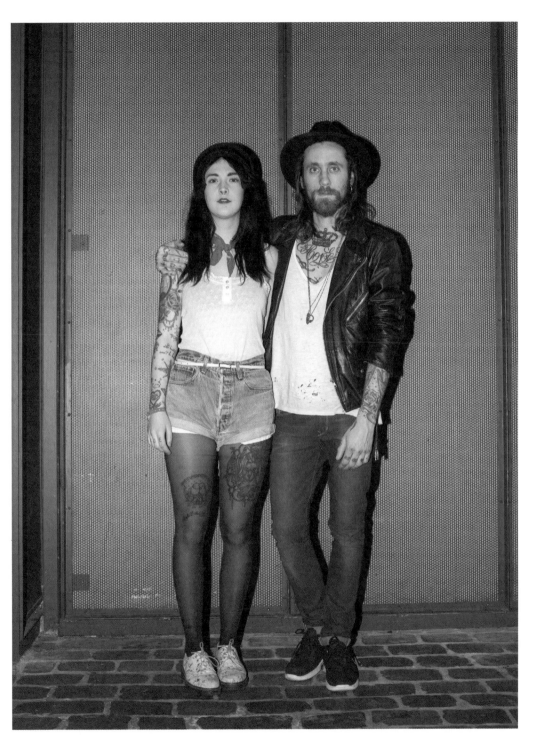

LOCATION
rue de Venise (Paris)

JULIETTE

TATTOO ARTISTS

TRICKY NICO *at*
ANOMALY
in Paris

TRIPLE STARS
in Paris

FAT CAPS
in Caen

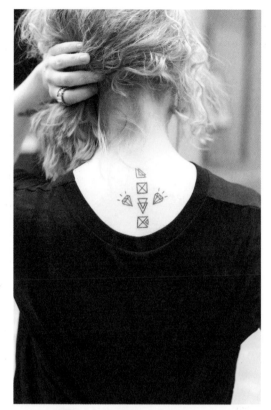

Juliette was talked into getting her first tattoo by a close friend.
She has always found it a beautiful and expressive art form
that allows her to do what she likes with her body. She shares
messages and symbols with the person who sees and interprets
her tattoo, but she is the only one who can understand its
meaning, aided and abetted by her tattooists.

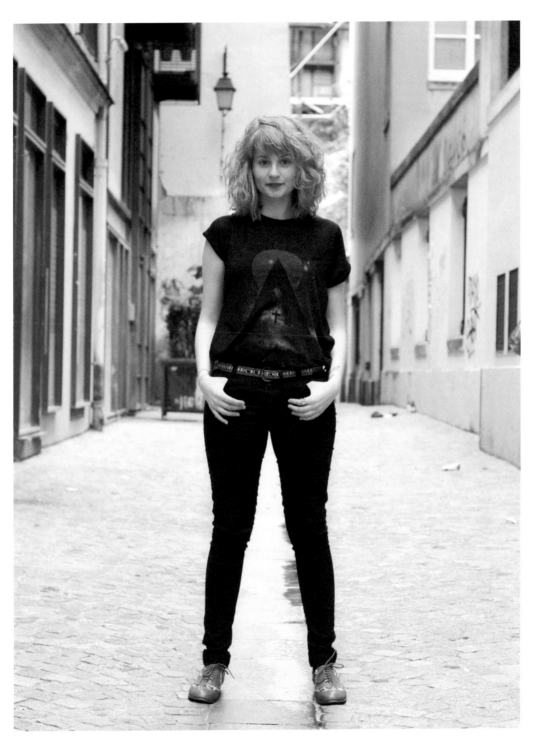

CHLOÉ

TATTOO ARTISTS

ROMAIN *at*
TIN-TIN
TATOUAGES *in Paris*

KURV *at* **LA MAISON**
DES TANNEURS
in Paris

NY ADORNED
in New York

TINE DEFIORE
at **METAMORPH**
TATTOO *in Chicago*

DARA *at*
TRIBAL ACT
In Paris

Chloé got her first tattoo when she was 15 years old, with the help of her grandmother. She felt the need to transform her body and turn it into a space where she can draw what she wants to remember, such as a journey, a relationship, or an event. It was the permanent nature of the ink that appealed to Chloé right from the start. The inspiration for her tattoos comes from an illustration, a particular typeface, or anything that arouses an emotion in her. Sometimes she becomes absorbed in the work of her favourite artists, William Eggleston, Diane Arbus, or Edward Hopper.

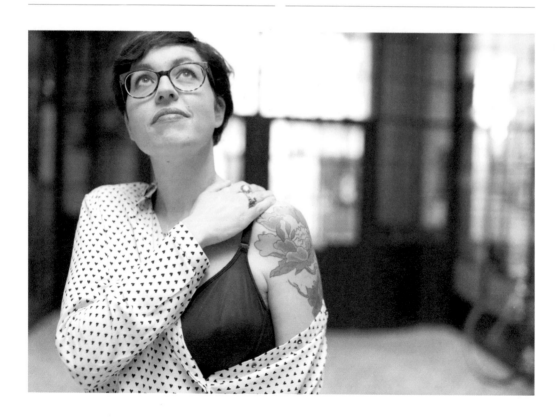

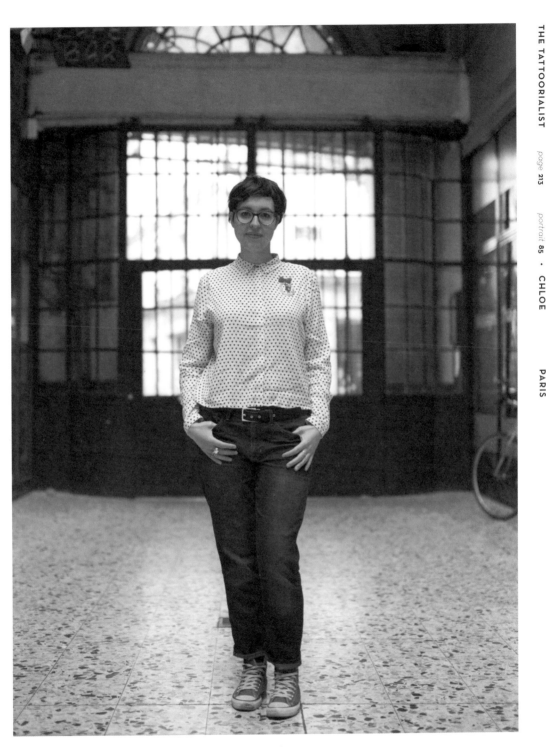

LOCATION
in a hotel at Neuilly-sur-Seine

COLINE

Coline was never really surrounded by people with tattoos, but she was attracted by their world, and took the plunge when she reached legal age. Since then she has had a tattoo done every year, unable to stop. What she likes most about tattoos is that they are aesthetic and indelible. Her tattoos define her character and act as her preferred form of expression.

The designs for her pieces come from the world of plants, sketches she did many years earlier, ancient objects, etc. Coline gets an idea and lets it mature, arranges a studio appointment, then leaves it up to the tattooist to create her tattoo. "You can be a very respectable housewife, who makes pancakes on Sunday and also has tattoos."

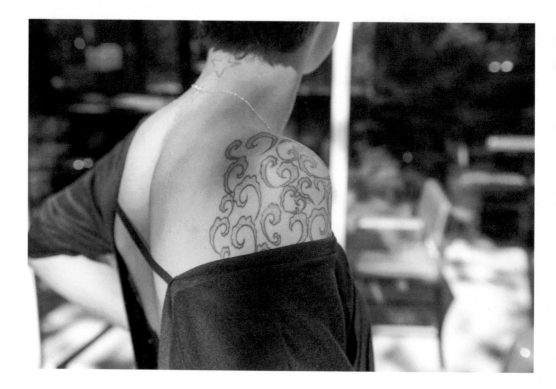

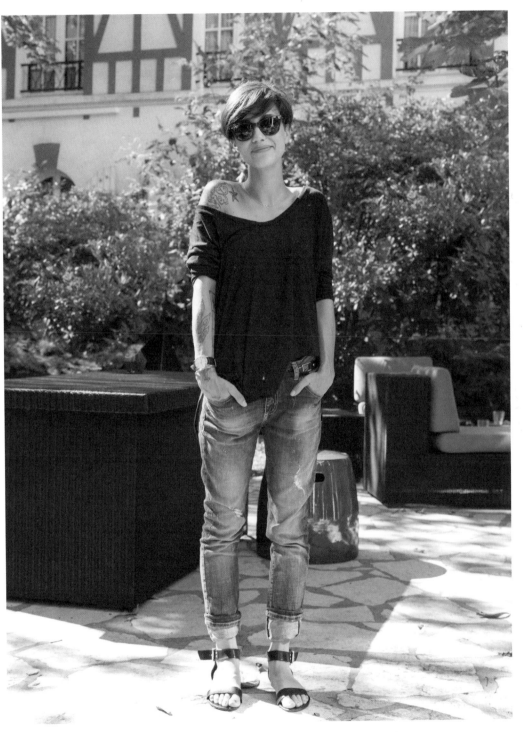

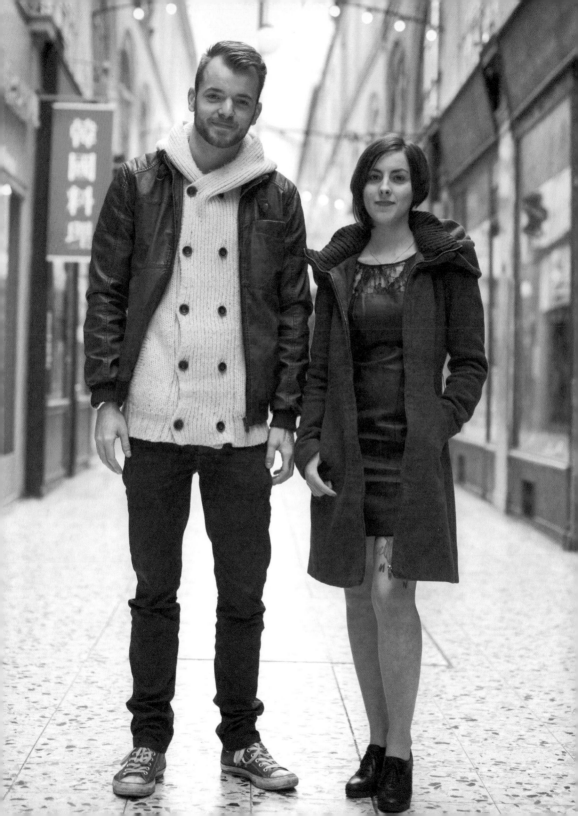

PORTRAIT

87

LOCATION
passage Choiseul (Paris)

TATTOO ARTISTS

MARC & MAÉVA

TATTOOED BY

For Marc

HIMSELF

For Maéva

MARC, HER FIANCÉ

In opening their own studio, Winchester's Tattoo Shop in Valenciennes, Marc and Maéva were fulfilling their dream of "painting people", a reference to Claude Lévi-Strauss's quote: "It was necessary to be painted in order to be a man: anyone who remained in a natural state was not differentiated from the savage".
Marc started getting tattoos when he was 17, because he actually wanted to become one of the various art forms he comes across on a daily basis. Every one of his many tattoos means something: a reference to a significant event, like the 23 on his finger (the date of his engagement); or a black bird (a reference to

"The Raven", the Edgar Allan Poe poem that changed his life). Marc draws his inspiration from the work of Tim Burton and Glenn Arthur, and especially from everyday life.
Maéva sees tattoos as a form of personal reflection, on what she has experienced as well as what she will experience in future (the 5 on her neck is her lucky number). According to her, it is a timeless act that demonstrates a person's sincerity – what's more, her own tattoos are arranged in a dialogue with Marc's. Anything can provide inspiration. Tattoos are a kind of thirst for freedom and knowledge for this young woman who dreams of going on a trip around the world.

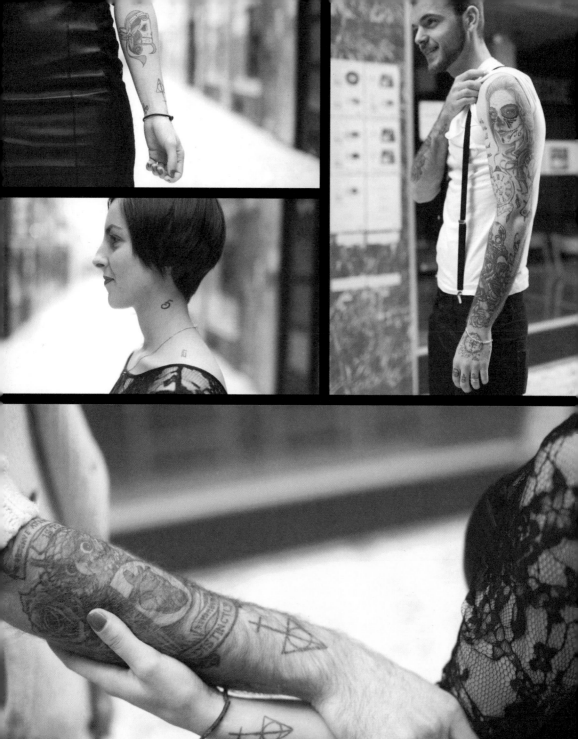

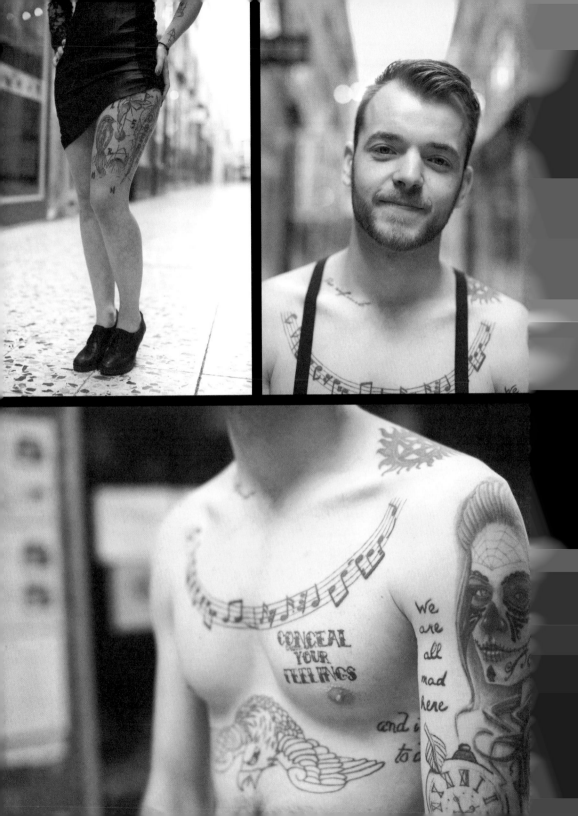

88

TATTOOISTS
SUSANNE KÖNIG
in Stuttgart, Germany

ANDI
in Enz, Germany

CHRISTIAN

We met up with Christian at Bread and Butter, a fashion trade show that took place in a restored former airport. He is a weirdly fascinating guy with the distinctive beard of the circles he moves in. A professional photographer with an offbeat sense of humour who collects spectacles, Christian got tattoos because he finds the process and result very cool. They make him feel more special.

His inspiration comes from his past and his daily impressions. Some of his tattoos are associated with his family, like his parents' favourite pet, and a doodle of his brother when he was 5 years old.

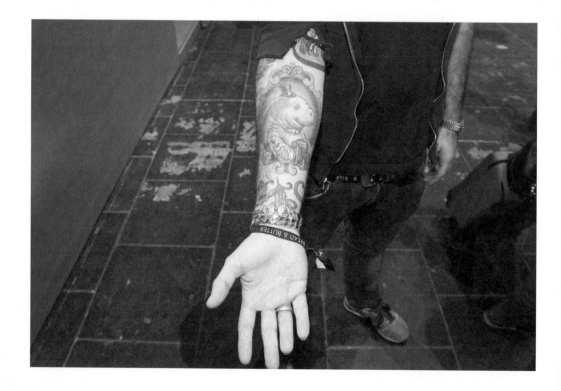

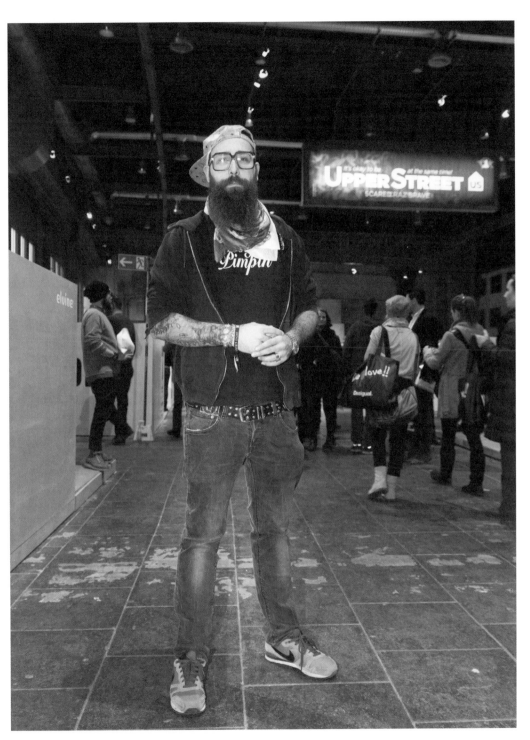

TATTOO ARTIST
ROMANO *at*
VELVET STUDIO
in Grenoble

AUDREY

Through her work as an artistic director and model, Audrey moves within a creative world where tattoos have a definite role to play. She sees the body as a delicate and evolving structure which each individual gives to a tattooist to express his or her creativity. Audrey has a special interest in different tattooing techniques, as well as in the symbolism of the tattoos chosen by each person to be inked on his or her skin, like a diary that is (sort of) private. Tattoos are a way of telling your own story metaphorically, making yourself beautiful, and giving some meaning to your life.

For her tattoos, Audrey is inspired by old engravings, religious iconography, classical painting, and Asian art.

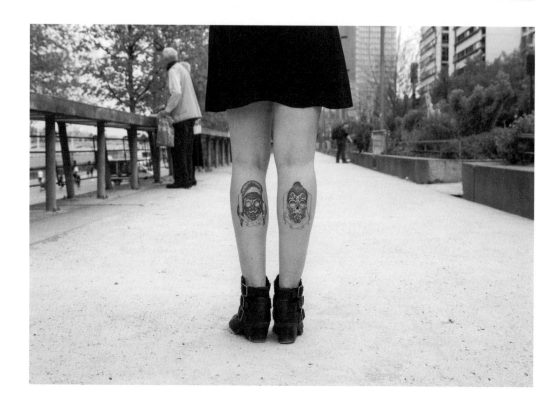

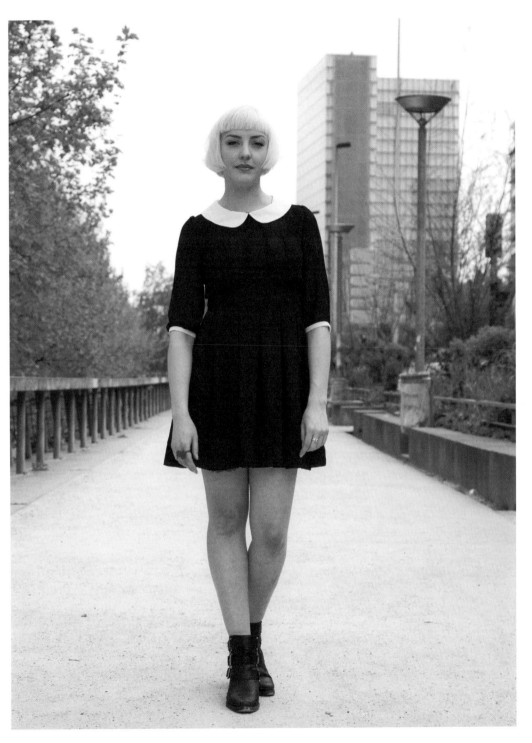

PORTRAIT

90

LOCATION
in front of the Louvre (Paris)

VICTORIA

TATTOO ARTISTS

LOU *at*
LOUTATTOO
in Clamart

FRED *at*
TRIBAL ACT *in Paris*

HUGO *at*
HAND IN GLOVE
TATTOO *in Paris*

GORAN IVIC *at*
ANOMALY *in Paris*

INKKO *at*
EAD TATTOO *in Paris*

Victoria is multi-talented: as a drummer, DJ, model, and TV casting director, she is fully engaged in the art scene. Steeped in a musical environment, she felt the urge to get a tattoo as soon as she discovered tattoo culture. There were powerful moments in Victoria's life that she wanted to relate and etch firmly in her memory, so tattoos were the obvious solution: "a beautiful protective shell" which she gradually constructed to match her personality. For Victoria, tattoos are a form of therapy under the guise of rock'n'roll.

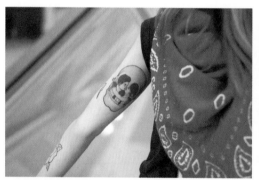

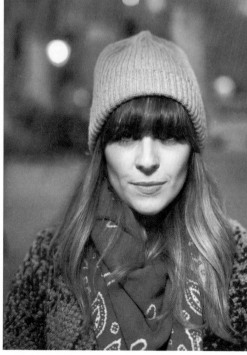

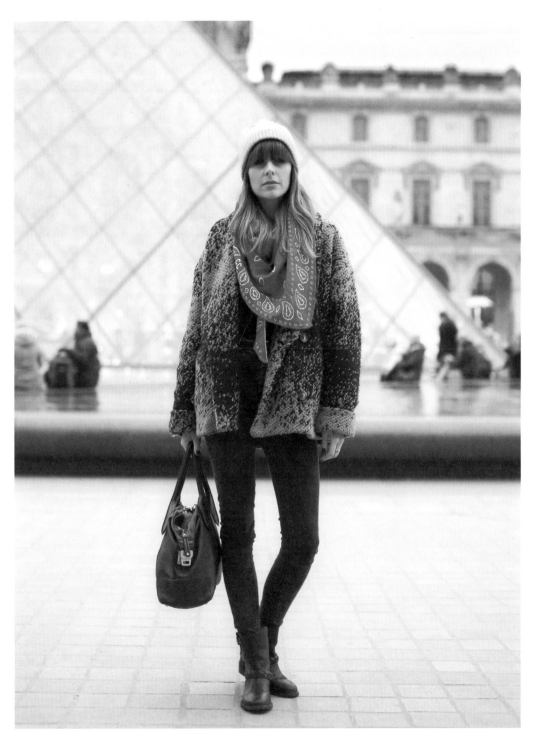

LOCATION
rue d'Argoult (Paris)

CHARLINE

TATTOO ARTISTS

IRON AND DREAM
in Reims

DESIGN ART
in Chaumont

ABRAXAS
in Chaumont

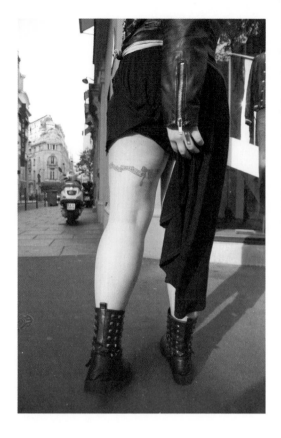

Tattoos are not a trivial matter for Charline. They have always been synonymous with being unhappy with the people around her. After much hesitation, she took the plunge when she was 20, then a few years later she went on to get five more tattoos in the space of just one year. Despite family arguments about it, Charline feels the urge to carve important moments in her life in her skin for ever, and to exteriorize who she is, what she has experienced, and what she feels. Her inspiration springs from her own imagination, her experiences, and the work of her favourite artists, Mark Ryden, and Tara McPherson.

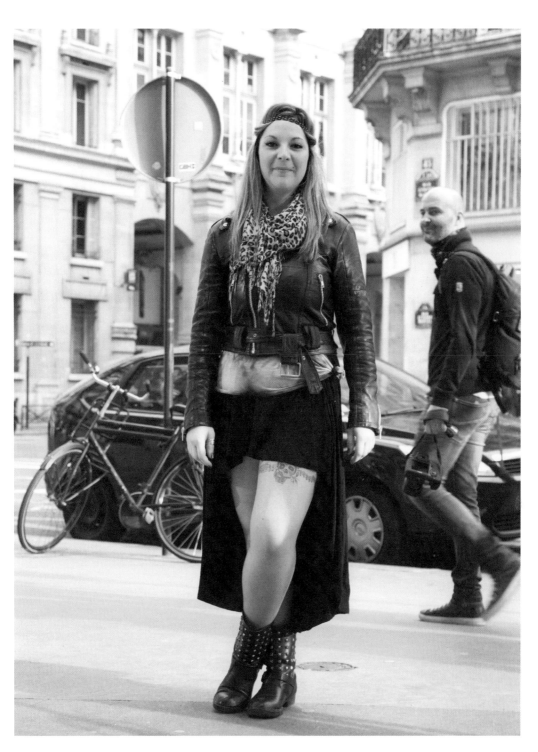

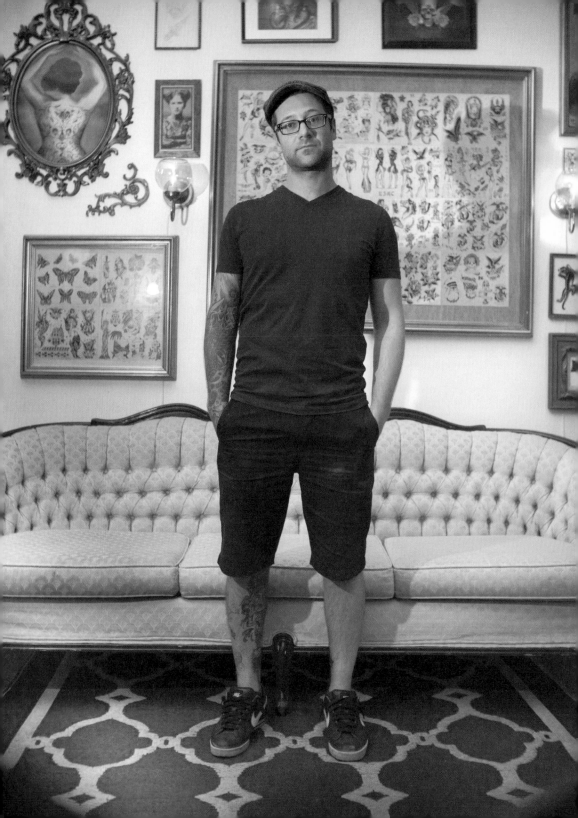

PORTRAIT

92

LOCATION
at Bodkin Tattoo, rue Bernard Ouest (Montreal)

TATTOO ARTIST

DAVID CHOQUETTE

TATTOOED BY

NAT JEAN *at* **IMAGO TATTOO**
in Montreal

POL TATTOO *in Montreal*

DAVID KNIGHT

For David, tattoos are associated with the present day: living for the moment, creating and wearing more and more visual images and designs, like a form of entertainment. A tattooist at Bodkin Tattoo, David is inspired in his everyday work by engravings, comics, the paintings of Gustav Klimt, and old illustrations. His own tattoos, which he had done because he thought it "very classy", are often associated with amusing anecdotes.

TATTOO ARTISTS

NICK BERTIOLI
at **MTL TATTOO**
in Montreal

MIMI *and* **THOMAS**
at **TIN-TIN**
TATOUAGES *in Paris*

JUNIOR

Leading a life on the move – in between tours and producing his own album – Junior feels the need to mark the moments in his life so that he will never forget who he is, where he comes from, and where he is going. A talented musician, he goes with the flow of his inspirations at the time to find ideas for his tattoos: the art deco tiles in a hotel shower in Prague; the logo of his first band; the work of his favourite artists, such as Dalí, Magritte, Led Zeppelin, and Mucha.

Junior sees tattoos as decorative pieces for transforming his body ("the ideal medium") into a work of art. Each of his tattoos was done by a tattooist friend and ties in with one of his tours with various bands.

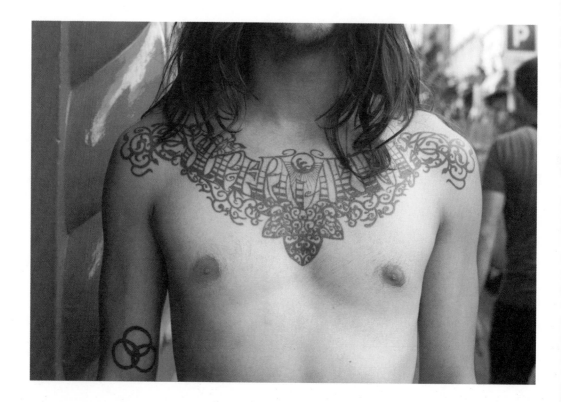

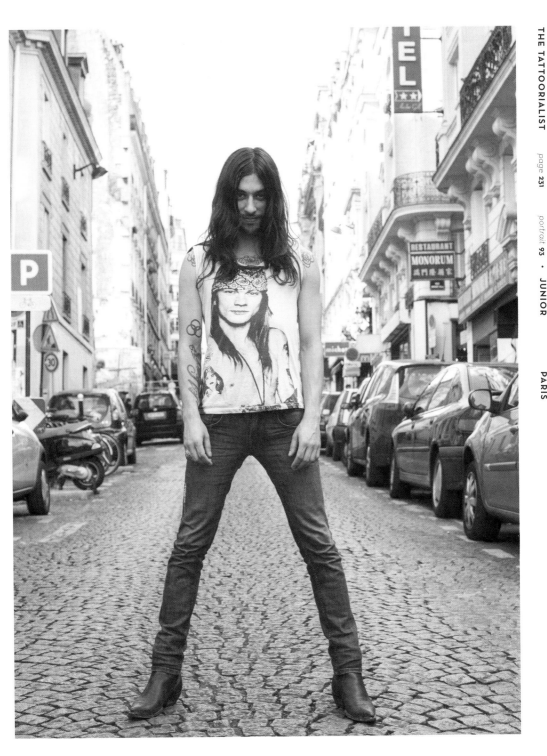

94

AURÉLIEN

TATTOO ARTISTS

RUDE WATERZOÏ
at **23 KELLER** *in Paris*

CÉCILE PAGÈS
in Geneva

KIM *at*
SALON SERPENT
in Amsterdam

FLORIAN SANTUS
in Paris

CHICHO *at* **TIGRE
TATTOO PARLOUR**
in Copenhagen

**ALESSIO
PARIGGIANO** *in Paris*

FAT MANU
in Tours

ALIX GE *at*
681 TATTOO
in Lyon

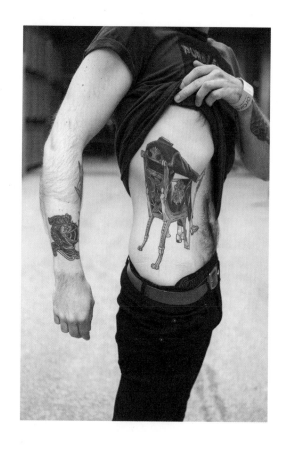

Aurélien is required to wear a standard black uniform conveying sadness for his day job, but this does not reflect his own personality. Having his tattoos hidden under his funeral outfit means that he can carry his own personal art gallery around with him. A collector of beautiful pieces, Aurélien draws his inspiration from romanticism, the punk cinema of John Waters, the Vanities, Wim Delvoye, and early 20th century freak shows and circuses. His take on tattoos? "They sting, but they're great!"

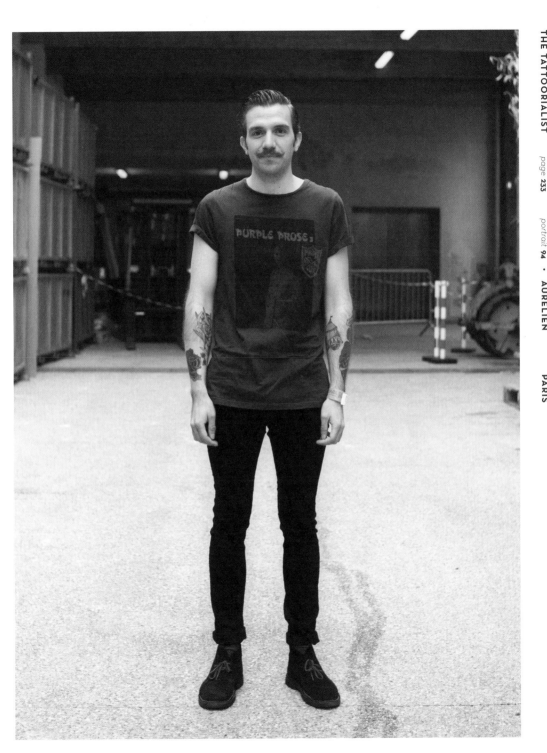

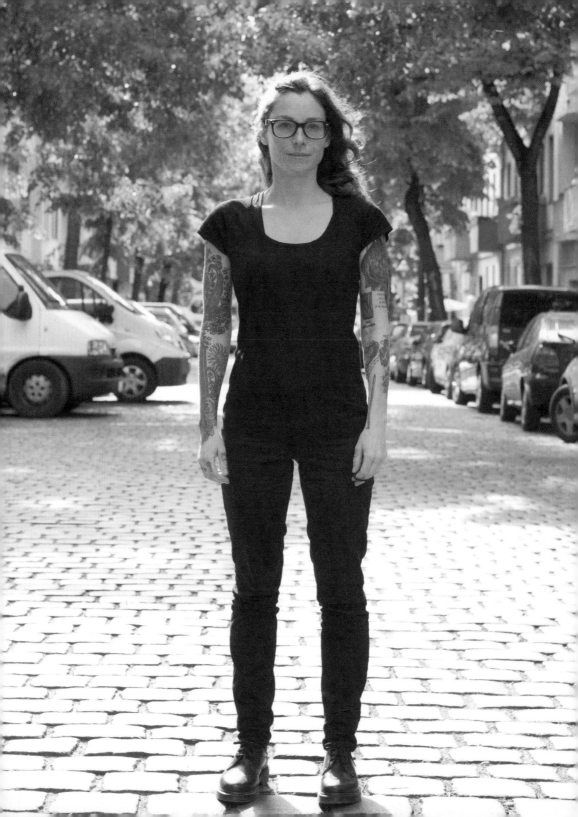

PORTRAIT

95

LOCATION
AKA, Pflügerstrasse (Berlin)

TATTOO ARTIST

MADAME CHÄN

TATTOOED BY

PHILIPPE FERNANDEZ
at **AKA** *in Berlin (p.75)*

GUY LE TATTOOER
on the road

SARA ROSENBAUM *in Berlin*

LÉA NAHON *at*
LA BOUCHERIE MODERNE
in Brussels

L'ANDRO GYNETTE *at*
DEUIL MERVEILLEUX
in Brussels

LIONEL FAHY *at*
OUT OF STEP
in Nantes

MARTIN JAHN
at **AKA** *in Berlin (p.103)*

A consummate artist who plies her trade between Brussels, Berlin, New York, and London, Madame Chän draws inspiration from graphic design and street art. She loves tattooing for its beauty as an art form and for the people she has met during her career, those she has liked and those who have tattooed her. She makes a clear distinction between the two processes: doing and getting a tattoo, putting things on another person's body and agreeing to get a new design inked on your own.

96

LOCATION
in a hotel, avenue de Friedland (Paris)

BIBIANA

TATTOO ARTIST
WALTER HEGO *at*
L'ENCRERIE *in Paris*

Bibiana sees her tattoos as an intimate diary. She is very fond of every one. A big fan of precious stones, spirituality, and mandalas, this jewellery designer is fascinated by the messages that can be conveyed through this unique art form. Bibiana has a total disregard for aestheticism: what she really values is the ability to carry very personal messages around with her throughout her life, on her skin.

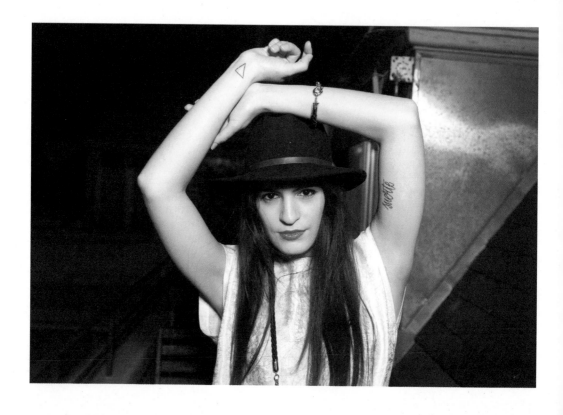

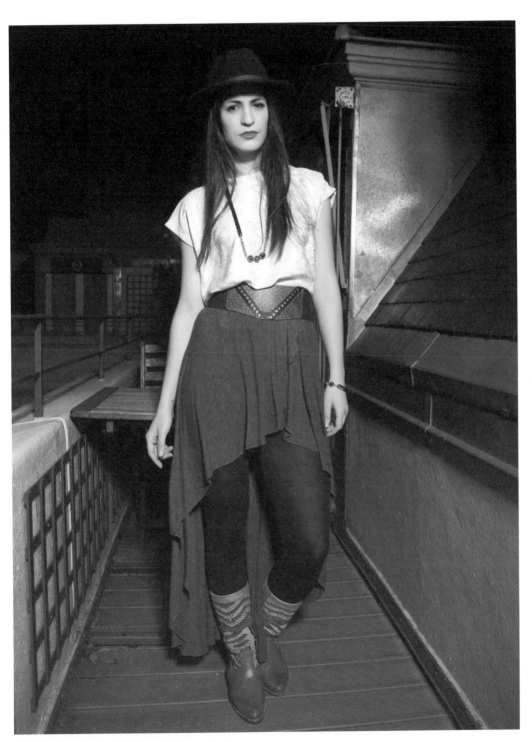

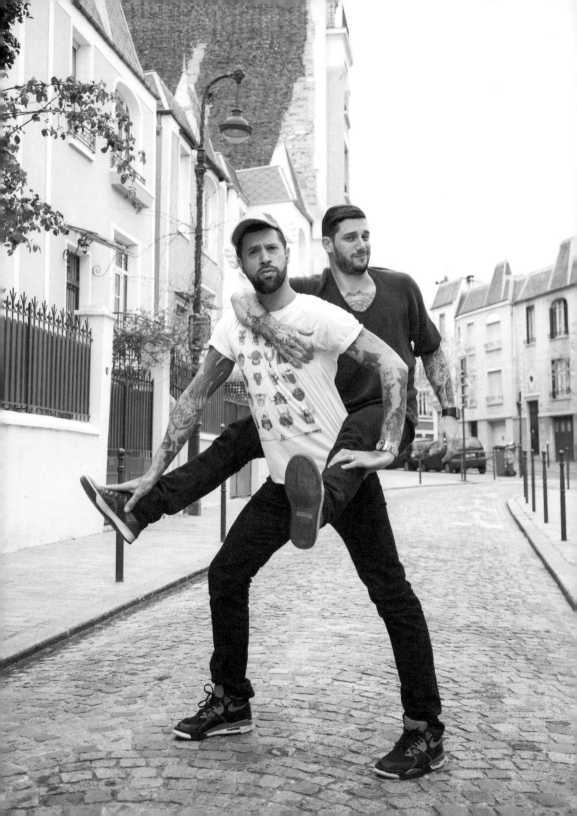

PORTRAIT

97

LOCATION
rue Dieulafoy (Paris)

TATTOO ARTISTS

ISSA & THIERRY

TATTOOED BY

For Issa

TIN-TIN *at*
TIN-TIN TATOUAGES *in Paris*

BLAISE *at*
TIN-TIN TATOUAGES *in Paris*

SACHA *at* **EASY SACHA**
in Paris

LÉA NAHON *at*
LA BOUCHERIE MODERNE
in Brussels

HORIZARU
in Japan

For Thierry

ISSA *at*
TIN-TIN TATOUAGES *in Paris*

LÉA NAHON *at*
LA BOUCHERIE MODERNE
in Brussels

MAUD DARDEAU *at*
TIN-TIN TATOUAGES *in Paris*

TIN-TIN *at*
TIN-TIN TATOUAGES *in Paris*

HORIZARU
in Japan

JONDIX
in Barcelona

Issa and Thierry share a love of tattoos and manga. Issy thinks of himself as a combination of Sailor Moon and George Michael, while Thierry cannot survive without his video games. Issa is about to fulfill his dream of opening his own exclusive studio. He loves this job more than anything, and creates designs tailored to his clients. Issa has a great talent for designs based on Japanese animation, manga, and unusual people. For him, tattoos are "an illustration of the costume of the soul". For Thierry tattoos were a way of marginalizing himself and having a different body. He is fascinated by the world of tattoos as a whole and the work of tattooists, especially that of his partner.

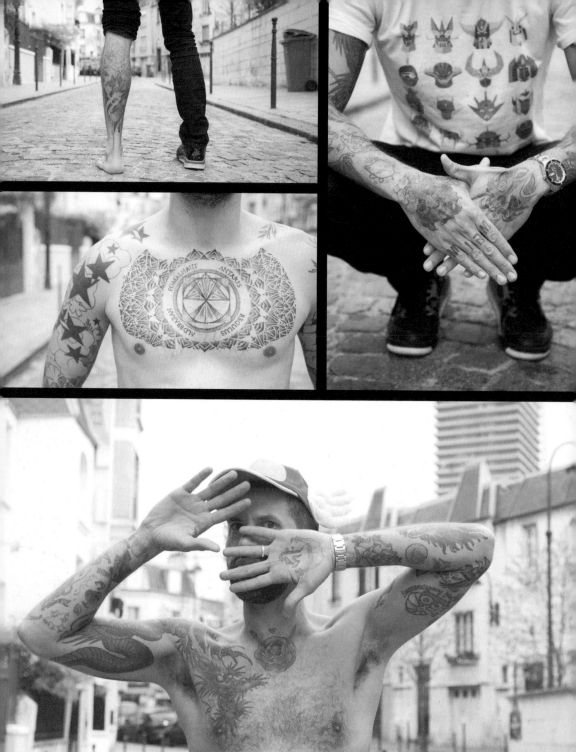

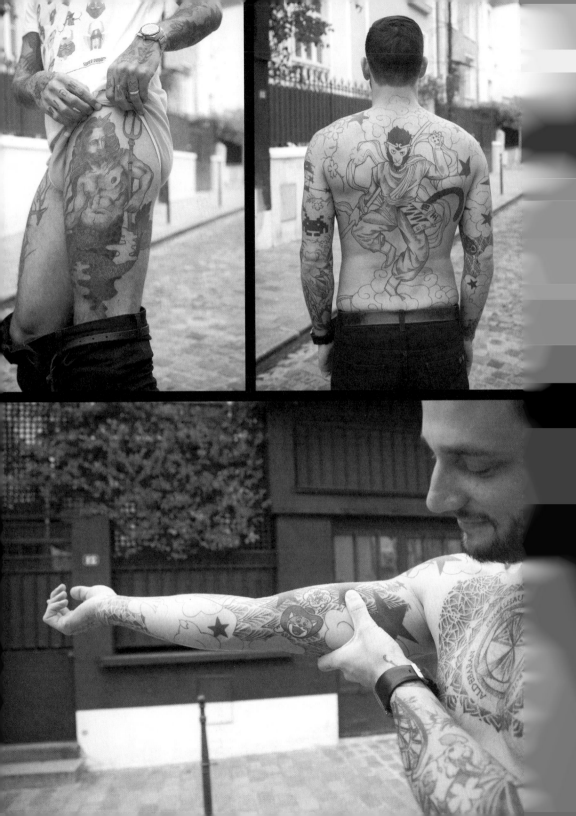

98

PATRICK

TATTOO ARTISTS

"Unknown tattooists who prefer to stay in the shadows..."

Patrick got a taste for tattooing quite recently. He had his first tattoo done "to fit in", but he has every intention of getting more. Fascinated by the relationship of trust he has with the tattooist, he likes the idea of artists leaving their mark on his own story by inking him for life.

A musician, Patrick is heavily into comics, sport, and wandering around Paris. He gets his inspiration for tattoos from everything around him; the plan is for them to cover his arms, in a metaphorical representation of the balance between life and death. For Patrick, a tattoo is a very personal thing, which he often associates with African tribes that tattoo their children at birth or to mark a rite of passage.

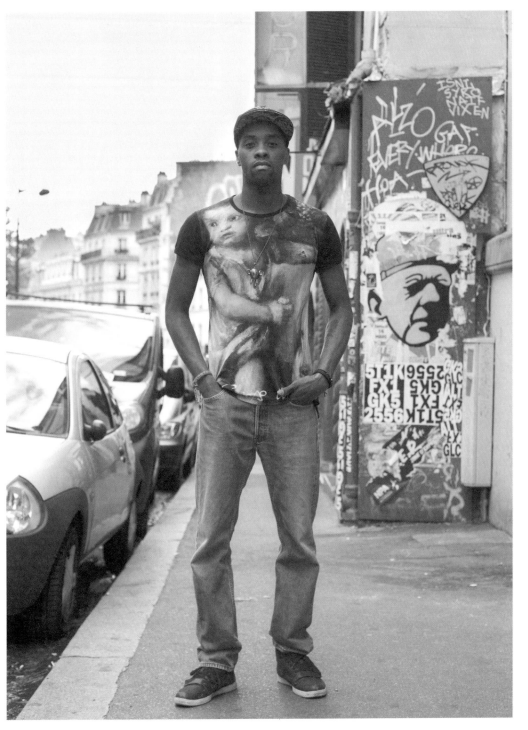

99

LOÏC

TATTOO ARTISTS

LAURENT VIATOUR
at **CALYPSO**
in Liège, Belgium

DEEXEN *at*
ABRAXAS *in Paris*

Although he wanted to get a tattoo when he was very young, and had symbolic dreams in which his grandfather was tattooed, Loïc had the sense to wait until he was sure of the design he wanted, and has no regrets about the delay. "For me, tattoos reflect your personality." A barber who likes body modification and the unique quality that tattoos give each individual, he is also interested in the technique associated with this art form. Loïc gets tattoos purely for himself; he mostly keeps them hidden, which isn't a problem for him. His tattoos derive their themes from his interest in the sea and old engravings.

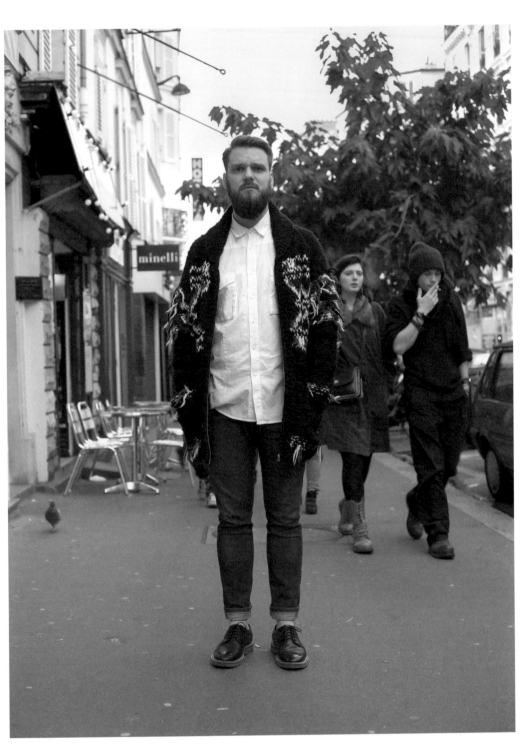

100

LOCATION
rue du Delta (Paris)

DOMINO ROSE

A passionate and tortured soul, Domino Rose is a young publishing assistant from Paris who is in search of an outlet. Her original ambition was to enjoy standing out from the crowd, but she soon got a taste for tattoos and now sees them as a way of taking back ownership of her body with its history of abuse over the years. This indelible jewellery, which tells Domino Rose's personal story, is also a way of rejecting society's rules and following the "rock'n'roll" code instead.

A fan of lowbrow art and the poetic, macabre world of Tim Burton and Morticia Addams, she plays around with her sources of inspiration. She makes it a point of honour to only get a tattoo on key dates, her way of telling the story of her life through original, eclectic images. About to tackle her second forearm tattoo, Domino Rose is gradually embracing the idea of being perfectly imperfect.

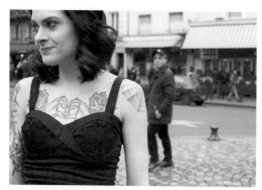

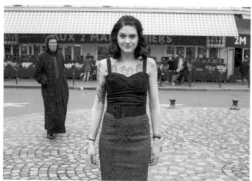

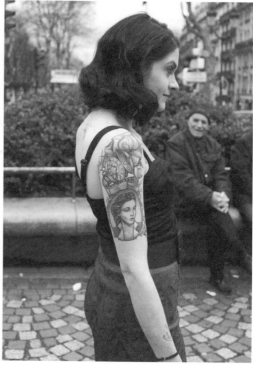

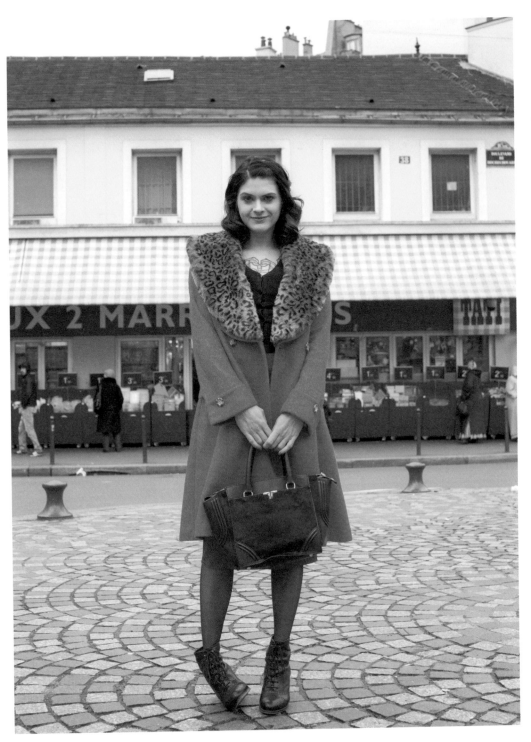

ACK-
NOW-
LEDGE-
MENTS

Étienne and Julie - Friendship is everything, Fanny E. - There for you, without grumbling, Galliane, Héline & Julien - Thank you!, James B. and Christian P. - One foot on the ladder, big-hearted, Jessy and Anthony - Because you always need to know how to read between the lines!, Kevin S., Lauren B. - An incredible session, a massive boost, Laurent B. - The project wouldn't exist without you, Lena B., The BDAG, Lisa F., Marie-Odile R., Maryse and Franck E. - Community management and excellent support!

Agnès Boucher, Anne-Hélène M. and Aurélie D. – Our most discerning fans! Anne-Laure B., AMK comptoir éditorial, Arlette and Jeannot B. – You can be proud of yourselves, Carole F. – English forever, Cathy and Olivier M. – The little donkey's far away, Charlotte F., Clémence and Jérôme – Always there for us!, Damien and Fanny, Delphine B. - It's the way you trust us, no questions asked, Edouard D., Émilie D., Erik and Julie, Esther and Julie / Léa and Dounia – Our bold and stylish assistants,

Mylène – I love you, Najoie and JP - The family, naturally, Olivier and Elsa - Because quite simply, Pauline T. - "Everything about her is great!", Pierre and Virginie - out of sight but not out of mind, Rémi L., Romain and Julie - The North forever, Sarah L., - My favourite all-rounder, Thibaut B., Thomas and Leslie - the perfect team, Tristan N., Valentine M. - For your unconditional trust..., Wilhelmina and Locko, Yana R

Alizée and Fatih, Amy MyMouse, Andy, Anik, Anne-Sophie and Julien, Arnaud and Noémie, Arnold and Capucine, Audrey D., Aurélien P., Avalon, Barbe Rousse, Bibiana, Bruno C., Calix, Camille, Camille and Jon, Cédric, Charline, Chloé, Christian M., Coline, Dago - Because we love Chile, Dan, Danik, David, David Choquette, Dimitri HK – You gave me confidence from the first day, Dominique Bodkin – simply for your kindness, Domino Rose, Élodie J., Élodie P., Élodie Very Petit, Émeric Pourcelot, Fab, Fanny and Julien, Flo M., Florence, François C., Fred, Georgie Harrison, Grizzly, Guillaume S., Hannah Holycamille, Inari,

Iris Lys, Issaet Thierry, Jessi Preston, Jimmy, Romaine and Christopher, Jon S. Maloy, Julie, Julien and Marine , Juliette, Junior Rodriguez, Katia G., Kirkis, Ladychips and Jay - Tsais hashtag Keur Keur, Laurine and Léo, Léandre, Lilou and Philippe, Lita and Émeline, Liz and Anthony, Loïc E., Loïc L. , Lorenzi, Lorna, Louis Aguilar, Louis B., Lucas L., Lucas Z., Lucy H., Lussi In The Sky, Macha, Madame Chän, Maéva, Marc and

Maéva, Marine and Axhell, Marion and Brocokid, Marion and Guillaume, Markus and Anna, Martin Philipp, Miss Glitter Painkiller, Nicolas Durand, Olivier T., Patrick, Peter G., Philippe Fernandez, Priscilia, Priscilla, Rachel F., Safwan, Sarah and Mehdi, Sébastien L. - My favourite Swiss Army Knife, Simon, Soraya G., Stef and Alex, Tété, Val Day, Victoria, Vincent Brun, Vincent K.

AIRNADETTE, BERNARD FOREVER, CHATEAU BRUTAL, CORPUS DÉLIT, GUILTY SO WHAT, LABEL BLACK MOOMBAH, THE BUS PALLADIUM, NOSWAD, TIN, WHERE IS NINA

PORTRAITS

THE TATTOORIALIST THANKS

PARTNERS

IN-
DEX

AN HACHETTE UK COMPANY
www.hachette.co.uk

First published in France in 2014 by Tana Éditions

This edition published in Great Britain in 2015 by
Mitchell Beazley, a division of Octopus Publishing Group Ltd
Carmelite House
50 Victoria Embankment
London EC4Y 0DZ
www.octopusbooks.co.uk
www.octopusbooksusa.com

Distributed in the US by
HACHETTE BOOK GROUP
1290 Avenue of the Americas
4th and 5th Floors
New York, NY 10020

Distributed in Canada by
CANADIAN MANDA GROUP
664 Annette St.
Toronto, Ontario, Canada M6S 2C8

ISBN 978-1-78472-092-6

A CIP catalogue record for this book is available from the British Library.

Printed and bound in China

10 9 8 7 6 5 4 3 2 1

PUBLISHER'S CREDITS FOR THE FRENCH EDITION:
Design: Le bureau des affaires graphiques (www.le-bureau-des-affaires-graphiques.com)
Graphic assistant: Martine Sartori
Editorial coordination & proofreading: Anne Kalicky, AMK Comptoir éditorial
Corrections: Clémentine Sanchez

PUBLISHER'S CREDITS FOR THE ENGLISH EDITION:
Commissioning Editor: Joe Cottington
Creative Director: Jonathan Christie
Design: Jeremy Tilston
Assistant Editor: Meri Pentikäinen
Translation: Ann Drummond in association with First Edition Translations Ltd, Cambridge, UK
Production Controller: Allison Gonsalves